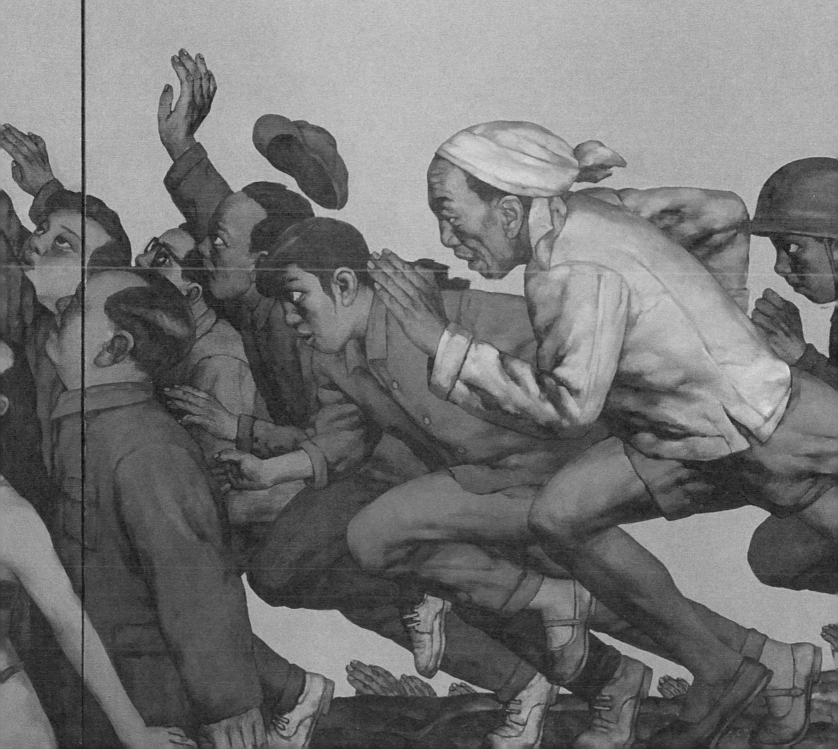

China!
New Art
& Artists

China!
New Art
& Artists

Dian Tong

Schiffer
Publishing Ltd

4880 Lower Valley Road, Atglen, PA 19310 USA

To My Parents

Library of Congress Cataloging-in-Publication Data

Tong, Dian.
 China! : new art & artists / Dian Tong.— Large print ed.
 p. cm.
 Includes bibliographical references and index.
 ISBN 0-7643-2324-5 (hardcover)
 1. Art, Chinese—20th century. 2. Artists—China. I. Title:
New art and artists. II. Title.
N7345.T66 2005
709'.51—dc22
 2005007963

Designed by "Sue"
Type set in Zurich BT

ISBN: 0-7643-2324-5
Printed in China

Front cover:
Zhang Xiao Gang
Blood Line: The Big Family
Oil on canvas, 190 x 150 cm

Back cover:
Ming Jing
White Air
Oil on linen
30" x 30"

Published by Schiffer Publishing Ltd.
4880 Lower Valley Road
Atglen, PA 19310
Phone: (610) 593-1777; Fax: (610) 593-2002
E-mail: Info@schifferbooks.com

For the largest selection of fine reference books on this and
related subjects, please visit our web site at
www.schifferbooks.com
We are always looking for people to write books on new
and related subjects. If you have an idea for a book please
contact us at the above address.

This book may be purchased from the publisher.
Include $3.95 for shipping.
Please try your bookstore first.
You may write for a free catalog.

In Europe, Schiffer books are distributed by
Bushwood Books
6 Marksbury Ave.
Kew Gardens
Surrey TW9 4JF England
Phone: 44 (0) 20 8392-8585; Fax: 44 (0) 20 8392-9876
E-mail: info@bushwoodbooks.co.uk
Free postage in the U.K., Europe; air mail at cost.

Contents

Acknowledgments

My thanks go first to my husband Bao Le De, who helped me create this book from the very beginning to the end. He contributed a great deal to *China! New Art and Artists*, going to China to help collect materials, taking photographs of paintings, caring for both our business and family matters, and creating a peaceful and quiet environment in which I could work. Without his help, I could not have completed this book.

Thanks go also to Professor George S. Semsel for polishing my English. I felt much safer under his scrutiny and thus owe him my special gratitude.

To my editor, Douglas Congdon-Martin, the best editor you could meet. He inspired me to write this book, and made everything possible.

To all the artists who are included in this book, I owe special thanks for their prompt response to my request for materials and their carefully prepared statements about art. I thank them for opening their hearts to me.

Foreword

For every action, my physics teacher told us, there is an equal and opposite reaction. When the ten years of chaos known as the Cultural Revolution ended in China, everyone waited to see what would happen. We didn't have to wait long. Within a few years an incredible flowering of the entire culture swept across the land. It was seen most notably in the arts, and despite the fits and starts of any such response, the development of the arts in China continues at a pace unmatched anywhere else in the world.

Most art movements are the result of national trauma. The Dada and Surrealist art movements are widely understood as a response to the trauma of the First World War, a rejection of the traditions and values that had produced a catastrophic chaos. Abstract Expressionism in the West is seen as a response to the trauma of World War II. In the West we have long accepted these developments in the arts. The same cannot be said of our knowledge of Chinese art. Aside from a relatively small group of concerned art scholars and critics, few of us know much about the explosion of "New Art" in China, which is reflective of the unparalleled progress taking place in that land. Tong Dian offers here a carefully considered and most welcome introduction to recent developments in Chinese painting.

China! New Art and Artists is a concise presentation of the various movements that have taken place in Chinese painting over the past century, concentrating on the most recent activity. Here we meet the artists who created the New Art of China, especially as it arose following the end of the Cultural Revolution period. The author explores how Chinese artists have dealt with the ancient tradition of inkpainting, how they have moved through Surrealism, Dada, Cynical Realism, and Political Pop and responded to the arts of the West, among other things, and this interesting discussion is presented in a well-conceived manner clear to the uninitiated.

Co-owner of the Tao Water Art Gallery on Cape Cod, a gallery that consistently offers some of the finest collections of contemporary Chinese painting, Tong Dian is more than qualified for the task. That she shares the gallery with her husband, Bao Lede, one of the pioneer artists who became prime movers of the recent movement, tells us she knows the territory far more intimately than most. We have waited far too long for this all-too-necessary work. Through it, our eyes will be opened.

George S. Semsel, Ph.D.
Professor Emeritus,
Ohio University College of Fine Arts

Introduction

In the early 1990s, the West was surprised to see contemporary art coming out of China for the first time. People were attracted by its freshness, diversity, vigor, critical perception, and ambition. All at once China's newest art and artists became a hot topic among art critics. Major museums, exhibition centers, and other eminent international venues throughout the Western world began to take contemporary Chinese art seriously and gave it a broad-based introduction. A number of major exhibitions in Europe and the United States presented the new work as a comprehensive whole.

In addition to successful exhibitions outside of North America, in 1998 *Inside-Out, China's New Art* toured from P.S.1 in New York to the San Francisco Museum of Modern Art, as well as museums in Seattle and Mexico, evoking repercussions in the U.S. and internationally. The following year the Guggenheim Museum in New York City showed the work of contemporary Chinese artists in a major exhibition: *China: 5000 Years*.

China has long been a closed country, isolated from the rest of the world, mysterious and almost unknown to outsiders. This isolation grew especially strong under the Communist government. In 1978, when Mao Ze Dong died, China finally ended its long period of confinement. In the following

quarter century, China has stunned the world by its unparalleled social and economic growth. The world has become increasingly fascinated with these far-reaching changes and how this dramatic and rapid development will affect Chinese culture and the everyday lives of the Chinese people. Though the country seems increasingly open and accessible, for much of the world China, because of its long history and complex culture, remains a mysterious land. The new art being created now may well serve as a channel into the heart of the land and its people.

What is happening in China today is one example of subsistence under the impact of the globalization of a commodity economy. Every country and culture has its own reaction to this and a very different experience of it. China has a special contribution to make to the world. The country's new art examines its present situation, links it to contemporary life, and interprets the thinking and philosophy that become its "Chinese-ness," its originality.

China has a five thousand year history of art, with long established traditions and techniques. It is in this history that the new art has its basis for creation. The ancient country's new artists must reckon with this past and excavate it again and again, to create the new ideas and new methods that will make China's new art not only outstanding, but unique.

1. A Hundred Years of Chinese Art

From the 18th Century to 1949: Western Art Disseminates into China

The Chinese have been creating art since ancient times; China's art history spans thousands of years. For centuries the Chinese have used ink and brush as their primary medium, painting on rice paper or silk. No matter how long the history, how varied the styles, this basic medium has been passed down over the ages without change. Chinese painting has its own system of philosophy and aesthetics, and its profound theory about rice paper, brush, ink, and color has produced an integrated and erudite art system, totally different from Western art.

By the beginning of the Qing Dynasty (1644-1911 A.D.), Chinese painting had passed its peak, but artists still adhered to the tradition with only minor amendments here and there. In the 18th century, with the colonization of Asia, Western religion began to disseminate into China, and brought with it, for the first time, Western art. By the middle of that century, the direction of China's art had been changed forever.

Beginning in the 18th-19th centuries, Jesuit painters from the West introduced Western oil painting in China. **Giuseppe Castiglione** (1668-1766, Italian), **George Chinnery** (1774-1852, English), **Joannes Ferrer** (mid-19th century, Spanish),

and **Nicholas Massa** (1815-1876, Italian) were the most influential painters at that time. Not only did they practice oil painting in China, they also taught Chinese artists how to paint in oils. Some even set up workshops where they taught the concepts and rules of oil painting, including perspective, color, volume, light and shadow, which hadn't existed in the history of Chinese painting. Castiglione, then an eminent artist hired by the Imperial Court, left many works behind.

Between the two world wars of the 20th century, Chinese artists, who had begun to go abroad to Europe and Japan, brought back more Western art and styles. In the meantime, in China, the waves of The May Fourth Movement, also called the New Culture Movement, surged forward dramatically. To "Learn from the West" became fashionable. Artists who came back from the West founded art schools that copied Western art education systems, and trained a new generation of artists who painted in the Western style.

The most famous artists of the era, **Xu Bei Hong** (1895-1953), **Liu Hai Su** (b. 1896), and **Ling Feng Mian** (1900-1994), all returned from France, where the modern art movement was rising and spreading. Liu and Ling became its active promoters, but the Chinese found Xu, who advocated the Western realist tradition, more acceptable.

World War II: Mao Ze Dong's Art for the Masses

During World War II, art became a tool for resisting Japan and saving the nation. Many artists, along with some Chinese intellectuals, gave up their own interests to create simple, easy to understand works designed to encourage the people involved in the resistance. The wood block print was very popular. Works by the Left Wing Wood Block Print group spread from Shanghai to Yanan. These works were concise and comprehensive. As straightforward propaganda messages they addressed people in simple and unadorned images and words, directly reflecting the people's desires and arousing their fighting spirit. Through the recommendation of the literary giant, Lu Xun, the German artist Kathe Kollwitz (1867-1945) and the Belgian artist Constantin Meunier (1831-1905), became an influential force in Chinese art. The realism promoted by Xu Bei Hong dominated the Chinese art scene.

In 1942, the Communist leader Mao Ze Dong gave a famous speech, "Talks at the Yanan Forum on Literature and Art," at Yanan, a Communist base during World War II. His words were to shape the direction of Chinese art for more than half a century. In this speech, which became the only policy for any kind of art in the future, Mao stated two goals of art. First, art should be a tool for the propaganda of Communist ideology. Second, art should serve the masses. The revolutionary masses are workers, peasants, and soldiers.

Mao asked the artists for whom they created their art, for a few people or for the masses? If it was for the masses, their art should directly connect with and touch the masses and the revolution. It should be popularized and easily understood by the masses. Western modern art embodies the bourgeois corrupt lifestyle and decadent thoughts, he warned, which are the first things proletarian art should banish. Most serves only a few people who are in a pretentious search for culture; thus art becomes the prey of art dealers and collectors.

By implication, in Mao's thought, not only should art be "popularized," but so should the artist. Artists should give up their up lofty social status and remold themselves. So it is that in recent Chinese history, most artists and intellectuals experienced the long, harsh, thoroughgoing process of "being reborn." Artists were to criticize and clean up anything bourgeois or petit-bourgeois in their minds, any corrupt thought, value, or aesthetic taste, eliminate the individual — the self — and in the end remold themselves into one of the masses, either a worker, a peasant, or a soldier. Ironically, some of the artists of the Left Wing Wood Block Prints group, who supported Communism so passionately, were forced to undergo the same process of thought reform.

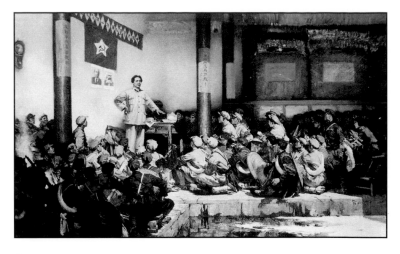

Fig. 1
He Kongde
Gutian Meeting
Oil on canvas

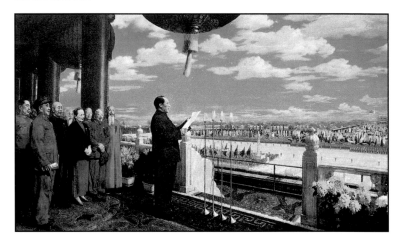

Fig 2
Dong Xiwen
The Ceremony of Declaration of The Birth of New China
1953
Oil on canvas, 230 x 405 cm

Fig. 3
Liu Chunhua
Chairman Mao Went to Anyuan
Oil on canvas

After the 1949 Communist Takeover: The Domination of Soviet Socialist Realism

In the 1950s, the slogan of young Communist China was "Learn from the Soviet Union!" Taking the Soviet Union as a model, China built its own academic system. There were eight art schools spread throughout the entire country each with a complete and rigid technical training program. Schools selected artists at very young age.

During that time, Soviet Social Realism dominated the art scene. There were scholar and student exchange programs between the two countries. When compared with the 1920s or 1930s, Chinese artists may have received a more sophisticated knowledge of Western realism or oil painting through study of the art of the Soviet Union. The most popular subjects concerned the leaders and the stories of revolutionary history. The dramatic, grand, and noble revolutionary motif governed the Chinese art scene.

The 1960s and 1970s: The Art of the Cultural Revolution

In the mid-1960s, the Cultural Revolution broke out and China's art took a new turn. The Cultural Revolution was the almost complete purge of culture and tradition. Whether seen from outside of China or internally, it was unprecedented in China's history. Mao, wanting a Chinese socialist Utopia of his own making, created a storm to destroy anything not suited to his idea. His dream for human happiness and the revolution evoked, instead, the rapid destruction of the Chinese culture and tradition.

"Smash Feudalism, Capitalism, and Revisionism!" was the slogan. To an artist at the time, Feudalism meant traditional ink painting, and the whole basic philosophy and aesthetics that lay behind it. Capitalism meant anything from the West, and Revisionism referred to the art from Soviet Union. Mao had a reckless and ambitious determination to transform the world. His faith became that of his followers. This was a time of revolution. Artists broke out in the most ambitious, creative bursts of energy. China's art moved closer to the spirit of Mao's speech at Yanan. It came down from easels to small newspapers, flyers, *Da Zi Bao* (big character posters that were written with calligraphy that stated an opinion for public view), blackboard newspapers, Chinese New Year's paintings, folk paintings, street performances, posters, theater, film, music, radio, newspapers, magazines — every available medium. Cultural Revolution art blanketed the earth and eclipsed the sky; it made full use of the media, reaching out everywhere to the masses and truly fulfilling its propaganda function.

It is not an overstatement to suggest that Cultural Revolution art verged on the avant-garde. Not only did it occur in the late

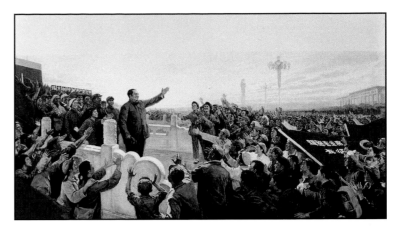

Fig. 4
Hou Yimin; Jin Shangyi; etc.
To Wage The Cultural Revolution to Its End!
Oil on canvas

Fig. 5
Yan Yongsheng
Unite Together To Get Bigger Successes!
Poster

Fig. 6
Tang Daxi
The Laughter of Mountains
Sculpture

1960s to the mid-1970s, at the time when Pop Art and various postmodern art movements were flourishing in the United States and Europe, but there were also similarities in the Chinese and Western ideas about art. It is no surprise that Andy Warhol produced his famous portrait of Mao during that time.

First, in both Chinese and Western art, the concepts of anti-art, of destructiveness, of abandoning the dream of modern art, of negating decadent, inhuman, abstract, and auragenic genres, and of achieving new and revolutionary ideas by giving up the refined subjects and media were the vogue. Art could be anything. Second, both Chinese and Western artists wanted to bring art to the masses, the common people, to reach into the life of all humanity.

Romantic-Realism was the only genre through which to express the Utopian Communist revolutionary ideals of the time. Artists adapted Chinese folk art, especially Chinese New Year's paintings, into their oil paintings. They used bright colors and joyous images, familiar to the masses. Unbelievably, such dogmas as "Red, Light, Bright " and "The Three Prominences" became the guides for every painter. "Red, Light, Bright " declared that there must be red in the painting since red symbolizes the revolution, happiness, and joy, and the painting must look bright with light, full of hope.

"The Three Prominences" is even more unbelievable, insisting that in a painting the revolutionary masses be projected among all the figures, the heroes stand out among the revolutionary masses, and that the main hero be most prominent among all heroes.

Most of the art of the time centers on the party leadership, heroes, and the revolutionary masses, and is concerned with party policies, the cultural values put forth by the party, the stories of revolutionary history, and the beautiful ideals and happy lives of the people. Artists romantically created these happy dreams and visions of Paradise with sincerity and passion. Amazingly, they believed in what they created, and so did the whole country.

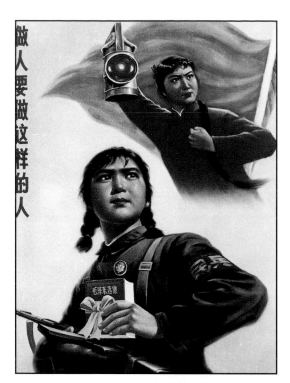

Fig. 7
Shan Lianxiao
To Be a Person Like Her
Poster

Fig. 8
Gu Pan
Another Harvest Year
Oil on canvas

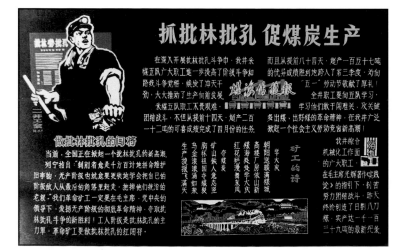

Fig. 9
Yangquan Machine Repair Factory
Black Board Newspaper

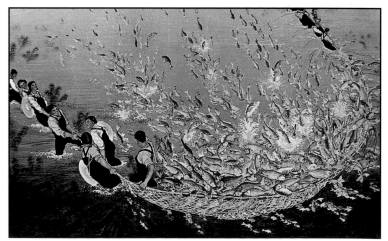

Fig. 10
Huang Zhengyi
The Commune's Fish Pond
Hu county's folk painting

The Transformation of Traditional Chinese Ink Painting

Chinese ink painting was challenged for the first time when Western painting was introduced into China. In the early twentieth century, many artists were swept up in the "Learn from the West" wave. Some artists argued for the transformation of traditional art forms, suggesting the application of Western perspective, light and shadow, and color to Chinese ink painting. From that time on, Chinese artists have never stopped trying to bring something new into Chinese art.

Chinese ink painting might really have needed to be transformed since the world of its origin and the culture from which it arose had forever been completely crushed by Western guns and cannons. It was impossible for Chinese artists to pursue their art and lives as their ancestors had. The advanced industry and technology proved that the ancient civilization lagged far behind. It was not difficult to understand why Chinese artists lacked confidence in their old traditions. Western art seemed as advanced as its science and technology, leading some to conclude that it had better

ideas and methods. The result was the invention of realist ink painting.

After the Communists took over China, this kind of ink painting had become more clearly defined. Artists painted using perspective, light, and shadow as was done in the West, but they used ink and Chinese colors on rice paper instead of oils on canvas. This break with tradition was unprecedented in China's art history. Traditional ink painting had never been about the object, the thing painted. It had always been about the painter, the painter's world or ideals. It was called *shie yi* — writing the thought or idea — which in concept was ideogrammatic. It was not realist, which was why there was no concept of perspective or of light, shadow, volume, and the like in it. During the Cultural Revolution period, Social Realism became the dominant style. The result was that Chinese traditional ink painting was transformed into something totally new.

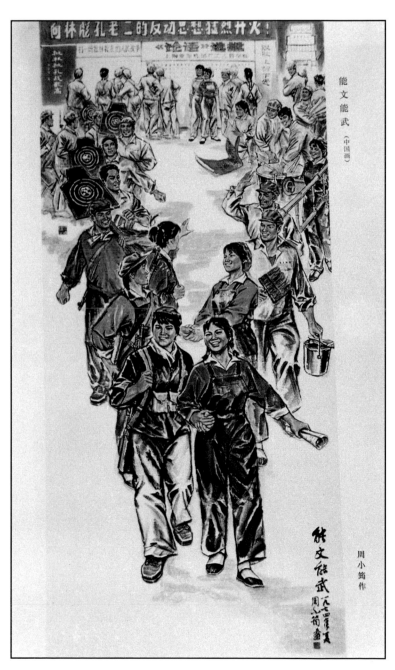

Fig. 11
Liu Zhide
The Party's Old Secretary
Hu county's folk painting

Fig. 12
Zhou Xiao Jun
Be Able to Wield both the Pen and the Sword
Ink on rice paper

2. After the Cultural Revolution: The Birth of China's New Art

The End of the 1970s: Nationwide "New Culture" Fever

When Chairman Mao died in 1976, China finally ended its isolation of a half century. Once the windows and doors were opened, modern Western civilization flooded over China. China faced two issues: first, the rebuilding of the country; and, second, the impact of Western culture and economics. A major discussion of culture was initiated among intellectuals. Some argued that China needed to move in a new direction. The country needed to open up to the outside and be integrated into the modern world; a new culture needed to be constructed, which would make China powerful and prosperous. The debate stirred an enthusiastic discussion.

As had happened in the past, the first choice of Chinese intellectuals was "enlightenment." From the Opium War in 1840 (launched by eight imperialist countries from the West) to the time of the debate, Western civilization had brought China nothing but detriment and humiliation. In the early twentieth century, Chinese intellectuals initiated the May Fourth or New Culture Movement. They adopted "Science " and "Democracy" as their buzzwords and tried structure a new civilization to contend with the West. They called this the "enlightenment" of a new civilization. But wars continue to be waged. China suffered a civil war and a war with Japan followed by a long period of isolation under Communist rule.

By the end of the 1970s, some intellectuals believed that China had never finished its "enlightenment," and that part of the fulfillment of that dream would be to become internationalized. Questions arose. If China were to learn from the West, what should it learn? What values should be brought to Chinese cultural traditions including the fifty years of Communist culture? What kind of new culture needed to be built?

The debate swept across the country, reaching the most remote corners of the land. Various Western theories, ideas, and new ideological trends became popular, and cultural values suddenly changed. Artists were the vanguard of this discussion. For the first time in fifty years, the Chinese experienced an excitingly free, dynamic, and flourishing cultural atmosphere. And this was very precious to intellectuals and artists alike.

The '85 New Wave: A Revolution in Modern Art Movement

Once the Cultural Revolution ended, China's academic system resumed operation after a ten-year suspension and began to admit students. But what the schools recovered was the rigid training system of the fifties. Realism remained the dominant genre. At the same time, during the fervor of the "Cultural Discussion," Western modern and postmodern art poured into China. Young people, filled with vigor and zest, voraciously devoured these new things, and challenged the old rules. The experimental art they dared to create was obstructed not only by the schools, but also by the authorities. This meant that there was no chance of having their work shown anywhere in the country. All exhibition spaces were under government control, and any exhibition had to be examined and approved by the governmental authorities. In addition, there were no private art galleries.

The new ideas, however, would not be stopped and groups of young, innovative artists began to form. The first was in Beijing. A loose assemblage of painters, sculptors, poets and writers, they called themselves "*Shing Shing* [star] Painters. " They set up shows in public parks, which didn't have many regulations regarding formal exhibition space. They pursued the direction of modern art, creating works that were brave and sincere, with everybody doing something different. Their goal was to make their own artworks and to show them in public. This happened in 1979. As soon as news of their first exhibition spread, others began to follow their example. A rising storm was on the horizon.

In the early 1980s, young artists around the country began to form other groups, organizing exhibitions by themselves at all kinds of locations, without approval from the authorities. Before long there were seventy-nine groups in twenty-three provinces. More than a hundred shows and other events, involving more than two thousand artists took place.[1] In 1985, this movement reached to its peak.

The young artists reveled in "The Movement," treating it as a revolution. They were not afraid of having their exhibitions shut down by the authorities. Even if the shows

lasted only ten minutes, they felt they had achieved their goal, which was to contend with the whole system. Their shows usually took place at informal exhibition spaces such as in the woods, a park, a town or city square, a classroom, or an apartment — any venue that would work.

Meanwhile, a group of young art critics in Beijing and a few other cities, who controlled some of the print media like *China Art*, *Fine Art*, *Art Trends*, *Jiang Su Pictoral*, and *Painter*, added fuel to the flames. They covered the exhibitions and printed up-to-the minute news stories about them in their newspapers and magazines. They got the word out and became advocates of the group artists. These critics also wrote reviews and discussed the new trends in art and art theory. No matter where in the country the young rebels lived, these artists could communicate with each other through the media. One of the critics called the new art movement the *"'85 New Wave."* The movement grew vigorously.

The *'85 New Wave* art movement was not a repeat of the Western modern art movement, but a totally new, revolutionary movement as defined by the new Chinese artists. Every art group had its own "Manifesto," a statement of its position on art. If you read them carefully, you will find that every "manifesto" argues for rebellion. For a long time, artists loathed the administrative regulations on creating art. They abhorred the use of their art to eulogize Communist achievements and virtues, detested the use of art to depict a sham happy life and beautiful ideals, and hated the riot of hypocritical emotion. The *'85 New Wave* was a political movement within the sphere of the "Major Cultural Discussion," a revolution filled with idealism. The various genres or ideas of Western modern and postmodern art were adopted as their weapons; from this arsenal the new artists would pick whatever suited their purposes. There was no pure issue such as "art for art's sake." China's new artists found this position of Western modern art too weak, not lethal enough, lacking in passion for society and humanity. From the very beginning, Chinese artists were more concerned with art in terms of its social and cultural meanings, and its relationship to human life. They thought it was their responsibility to build China's new culture.

China's new art was a mixture of the ideas of modernism and postmodernism. From painting to performance art, video art to installations, the artists experimented with everything. They lacked an in-depth knowledge of the external art world, and this may have had a liberating effect on them, taking away any limitations the "current trends" might impose. These group artists were mostly from the rigid art schools. They were trained at a very young age, were adept at handling paint and canvas or rice paper, and consequently were advanced painters. For them the brush was the most convenient tool. Painting was still the dominant medium, and remained as such until the mid- or late 1990s.

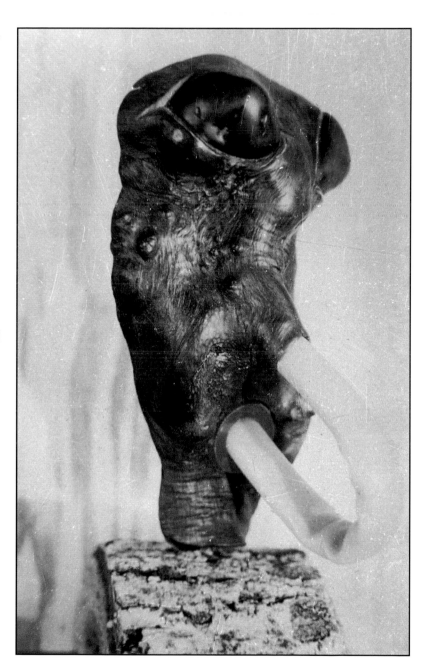

Fig. 13
Wang Ke Ping
Breathes
Wood sculpture

In February 1989, a group of young art critics curated a comprehensive national exhibition of *'85 New Wave* art at the China Art Museum in Beijing. The show was called *China/Avant-Garde*. On February 5th, 186 artists from all over the country gathered in the capital city; it was as if a band of guerrillas had finally come out of woods and occupied the final fortress. Nearly three hundred artworks were displayed, filling the building. They included paintings, installations, performance art, and video pieces. The author experienced this major event personally, so many memories of it are still as fresh as if it were yesterday.

On the very first day of the exhibition, a woman artist from Zhe Jiang province pulled a gun and fired a shot at her installation. That brought the police, and the authorities, too, and the show was closed down after only a few hours. Nonetheless, it got the attention of the media, and not just from the Chinese press, but from the many foreign reporters as well. After a ten-year revolution, the *'85 New Wave* art movement finally got its perfect ending. It took its victorious curtain call in a gunshot.

Was this revolution a success? Although the authorities didn't open their arms enthusiastically to welcome it, they nonetheless gave it their tacit consent. No one could bring himself/herself to believe that it would ever be possible to show the works of this "motley crew" at the China Art Museum in Beijing, China's foremost art institution. The exhibition was a testament to the hard fought campaign by the new art critics in Beijing, and to the open-minded artists within the academic system. As it turned out, even though they disdained what the rebels were doing, they had been giving them clandestine support from the very beginning.

In the early 1980s, there was a discussion about form and content within the academic system. Painters who just came through the Cultural Revolution gingerly requested some freedom from the authorities; in particular, the freedom to choose any content, not necessarily socialist ideology, and any form, rather than the acceptable realism. This was seen as a request for "art for art's sake." Art was the great unifier, and whether they were old academics or young rebels, the artists had same fundamental interest. But the young rebels had already charged ahead. They grew up during the Cultural Revolution, and they had some of the Red Guard's rebel impulse.[2]

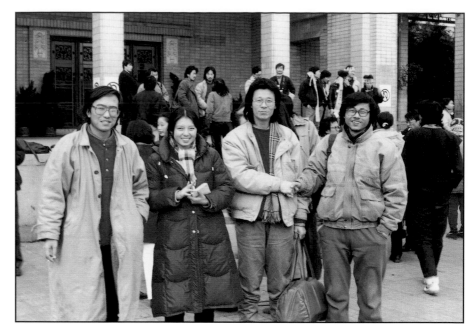

Fig. 14
The opening reception of China/Avant-Garde, February 5, 1989, in front of China Art Museum. From left Bao Le De, Tong Dian, Qu Yan, and Gao Ling.

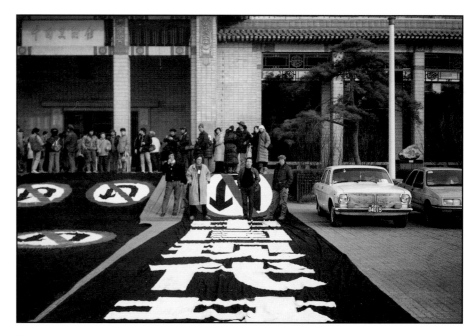

Fig. 15
The opening reception of China/Avant-Garde, February 5, 1989, as artists gathered in front of China Art Museum.

Some of them might actually have been members of the Red Guard. They believed Mao's doctrine: Revolution is not a banquet, but a storm.

All Chinese artists and their creative works have benefited from the *'85 New Wave* art movement. Of course, if there had not been Communist reform, and the ensuing changes in the new age of China, this movement may never have taken place.

Some Famous Groups and Artists of the *'85 New Wave*

The **Southwest Artists Group** was active at Yunan, Sichuan, and Gui Zhou. The artists had just graduated from the art schools of the three provinces. **Mao Xu Hui** (b. 1956), **Zhang Xiao Gang** (b. 1958) and **Yie Yong Qing** (b.1958) were the leaders.

They followed the slogan "Express and show concern for the real people, and human life; uphold the spirit of the Nature." Art should be "the figurative depiction of life."[3] They took stands against poetic, aesthetic, or sentimental depictions, and pursued the truth, an essential truth, and the shock of the human soul. They loved the philosophies of Nietzsche, Schopenhauer, and Freud. **Mao Xu Hui's [Fig. 17]**

paintings look primitive, innocent, simple, and unadorned. He painted heavy figures with dark red. **Zhang Xiao Gang's [Fig. 16]** motifs were initially death and dreams, but they later became acidic, symbolistic, and allegorical. They are obviously influenced by exotic myths, legends, and natural religions. **Yie Yong Qing [Fig. 18]** painted deftly and naturally, creating a dream-like milieu. There are metaphors of subtle stories told through the figures, animals, and plants in his paintings.

Yunan and some sections of Sichuan Province, far from the cities, and full of sunshine and lush flora, are the places where various minorities congregate. There the exotic forms of nature and the free, rich, and colorful cultures, with different religions and legends, made their art extraordinary. The purity and sincerity in the artists' work, so full of life and passion, blows like the fresh wind across your face.

Zhang Xiao Gang
(b.1958)

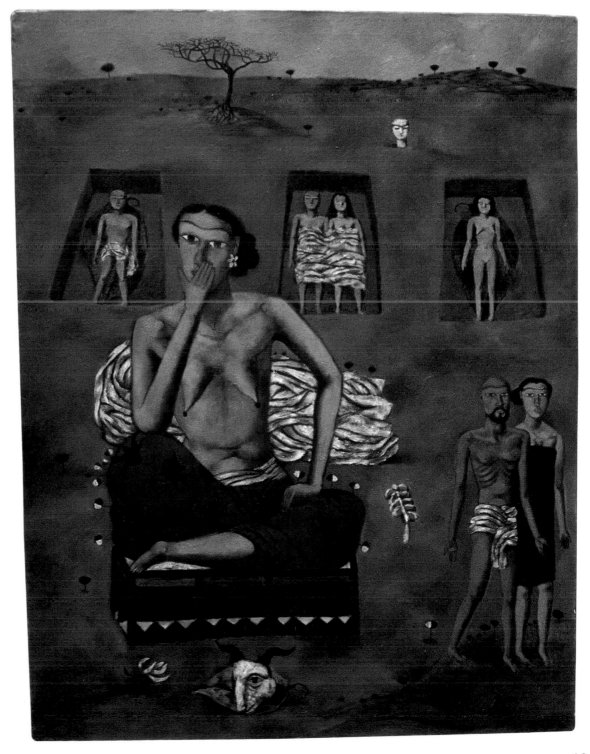

Fig. 16
Zhang Xiao Gang
The Endless Love (one of three)
1988
Oil on canvas 130 x 100 cm

Mao Xu Hui (b. 1956)

Fig. 17
Mao Xu Hui
Red Nude
1984
Oil on canvas, 84 x 98 cm

Yie Yong Qing (b.1958)

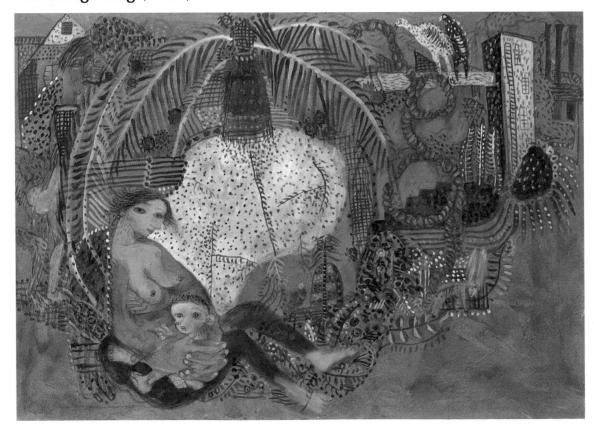

Fig. 18
Yie Yong Qing
The Last Garden
1980
Oil on canvas, 120 x 80 cm

The **Northern Artists Group** was in the coldest province, close to Russia. **Su Qun** (b.1958) and **Wang Guang Yi** (b.1957) were its representative artists. **Su**, the theorist and activist of the group, was an energetic, fanatic idealist whose words poured forth like a rushing river. He had a burning passion for Nietzsche's philosophy. He believed that only a new civilization with a healthy and lofty spirit and reason could save China from ruin and chaos. The artist should take it as his duty to supply samples for the new civilization. More than just confident with his ideas, Su talked about them as often as possible. The author experienced his passion when working with him on a book in 1987. He could encircle Beijing on a single thought. His ideas coincided with some of the elites in the " Major Cultural Discussion," which gave him and his group greater credibility. **[Fig. 19]**

But how does art depict the ideals and dreams of Chinese intellectuals, thoughts that span a hundred years? These philosophical ideas were not easy things to paint and in the attempt some farfetched depictions may find their way into the artist's paintings.

The **Chi She** or **'85 New Space** was a group artists around Jiang Shu and Ze Jiang provinces, on the east coast of China. **Zhang Pei Li** (b.1957) and **Geng Jian Yi** (b.1962) were its leaders. They took stands against "prostitute art" and tried to let their art be "pure and true." They didn't passionately criticize or advocate something, but pursued the truth. This cool attitude revealed the strength of their thinking in the hot cultural climate. Once, after he had spent time in a hospital, **Zhang** repeatedly painted rubber gloves in his "X", showing his concern for the human condition. His depictions are cold, detached, and uncomfortable. He constantly switched mediums, from oil to objects, glass, paint, and plaster. **[Fig. 20]** **Geng's** "The Second State" was the first bald portrait in China's new art, cold, bantering, and mocking. His style and attitude later influenced Cynical Realism. **[Figs. 21]**

Su Qun (b.1958)

Fig. 19
Su Qun
The Absolute Rule No. 1
1985
Oil on canvas

Zhang Pei Li (b.1957)

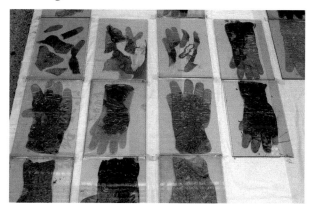

Fig. 20
Zhang Pei Li
X
1985
mixed media

Geng Jian Yi (b.1962)

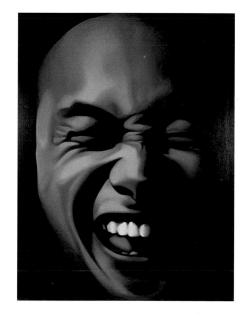
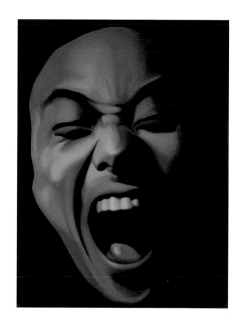
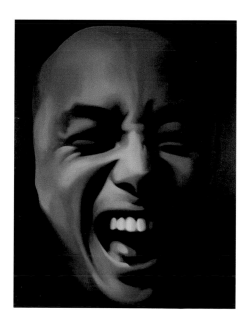

Fig. 21
Geng Jian Yi
The Second State
1988
Oil on canvas

Xia Men Da Da, China's Dadaists, were founded in Fu Jian province, in the southeast of China. **Huang Yong Ping** (b.1954) did something extraordinary at a time when most Chinese artists had yet to learn about Dadaism. He played some destructive games. In one of the most famous, in 1987, he stirred two books, a Western art history and Chinese art history, in a washing machine for two minutes, then put the mixture on the top of a box which he called "Book Washing." His art invariably displays Eastern wisdom, a mix of Zen and Dadaism. Later he moved to Paris, where he became an active figure in French and international art circles.

Gu Wen Da (b.1955) was a eminent pioneer in ink painting, walking alone as a wandering monk, unrivalled in his time. In the late 1980s, he settled in New York, where he gained even greater success. His works have been collected by the world's major museums.

During the *'85 New Wave* Gu began with Chinese calligraphy, transforming calligraphy into huge expressionist paintings by first breaking apart, then re-assembling Chinese words. On one level, the calligraphy has an abstract form and expressive structure; on a second and deeper level, the Chinese language (word) is the bearer of Chinese culture. Gu combined the two and created something very new. He kept the expressive strength of calligraphy and maintained the beauty of ink, both of which are at the core of the tradition of ink painting. Further, he went back to the tradition of the ideogram, which had been lost for almost fifty years. Going back into history to dig up the tradition has always been the manner of China's new art. In Gu's works, which are usually huge, the deconstructed or reassembled words become metaphoric or metonymic. The Eastern, mysterious grand consciousness of the universe calmly emerges on the surface of his paintings. He usually worked with rice paper, ink, and the Chinese brush as his medium, at times adding bamboo and cotton.

Since coming to New York, Gu has been working on more conceptual and idea art. His works have gone far beyond ink painting. "United Nations," started in 1991, but still unfinished, is a grand-scale installation of using human hair and words from various languages. Creating this work on five continents, in fourteen countries, Gu interprets his Utopian dream by using human hair from different races and nations. When he lives in New York, an international and cosmopolitan city where various culture and races are gathered, he feels deeply the need for the exchanges and understandings between the various peoples and countries and races. [**Figs. 25-27**]

Xu Bing (b.1955) is another artist who has gained his international reputation in New York. In 1989, two artists evoked repercussions in the famous *China/Avant-Garde* exhibition. One of them was Xu Bing. While the *'85 New Wave* was growing vigorously outside the academic world around 1987-88, Xu hid inside of the best art school in Beijing, creating his great piece, *The Book from the Sky*. Trained as a printmaker, he hand carved about two thousand wooden molds of

invented characters, which, though based upon the components of Chinese characters, did not exist in the Chinese language. He printed them using one of China's four ancient inventions, letterpress printing, and hung them as *Da Zi Bao* from floor to ceiling or displayed them like old fashioned books on the floor. People were stunned by his vast project and the dark, cool visual impact of his meaningless characters. He left the author with a very deep impression during their interview at the exhibition because he was so different from any of the unrestrained rebels, not just in his appearance, but also with his cultivated mind, which was that of an intellectual. He seemed to be well-versed in Chinese culture, history, Zen philosophy, and traditions. In the hot climate of the "Cultural Fever," he towered above the rest, not by building a new culture, but by deconstructing or challenging what we had. Since he moved to New York, in 1989, his *Book from the Sky* has been studied by scholars from worlds of philosophy, linguistics, epistemology, Chinese history, mythology, religion, literature, psychology, anthropology, archaeology, making him an international artist of major significance. [**Figs. 23, 24, 28-31**]

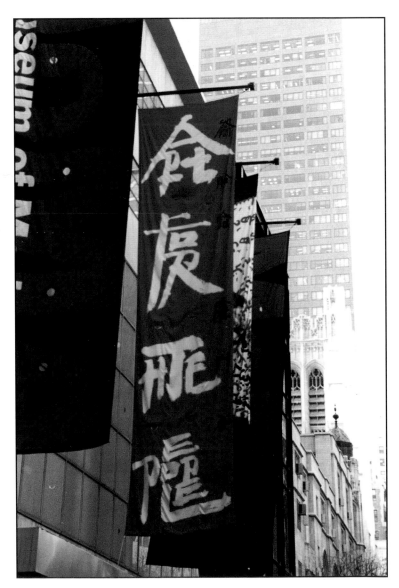

Fig. 23
Xu Bing
Art for the People
1999
Banner, cotton

Xu's *Book from Sky* [**Fig. 29**] is a work of Chinese conceptual art. Even though he used language as the medium, he didn't try to interpret the philosophical issue of truth or the essence of the objective reality as did the Western conceptual artists. This is an issue of epistemology. To Western conceptual art or the tradition of Western philosophical thinking, the objective reality is always separated from the subjective world; the language becomes the code through which to channel truth or describe the illusion of truth. Xu Bing negated the knowability of objective reality. His invented characters delivered nothing meaningful. The *Book from Sky* tells one thing, that human language, culture, and knowledge does not offer the truth of the world. He was somewhat agnostic at this point, but afterwards deviated from this position.

Ancient Chinese philosophy did not separate the subjective and objective realities, they were the one whole. To attain essential truth, which the Chinese call *wu-tao* — "awake to truth" or enlightened — you can find it living in you or you need to live through it. This has nothing to do with human knowledge or culture. In fact, the first condition of *wu-tao* is to limit or to clear the mind of such things. Zen philosophy is a combination of Chinese ancient philosophy and Buddhism. Xu Bing seemed to be a seeker or a practical man who, equipped with the ancient wisdom, tried to live through the truth by carving more than two thousand molds, showing his (or the Chinese) way of reaching truth. Is this an answer to the "no" answer of agnostics or postmodern Deconstruction?

In *Book from Sky,* Xu Bing has a contradiction. His anti-culture, anti-knowledge notion was very much based on reason, knowledge, and culture, unlike Zen, and his work was also very philosophically oriented and designed. Of course, the way he offered to reach the truth and his wisdom had to be shared with other people.

In New York, Xu Bing has been creating more interesting works, constantly offering his Chinese wisdom to the world, and challenging contemporary culture. His art has been shown in almost every major museum and won numerous prizes internationally, including the prestigious "Genius" grant from the MacArthur Foundation in 1999.

An Introduction to New English Calligraphy, 1994-96 [**Fig. 28**], is a fusion of written English and written Chinese. The letters of an English word are slightly altered and arranged in a square word format so that the word ostensibly takes on the form of a Chinese character, yet remains legible to the English reader. He set up a classroom in the museums, teaching visitors English calligraphy.

A Case Study of Transference, 1993-94, [**Fig. 24**] is a performance/mixed media installation with male and female live pigs tattooed in false English and Chinese scripts, a wooden enclosure, and books. The center of the exhibition space is occupied by a fenced enclosure, the ground of which is littered with piles of books. The performance begins with the appearance in the enclosure of two breeding pigs

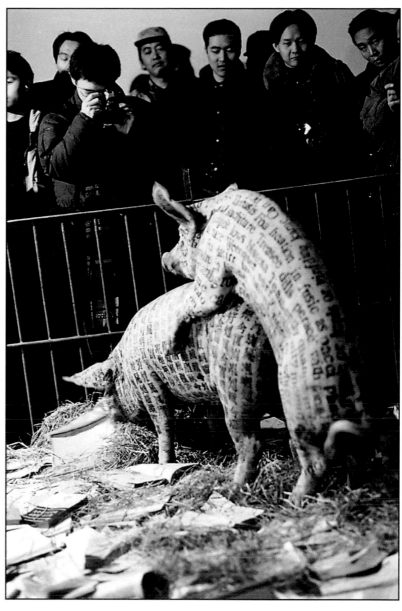

Fig. 24
Xu Bing
A Case Study of Transference
1993-94
Installation, pigs, and books

whose bodies are covered with tattoos in the form of "false scripts" (the male pig with false English words and the female with false Chinese characters). Within this confined space, the pigs cohabit, commune, become aroused, and finally mate.

In *Art for the People,* 1999 **[Fig. 23]**, commissioned by the Museum of Modern Art in New York, Xu emblazoned his eye-catching red-and-yellow banner, measuring 36' x 9', with the slogan "ART FOR THE PEOPLE: Chairman Mao said" inscribed in his own invented system of "New English Calligraphy" — English words deconstructed but then re-configured into forms that mimic the square structure of Chinese characters. Xu Bing's new works seemed closer to the masses; he intended to publicize his belief in Mao.

Where does the dust collect itself, 2004 **[Fig. 30]**, was awarded the first Artes Mundi Prize at the National Museum & Gallery, Cardiff. Xu Bing made this new installation using dust collected in the aftermath of the September 11, 2001, attack on New York, a few streets away from the devastated site. The outline of a Zen Buddhist poem is visible, revealed as if letters have been removed from under the dust layer:

> The Bodhi (True Wisdom) is not like the tree;
> The mirror bright is nowhere shining;
> As there is nothing from the first,
> Where does the dust itself collect?

This was written by Hui-neng (638-713), the Sixth Patriarch of the Zen sect in China. It was written in response to another poem by a Zen monk who claimed to understand cleaning up one's mind:

> The body is the Bodhi tree;
> The mind is like the mirror bright,
> Take heed to keep it always clean,
> And let no dust collect upon it.

Xu Bing discusses the relationship between the objective and the subjective realities, and the complicated circumstances created by different perspectives of the world. There is nothing better than the real dust from 9/11 to describe the differing perspectives that cover the minds of different people and races, keeping them from reaching truth. He interprets the truth that was told 1,400 years ago.

[1] Gao Ming Lu and Tong Dian et al. *Chinese contemporary Art History 1985-1986*, Shanghai People's Publishing, 1991, p. 606-626
[2] A mass organization of young people during the Cultural Revolution.
[3] Mao Xu Hui: "New Representation — Represent and Surpass the Depiction of Life," *Art Trends*, 1987

Gu Wen Da (b.1955)

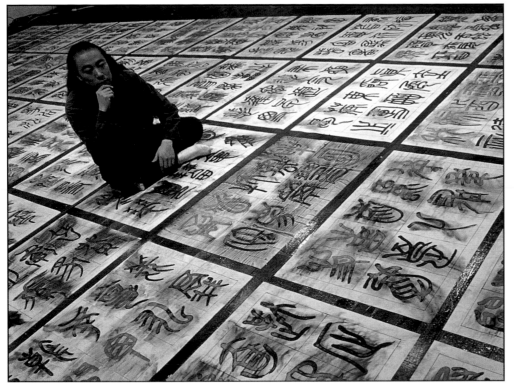

Gu Wen Da with his *Mysthos of Last Dynasties-form #c: pseudo-seal scripture in calligraphy copybook format*
1983-1987. #c-1 to #c-50
96.5 x 66 cm each
Gu's works are in the British Museum and in many private collections

Fig. 25
Gu Wen Da
Wisdom Comes from Tranquillity
1995
500 x 800 x 80 cm
Ink and mixed media installation

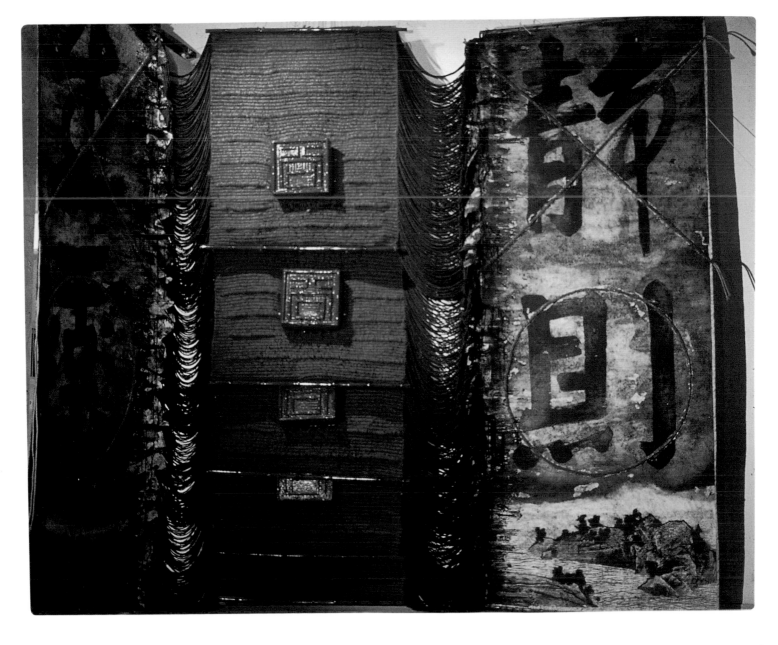

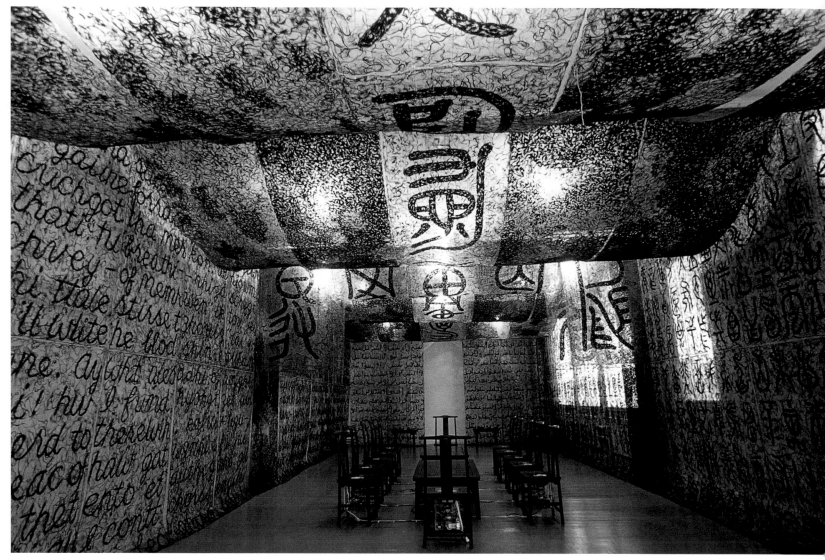

Fig. 26
Gu Wen Da
United Nations: China Monument Temple of Heaven
1998, commissioned by Asia Society and Museum, PS1
Museum, New York. The temple is of pseudo-English,
Chinese, Hindi and Arabic characters made from human
hair collected from all over the world
52" x 20" x 13"

Opposite page:
Fig. 27
Gu Wen Da
United Nations: The Babel of the Millennium
1999, permanent collection of San Francisco
Museum of Modern Art. Screen tower made of
human hair with pseudo Chinese, English,
Hindi and Arabic languages
75" x 34" diameter

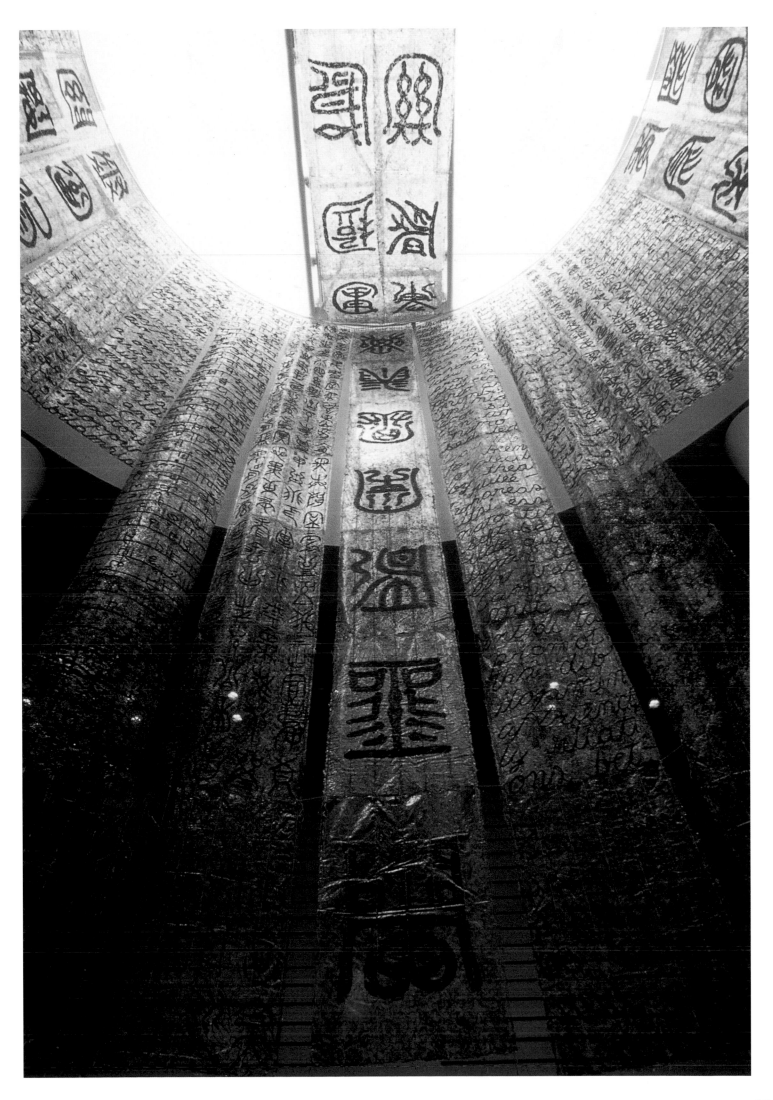

Xu Bing (b.1955)

Opposite page:
Fig. 29
Xu Bing
The Book from the Sky
1988
Installation, ink and rice paper, cotton,
and wood

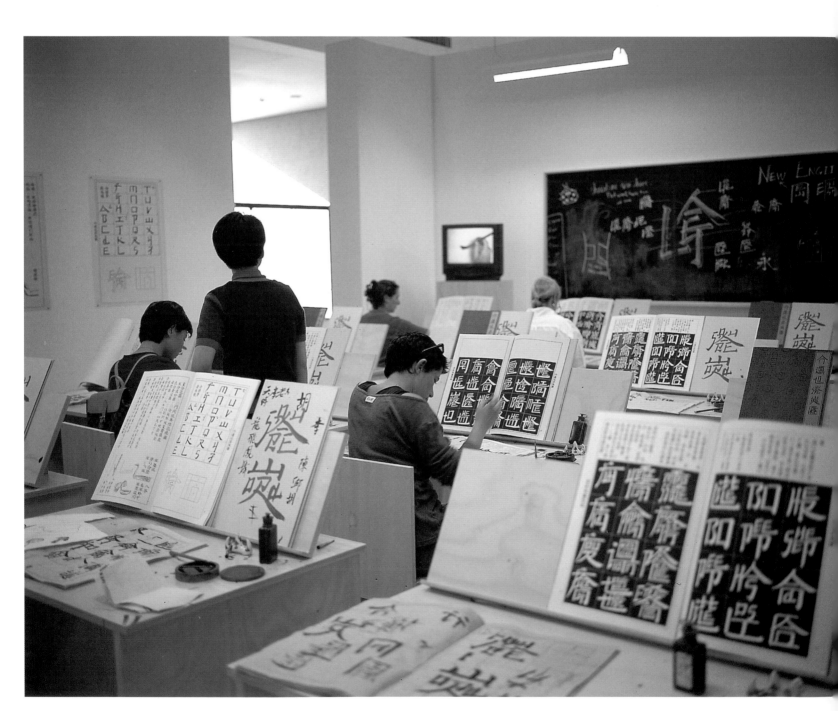

Fig. 28
Xu Bing
An Introduction to New English Calligraphy
1994-1996
Performance

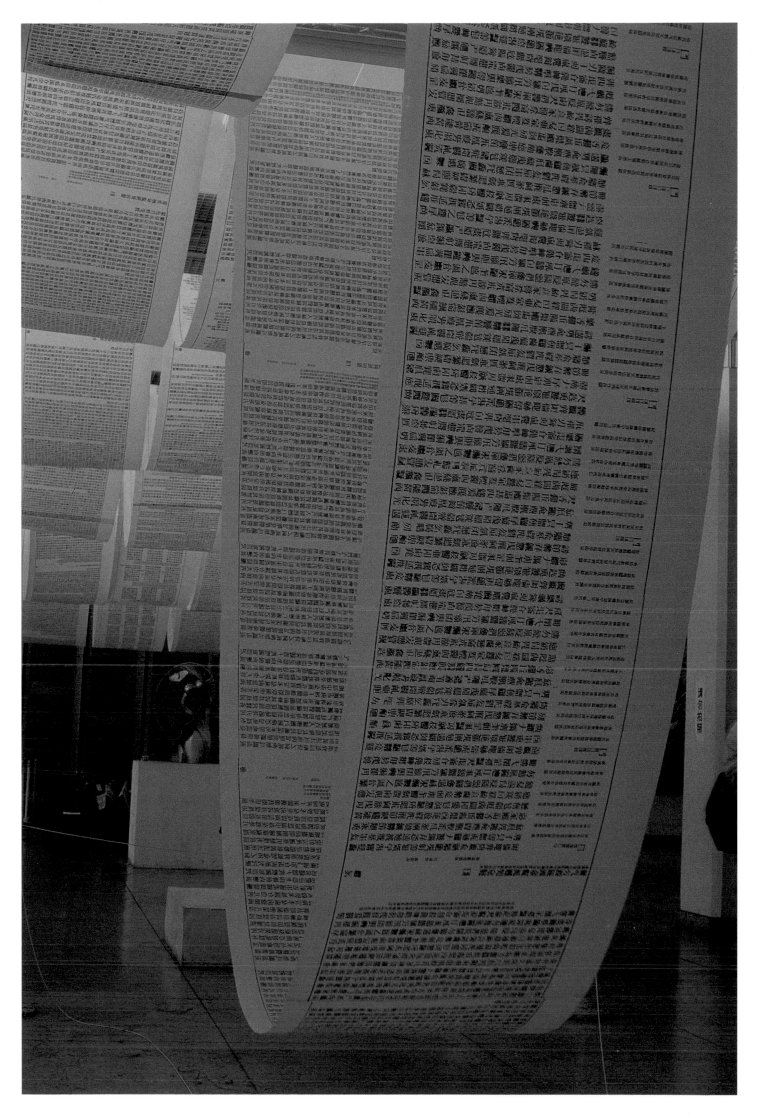

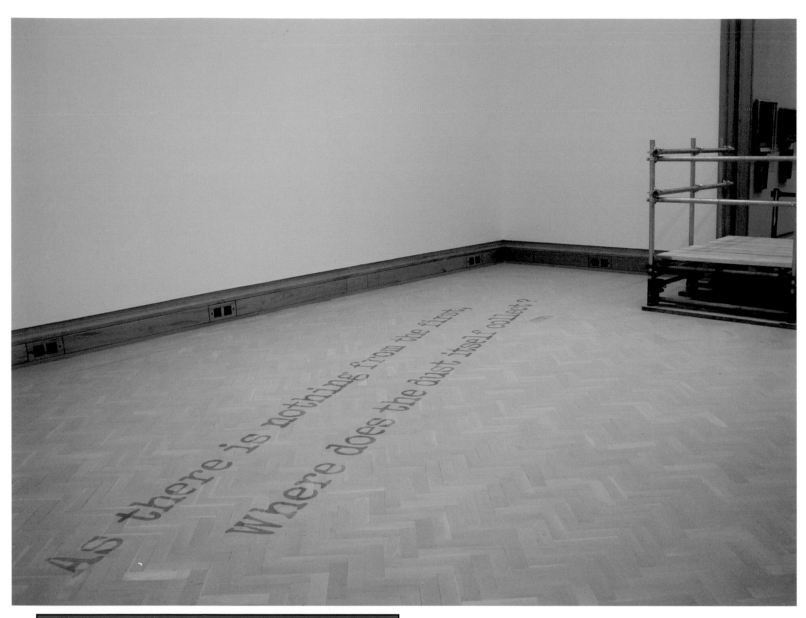

Fig. 30
Xu Bing
Where does the dust itself collect?
2004
Dust from September 11

Fig. 31
Xu Bing 2004

3. Post-1989 to the Early 1990s: China's New Art

In June 1989, two months after the *China/Avant-Garde* exhibition, the Tiananmen Movement came to a head at Tiananmen Square in Beijing, in an event that shocked the world. Chinese artists felt as though they had been bashed on the head, and were finally brought back down to earth from their lofty state of extreme passion. The chilling facts made people realize China's true reality. The desire to build a new culture might have been little more than the unilateral wish of intellectuals; it was probably a utopian, unrealistic, century-long dream. After the turbulence, the freedom and flowering of the *'85 New Wave* seemed as though it had been in another world. There was an apparent silence among the artists, but underneath thought and creativity were growing much deeper and stronger. The true meaning of the times would emerge in China's new art.

In the early 1990s, something new occurred in Beijing's literature. A cynical, philistine, vulgar style of writing became very popular. The characters in these stories were aimless wanderers, drifting through grotesque and shallow emotional lives. The language consisted of seemingly endless witty remarks made in the Beijing accent, and the plots were meant to do little more than amuse. In meantime, the cheap, tacky, and gaudy pop culture of Hong Kong and Taiwan poured into China. Its popular songs echoed down every street and avenue. Posters of the stars, glittering with gold, hung everywhere you looked, and their television shows occupied the golden hours. Such was China's pop culture.

Cynical Realism

Starting in 1990, some artists in Beijing began to gravitate to the village around Yuanmingyuan, the ruins of the summer palace of the Qing dynasty, which had been destroyed by the forces of the eight Western allies in 1900, after the Opium War. Gradually more and more artists and new-style poets gathered there because of the cheap rent and the convenient, short distance to downtown and China's best two schools, Beijing University and Qing Hua University. The village became an artist community.

Among the Yuanmingyuan Artists, **Fang Li Jun** (b. 1962) was most famous for his Cynical Realism paintings, and his style later became very influential in China's contemporary art. Though trained as a printmaker in art school, with solid skills in realism, he refused to follow the rules of oil painting from the very beginning. He painted backgrounds flat, using singular colors that made his idiot-like figures appear all the more towering. Between 1990-1993, he painted a series of baldheaded figures with masks of empty smiles, who seem to be idle with boredom. There is a self-mocking emptiness and indifference in his paintings, a sense of aimlessness, a mood of cold detachment. The self-consolation and self-ridicule that were the Chinese people's very natural reactions to the suppression of the Tiananmen Movement were his as well. The entire city felt the same way. The popular novels of Wang Su and the TV series called *Stories of the Editorial Room* made Beijingers laugh hard and allowed them to conceal their wounds deeply in their hearts. Later, Fang seemed more detached from reality; he painted a new series paintings entitled *Swimmer* in which he got rid of the expression of his characters. These later paintings are bold, indifferent, cold, and absurd. [Figs. 33-35]

Yue Min Jun (b.1962), also a painter from Yuanmingyuan, made his name at almost the same time as Fang. He exaggerated the "joy" and "happiness" of the Cultural Revolution and his characters' smiling, open mouths to the ultimate end. The faces of the people in his paintings become stiff masks with solid white teeth. They all have same look, wear the same "Cultural Revolution" clothes, and seem to be acting as if it really matters to them. He even borrowed composition from Western masterpieces. Yue deconstructed the Cultural Revolution with a happy and light manner, bantering or satirizing, turning everything into an act at which his viewers cannot help laughing. Those who endured the Cultural Revolution found his work especially amusing. He pushed Fang's ironic humor to the extreme with an affected, yet earnest manner, and, being well-trained, he had excellent creative abilities. Yue painted resolutely and with strength, often with surprising ideas. [Figs. 36-38]

Song Yong Hong (b.1966) a backbone of *'85 New Wave* in Shanxi province, has been living in Beijing since 1989. In the early 1990s, he painted the life of city youths in what became known as Cynical Realism. The people under his brush are always wearing the same smile, revealing an affected reality that is empty and boring. His later paintings dig deeper into life. Somewhere in the mid-1990s, when he began to paint his "bath" series, his art went from the cynical to the absurd. **[Figs. 39-41]**

Taking a bath is the most private time of one's day, the only time people can truly face themselves and be real. In Song's paintings, water pours down from unexpected places, splattering everywhere, and giving the viewer as well as the people in the painting a sudden, inexplicable flushing. He interprets the feeling or the sense of the moment, whether it holding one's own against the powerful onslaught of the water or surrendering to it and going with its invigorating flow. Song's painting moves the viewer by stirring up an inarticulate something inside of them, be it numbness, confusion, or loneliness, the small details, fragments, and scraps of their everyday life. The water, heavy and thick, has symbolic meaning. His paintings are not only metaphoric, but also absurd. Song painted them purely and concisely.

Liu Xiao Dong (b. 1963), a gifted painter, works at the most famous art school in China, Central Academy of Fine Art, and his skills and talent are generally recognized. He directly paints snapshots in his paintings, which are fragments of life, the little people who live on the fringes of society, and his friends. Boredom, lifelessness, indifference, and idleness are the dominant feelings in his works, which he paints fluently and handsomely, seemingly without any effort. **[Figs. 42-43]**

Wang Yu Ping, another excellent painter who works at same school as Liu Xiao Dong, uses brilliant colors in his paintings of the people around him. **[Figs. 44-45]**

Political Pop

Wang Guang Yi (b. 1957) is a well-known artist of the Northern Artists Group of the *'85 New Wave.* He always could attract people's attention through his ambitious and quick-witted ideas. In 1989, at the famous *China/Avant-Garde* exhibition at the China Art Museum, his paintings were the most shocking pieces among the 279 shown works. *Mao Ze Dong* **[Fig. 32]** is a series of portraits of Mao, which was deconstructed by a grid black squares purposely left on the canvas, as if the painting were being prepared for enlargement. Though he may have taken the idea from Andy Warhol, he had his own point to make. Of course, Mao was a pop icon; depictions of him were everywhere during the Cultural Revolution. Mao was a god, his portrait was iconography, and Wang knew this better than Warhol. Who would dare to blaspheme? Wang blatantly painted the thick black squares across the visage. His intention of deconstructing and criticizing the Cultural Revolution and the "faith" that had fooled the Chinese for more than half a

century was all too clear. He was the first artist in China's new art who dared to do that. His bravery and wisdom brought him instant stardom in 1989.

After that success, Wang became even more committed to bringing the signs of the Cultural Revolution together with the ideas of Western Pop Art to create what became famous as "Political Pop".

Wang was straightforward, painting in the style the Cultural Revolution poster, and adding some symbols of Western pop culture such as the Coca-Cola bottle and the Campbell Soup can. Though the Cultural Revolution was an emblem of Red China rather than the target he criticized earlier, this kind of simple juxtaposition attracted the attention of the West. A title like *Mao Goes Pop* (an exhibition at the Sidney Modern Art Museum, 1992) would cause a stir. Wang's success was due to a large degree to his wisdom and to the curiosity the West had for Red China after the Cold War. He created something new in China's art history and influenced many other artists. **[Figs. 32, 46-48]**

Gaudy (Kitsch) Art

In the early 1990s, before Western pop culture had arrived in China; strong pop culture influences came from Hong Kong and Taiwan. Their glittering, overt, and shallow lifestyles were in stark contrast to the lives of most Chinese people. But these, along with their fashions, pop music, kung fu movies, and soap operas occupied much of Chinese TV. While in the early 1980s most Chinese had few ideas about getting rich or making money and were dreaming about building a new culture, after the transformational Tiananmen Movement China was caught up in the flow of the commodity economy that was dominating the world.

In early 1990s, a group of artists from Yuanmingyuan began to paint something new, which later became known as Gaudy Art. It was actually about Chinese pop culture. They thought their art was truer to the reality and tastes of the masses. They gave up "good taste" and refined motifs, and began to paint "bad taste" on purpose, drawing upon the extravagant color in works that were blatant, cheap, or "tacky." They combined the tastes of Chinese peasants, Chinese New Year paintings, the rule of "Red, Light, Bright," and posters of the Cultural Revolution in their art. They painted the most popular, vulgar lifestyle of the Chinese, who are depicted as happier than ever before. Wedding albums, Karaoke, scenes of eating and drinking, and city *Yangge* teams (a popular rural folk dance) were among their regular motifs, and even the most basic of life's necessities like cabbages and radishes often appeared in their art. As if this were not enough, they painted life at the very bottom society — gambling, alcoholism, prostitution — and later, when Political Pop was popular, they added ciphers of the Cultural Revolution into their works, becoming in the process, Political Pop Gaudy Art. They painted the dream of getting rich in the manner of Hong Kong and Taiwan, with depictions of money that could be seen and counted clearly. They had no limitations on their media. In addition

to painting on canvas, they created sculptures, photographs, performance art, and tapestries, using polyester, synthetic resin, embroidery, crystal, Chinese lacquer, and silk.

They tried to interpret the truth of life, rather than deride or scorn China's popular culture. In opposition to cultured and refined art, they allowed their art to be as vulgar as it could be, a direction that can be traced to the ideas of Western Pop Art and Mao Ze Dong's Mass Art. They probably revealed more of the essential truths of China's popular cultural than did Wang Guang Yi, and may have had a more authentic Chinese way of interpreting this issue.

Yang Wei, Hu Xiang Dong, Liu Zheng, Xu Yi Hui, Wang Jing Song, and Luo's Brother formed the first group of Gaudy Artists; later Feng Zen Jie joined them.

In their opposition to the high art of refined painting, **Liu Zheng** (b.1972) **[Figs. 49-51]** and **Yang Wei** (b.1969) **[Figs. 52-53]** used embroidery as their medium. The shiny, gorgeous colors of silk or polyester were precisely what they needed to bare their ideas. Liu embroidered young girls (or prostitutes), pop icons, Mao Ze Dong, money, movie stars, and the like, on silk or polyester, working with silk and beads by hand. It is amazing to see the detail achieved by this young, tall man. Yang embroidered money over and over again in his designs. He even used crystal to do his money works.

In the beginning, **Hu Xiang Dong** painted, but in his later career, he made cabbages out of synthetic resin and planted them in the ground with real ones. He called his work *The Ideal Plantation*. **[Fig. 54]**

Wang Jin Song painted *Chorus* in the style of Chinese folk art, depicting national pride, confidence and heroism in the happy situations that people had experienced since the Cultural Revolution. **[Figs. 55-56]**

Luo's Brother — three brothers who create their art in one name — work in a folk craft tradition called *Chi-Hua*, which was usually painted on furniture or buildings using special lacquer. They painted on boards, combining the style of posters of the Cultural Revolution with Chinese New Year painting and symbols of Western pop culture. The appropriation of folk art made their works outstanding. **[Figs. 57-58]**

Feng Zheng Jie's (b. 1968) paintings are loudly eyecatching, with bright, gorgeous colors that are as exaggerated and bantering as possible. His *Wedding Album* series opened up the possibility of satire. He also paints huge portraits, some of cool modern young girls peering around, some of figures with dark glasses. He paints boldly, with confidence, creating works that are surprisingly attractive. **[Figs. 59-61]**

Gaudy Art thoroughly experimented with anti-art, challenging the traditional idea of refined art. The artists picked up the bad taste from the reality surrounding them as if by just stretching out their hands. There was nothing that couldn't be painted, nothing that couldn't be exploited. For the most part, they employed the "low" way — that is, the way of Chinese folk arts and crafts — to create their "high" art. It cannot be denied that they broke through the barriers. The appropriation of Chinese folk art became one of the methods for delving into the roots of Chinese culture. **Wang Yin** (b. 1964) is a painter who exercised the appropriation of Chinese folk art in the late 1990s, even though his work is totally different from that of Gaudy Art. He once hired a folk artist to paint peonies following his idea, using a Western perspective concept that is not the tradition of Chinese folk art and thereby totally transforming the tradition and practice of Chinese folk art. In another piece, called *Sand Storm*, he painted impressionist-like yellow dots on a painting by a folk artist; the finished painting became his landscape. He had employed the hands of folk artists and used their works to create his own art. His appropriation of Chinese folk art may be more systematic than is found in the works of others. **[Figs. 62-63]**

Self Portraits and Cultural Identity

Zhang Xiao Gang (b. 1958) is a sensitive and melancholy artist. In the *'85 New Wave*, he was a leader of the Southeast Artists Group. His first paintings were allegorical and filled with wit. (fig 17-18) In the early 1990s, he began to paint in a new direction.

Inspiration came from some old photographs in his private collection. He said: "Thoughts crowded into my mind after I saw them. I couldn't put them down."[1] He always had been an insightful painter, dealing with illusions from the very beginning. Zhang painted mostly death and dreams because of his family's tragedy and his own illness in the past. The old photos filled him with memory and sentiment.

The truth is, these old photographs reveal not only his family's destiny, but also that of all Chinese people of the past half century. The will of society and the nation intruded into and occupied the private lives of Chinese people, who weren't allowed any personal space. Everyone was forced to have the same faith, to live the same life, even to wear same clothes without differentiating between the sexes. The traditional Chinese family vanished; everyone was a member of the huge "family" called "the big revolutionary family." It was similar to the situations found in religious cults. Zhang grieved and sympathized deeply not only for his family, but also for all Chinese people. He began to paint a group of family portraits, which became his famous *The Big Family Blood Line* series.

The people in the various groups all have similar faces. Only generalities remain, and these are pedestrian, indifferent, feeble, delicate, fragile, and pale. The eyes of his people are the only things that still show a glimmer of life; they are clear and bright. Often on the verge of tears and sometimes confused or perplexed with hidden fears, they stir the viewer's heart. Under their calm and undistin-

guished expressions, are unspeakable stories, tempestuous truths suppressed inside their hearts. His paintings are metaphorical, vague, and obscure. **[Figs. 64-66]**

Everybody in his paintings is connected by a red line, the bloodline, a symbol of fate or destiny. In ancient Chinese stories, when the god ties people together with an invisible red line, they will be involved with each other throughout their lives. But there is an ambiguity in Zhang's red line. While it indicates social and private relationships, it hints of two things: first, the public relationship between Chinese people, and, second, the inescapable fate of this kind of relationship into which one was born and which one then passed on to a new generation.

Basically, Zhang has abandoned the traditions of oil painting he learned in art school and paints flatly, finely, and exquisitely, following the way of old-style Chinese calendars and charcoal portraits. His paintings are representational but unrealistic, a large-scale illusion. Sometimes there are colored marks in the paintings that seem to come from the old photos, and abrupt bright colors (usually red) on the child in the center, which look lofty against the mostly grayish background. A red child is full of symbolic meaning. Red represents revolution. Its use thus signifies that the Chinese people were born with the destiny of *red*.

Zhang had been dreaming his gray dreams for long time, and couldn't get out. One cannot miss the nostalgia in his painting. He manipulates sorrow and sentiment in a quietly enduring realm; there is no wailing in his baring of a

deeper pain. Zhang is not a cynic. He takes the Cultural Revolution as fate, an unavoidable part of history, and quietly tells the world the stories of the Chinese people.

Mao Ze Dong took ten years to scrub China's tradition and ancient culture. The generation born after the establishment of *red* China, that grew up in those ten years, was ignorant, but confident in whatever was taught. After the Cultural Revolution, that confidence was gone. The discontinuation of their own traditions and the dislocation of their own culture engendered feelings of confusion, chaos, and loss. The Chinese people started to search for their cultural roots, to find their own identity. This cultural identity was not just something for the rest of the world to recognize, but more significantly, for them to clarify for themselves. Zhang was the first artist to paint the portrait of all Chinese. Following him, there would be no stopping Chinese artists who sought their identity, finding out who they are. Zhang was also the first to use family photographs to interpret his ideas. He invented a way of using photographic portraits (old, new, family, individuals, groups) to tell Chinese stories in China's new art. Because of him and the popularity of his style, we will see the endless use of all kinds of portrait photographs in the future. Zhang created a new genre of Chinese oil painting by mixing Chinese calendar painting with charcoal drawing, making him one of the representative artists of China's new art.

[1] Zhang Xiao Gang, Art Statement 1995, *Umbilical Cord of History* — catalog of Hanart TZ Gallery

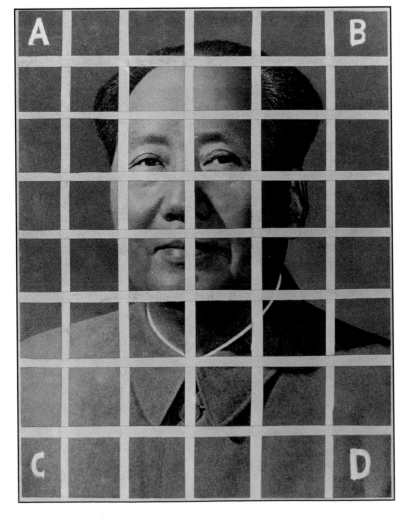

Fig. 32
Wang Guang Yi
Mao Ze Dong
1988
Oil on canvas, 200 x 150 cm

Fang Li Jun (b. 1962)

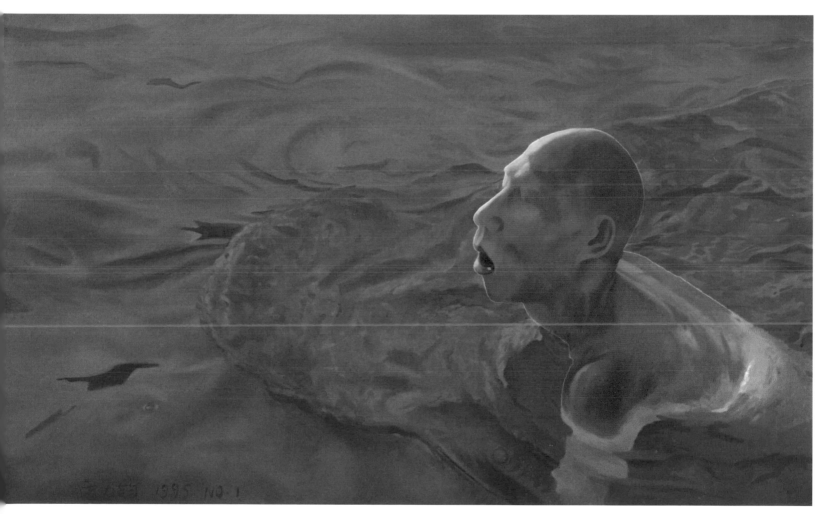

Fig. 33
Fang Li Jun
1995.1
1994-1995
Oil on canvas, 70 x 116 cm

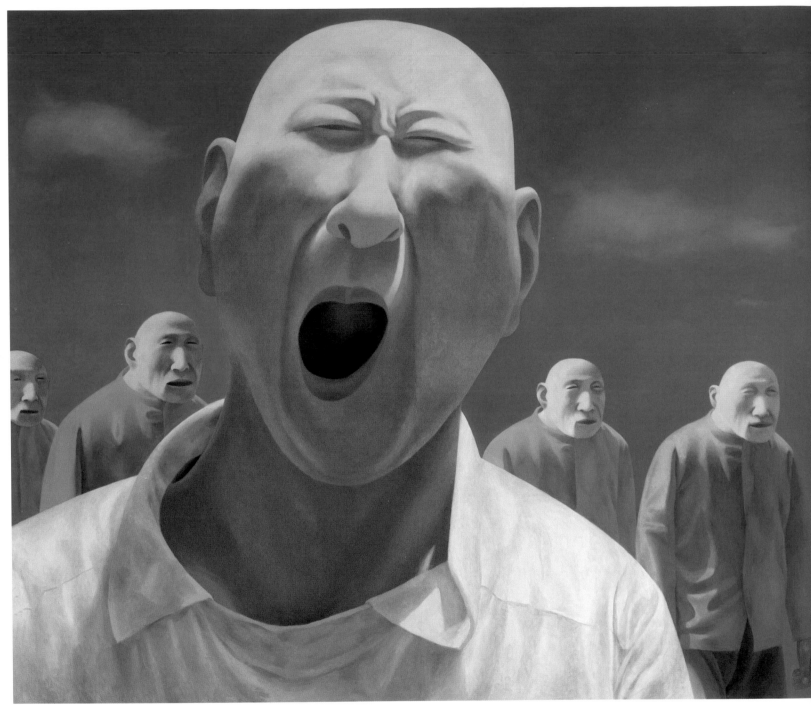

Fig. 34
Fang Li Jun
1991-92 series (2)
1991-1992
Acrylic on canvas, 200 x 230 cm

Opposite page:
Fig. 35
Fang Li Jun
2000.1.30
2000
Acrylic on canvas, 360 x 250 cm

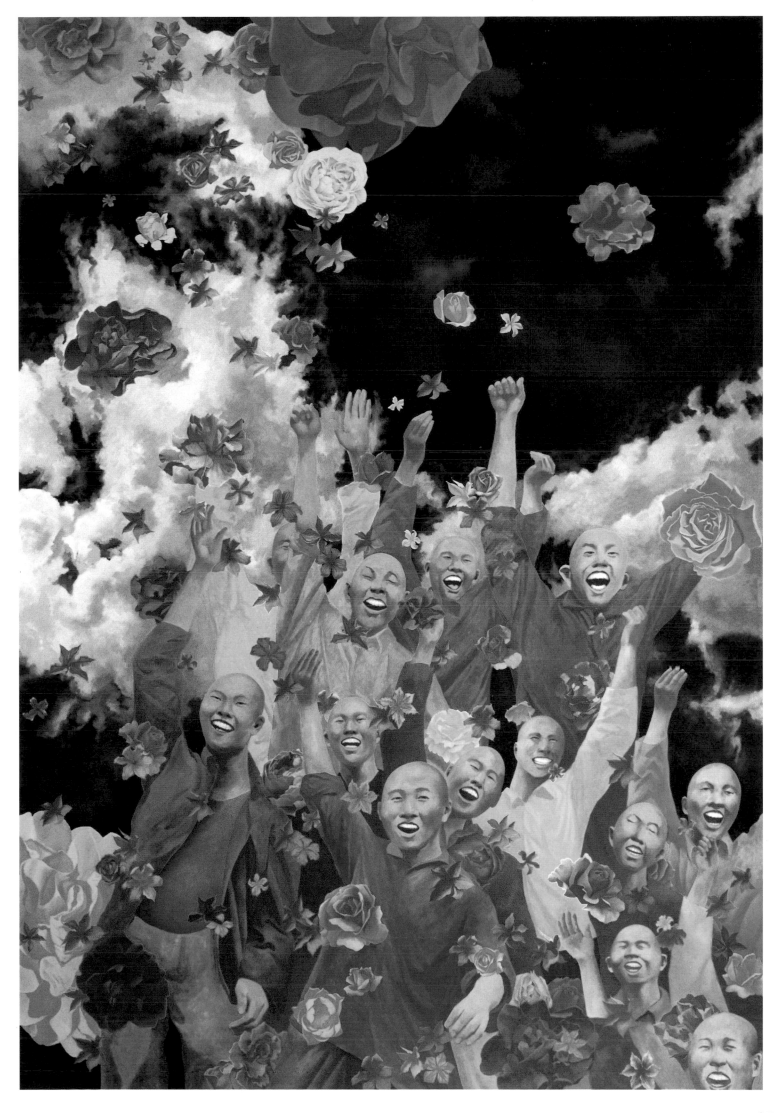

Yue Min Jun (b.1962)

Fig. 36
Yue Min Jun
Great Solidarity
1992
Oil on canvas, 190 x 200 cm

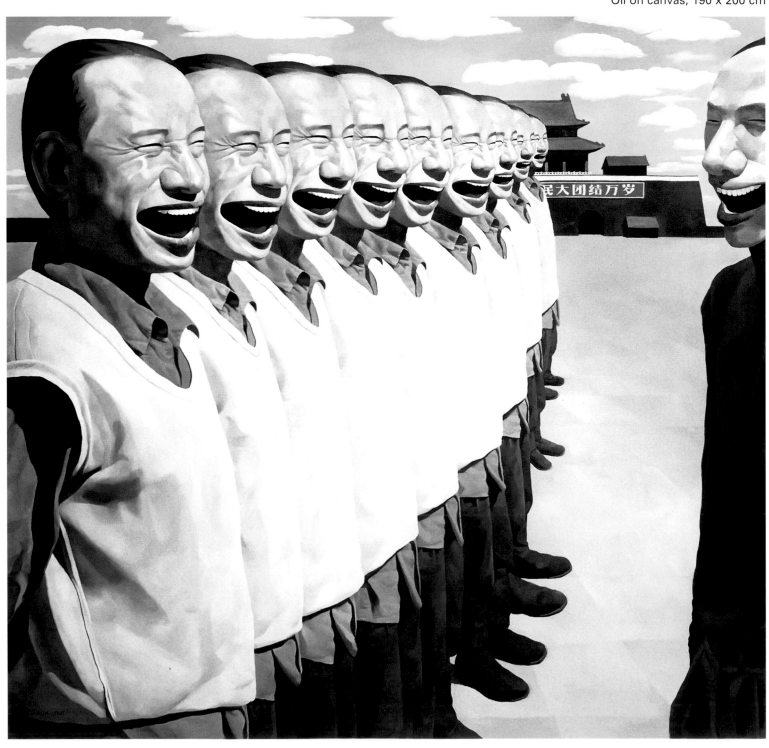

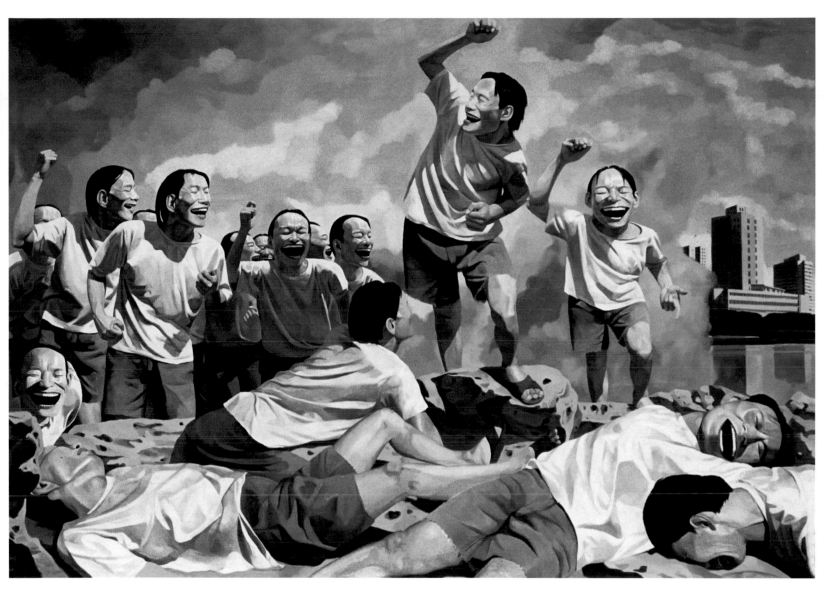

Fig. 37
Yue Min Jun
Freedom Leading the People
1995-1996
Acrylic on canvas, 360 x 250 cm

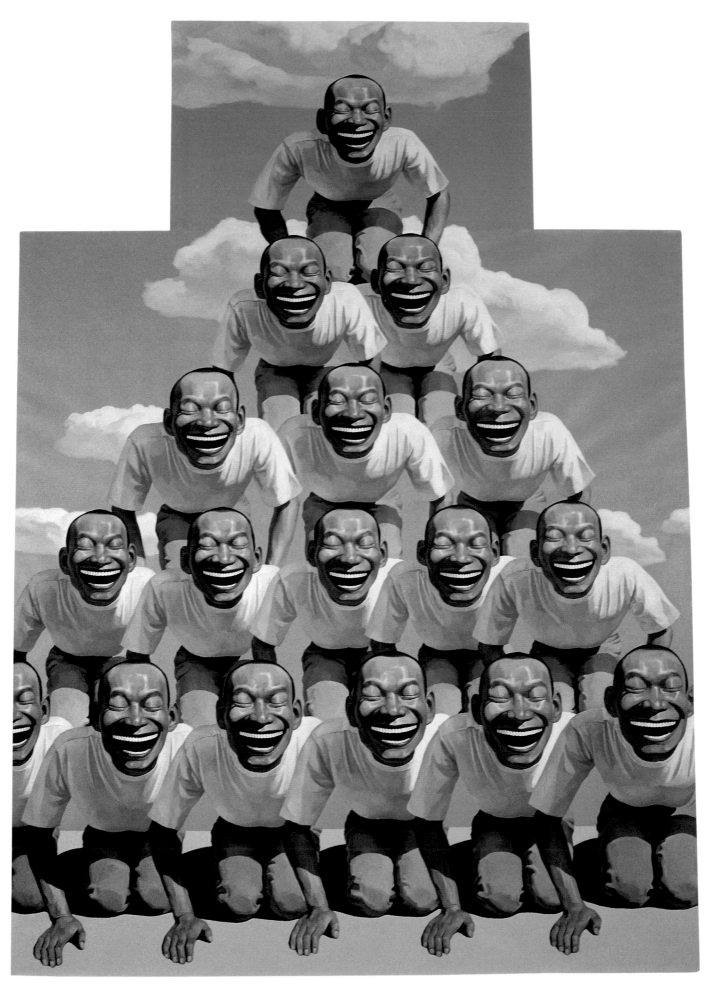

Fig. 38
Yue Min Jun
Monument
2001
Acrylic on canvas, 280 x 200 cm

Song Yong Hong (b.1966)

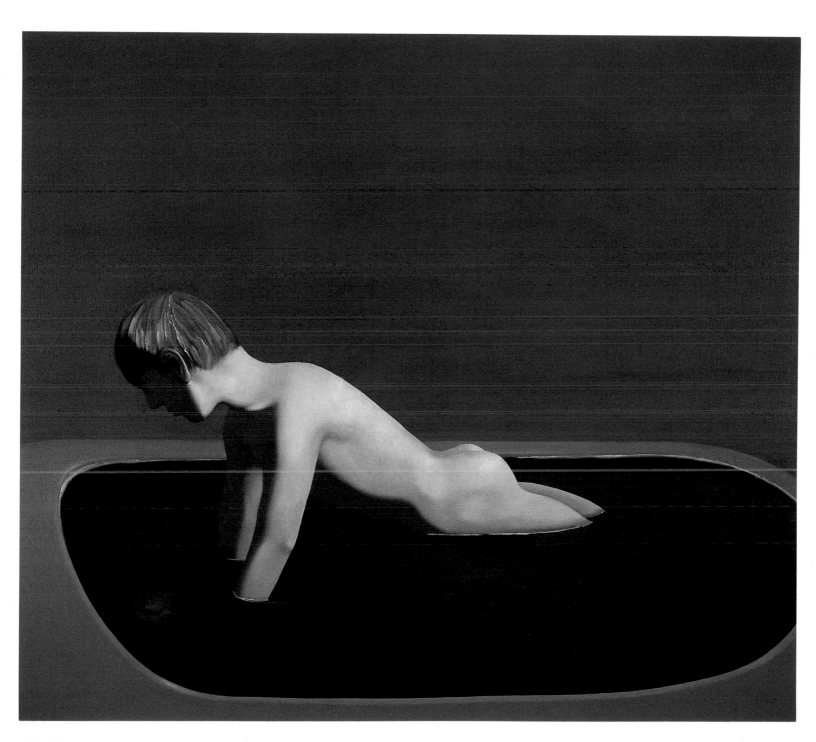

Fig. 39
Song Yong Hong
The Bath of Consolation 2004, No. 5
2004
Oil on canvas, 150 x 170 cm

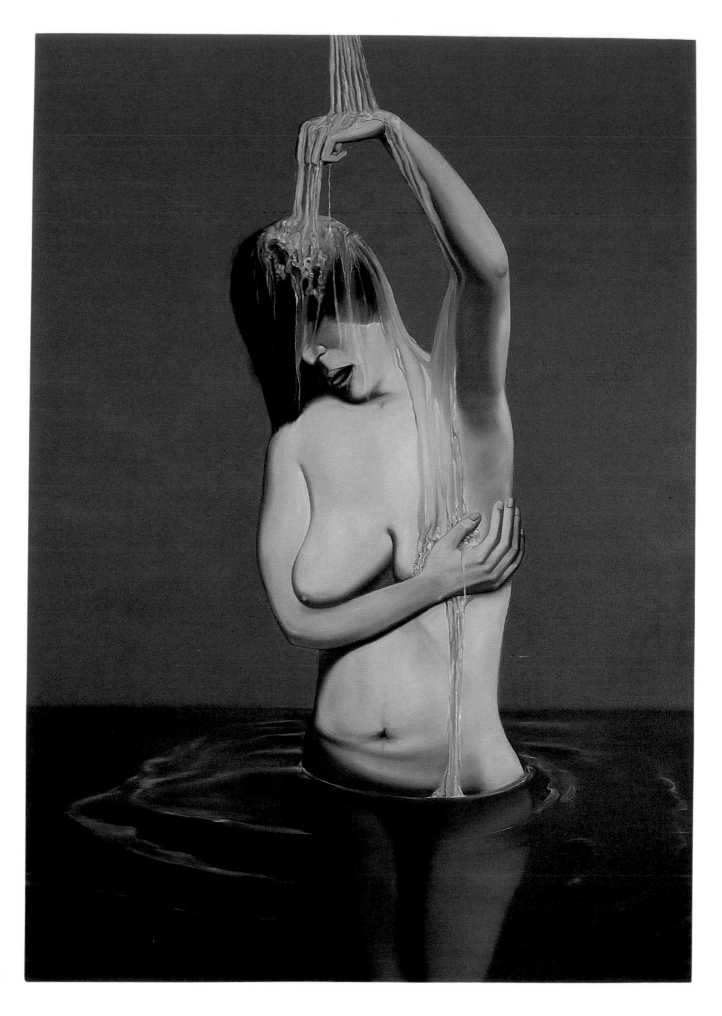

Fig. 40
Song Yong Hong
The Bath of Consolation 2001. No. 1
2001
Oil on canvas, 200 x 150 cm

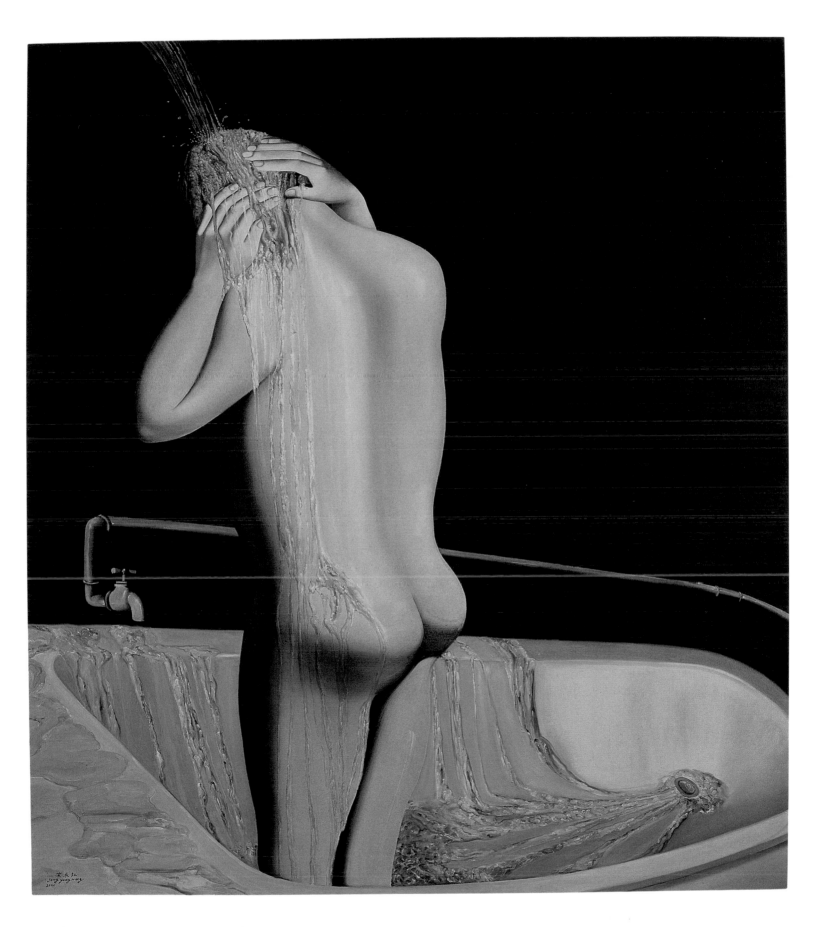

Fig. 41
Song Yong Hong
The Bath of Consolation 2000. No. 5
2000
Oil on canvas, 170 x 150 cm

Liu Xiao Dong (b. 1963)

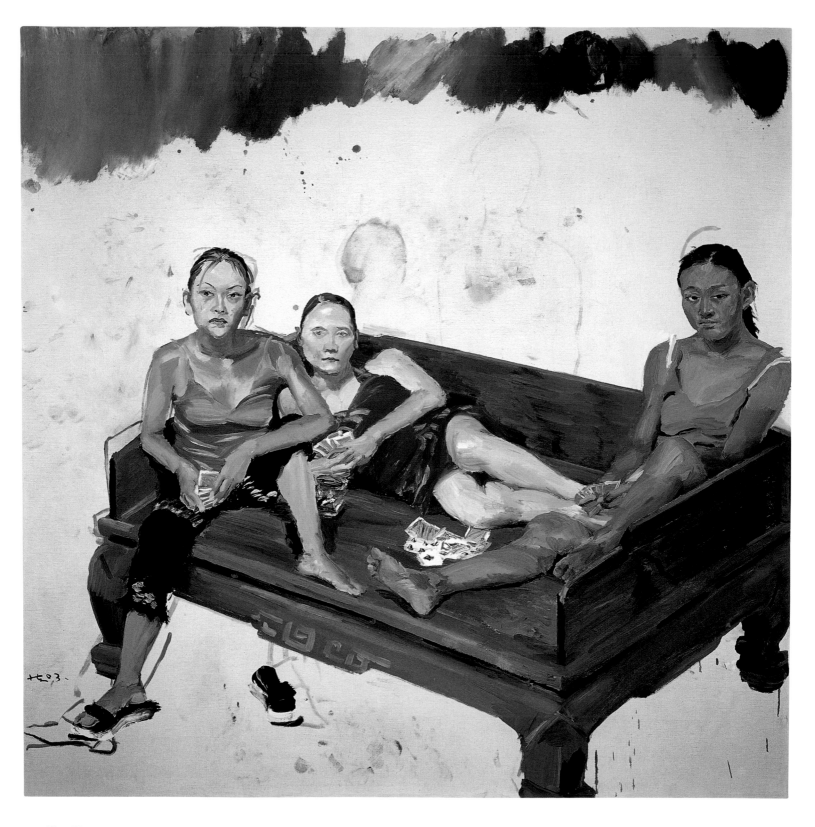

Fig. 42
Liu Xiao Dong
Playing Cards
Oil on canvas, 200 x 200 cm

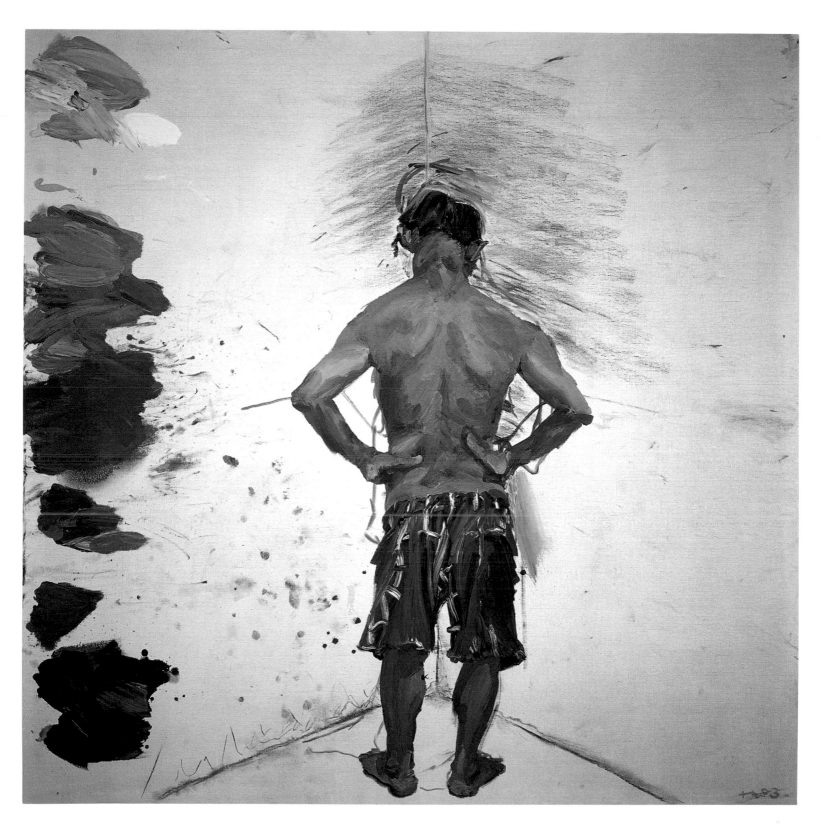

Fig. 43
Liu Xiao Dong
Corner
Oil on canvas, 200 x 200 cm

Wang Yu Ping

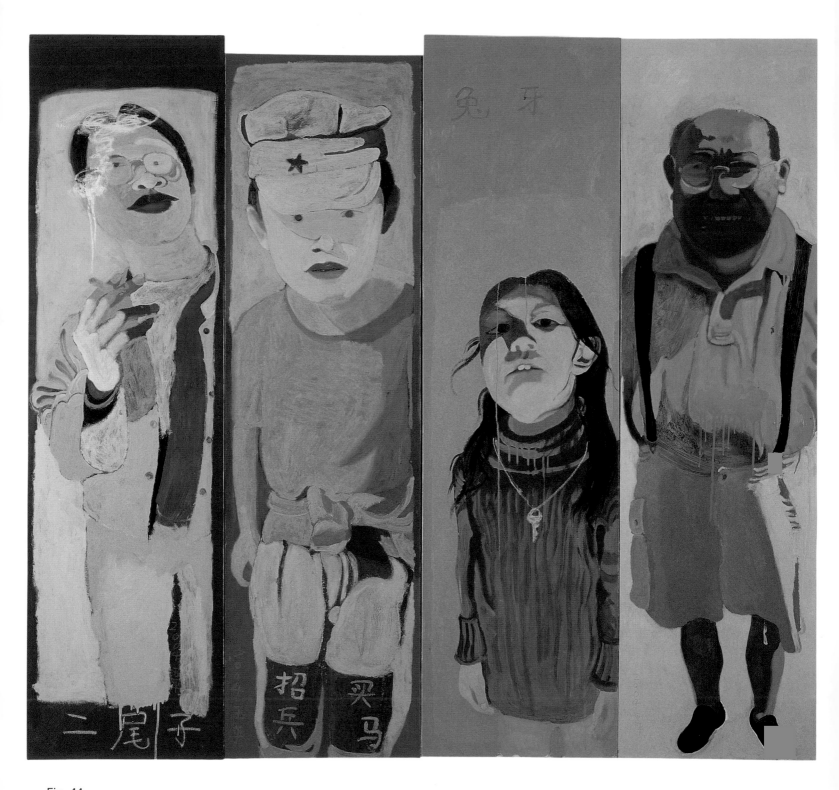

Fig. 44
Wang Yu Ping
Red Grapevine
2004
Oil on canvas, 4 x 180 x 50 cm

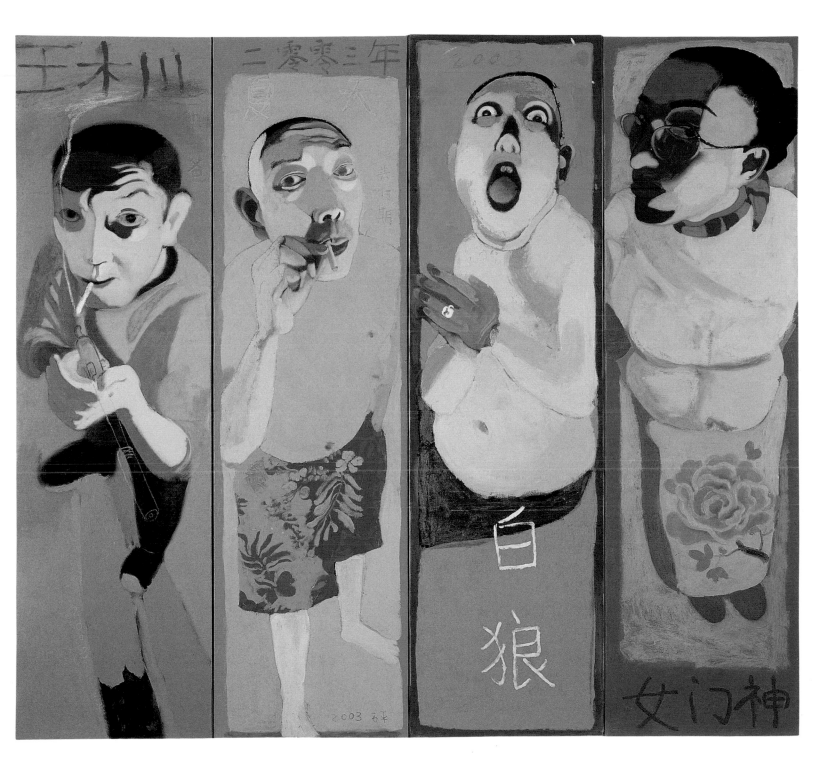

Fig. 45
Wang Yu Ping
Red Grapevine
2004
Oil on canvas, 4 x 180 x 50 cm

Wang Guang Yi (b. 1957)

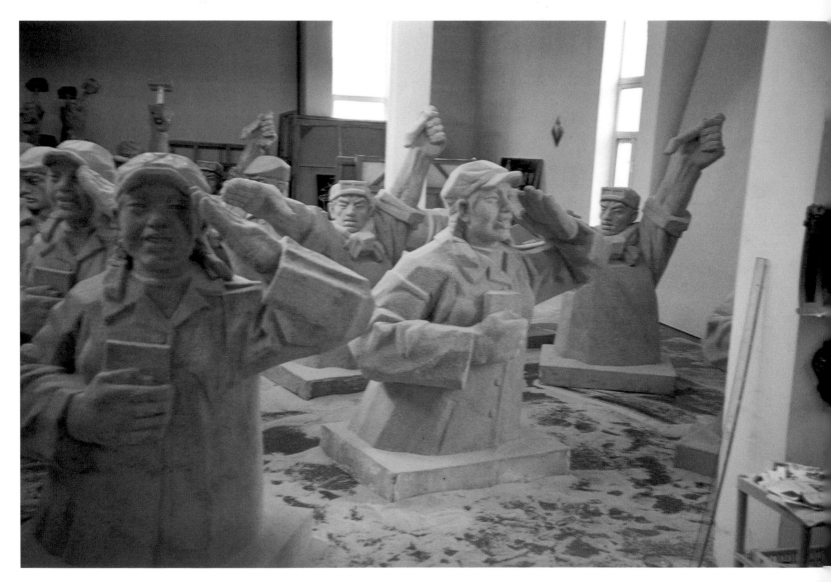

Fig. 46
Wang Guang Yi
Materialist
2001
Glass-fiber and millet, 180 x 80 x 80
cm, 26 pieces

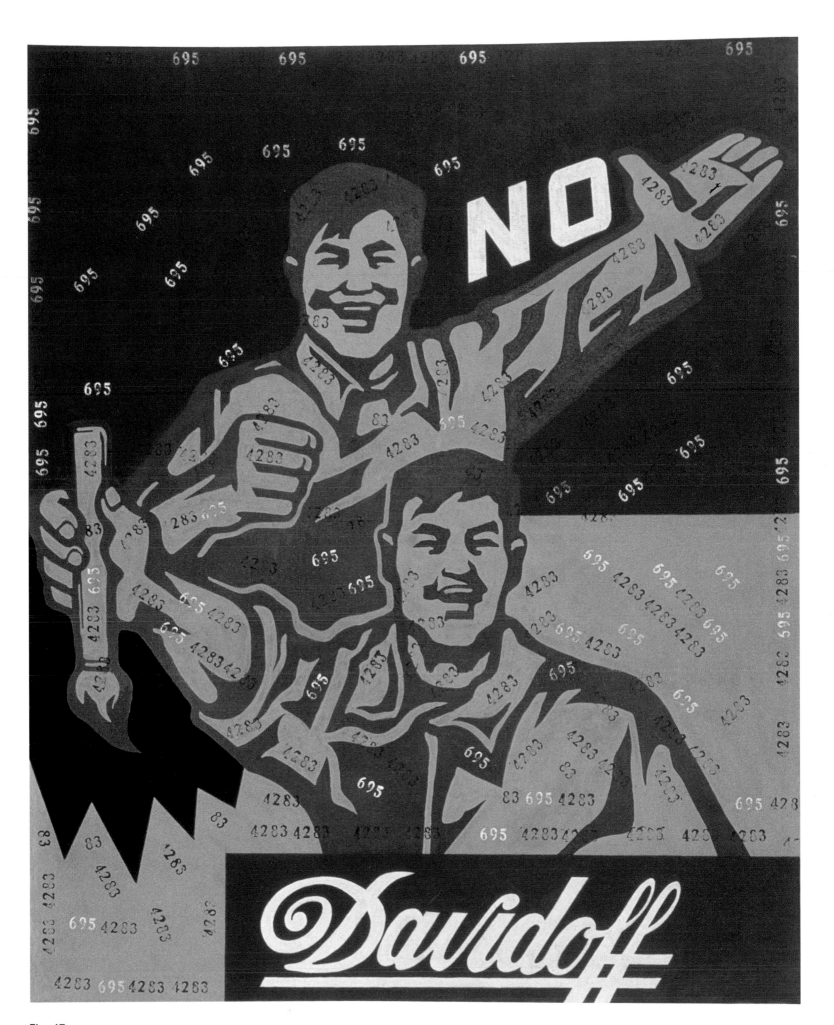

Fig. 47
Wang Guang Yi
Mass Criticism: Davidoff
1998
Oil on canvas, 150 x 120 cm

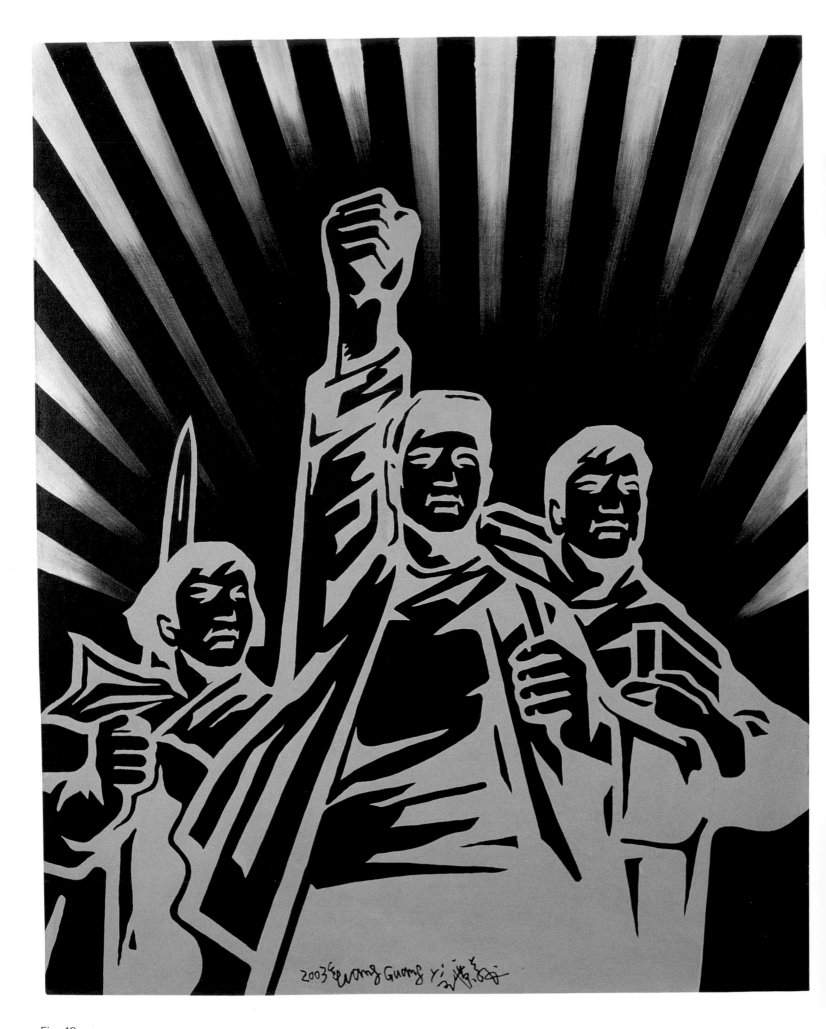

Fig. 48
Wang Guang Yi
Radiate Forever No. 1
2003
Oil on canvas, 150 x 120 cm

Liu Zheng (b.1972)

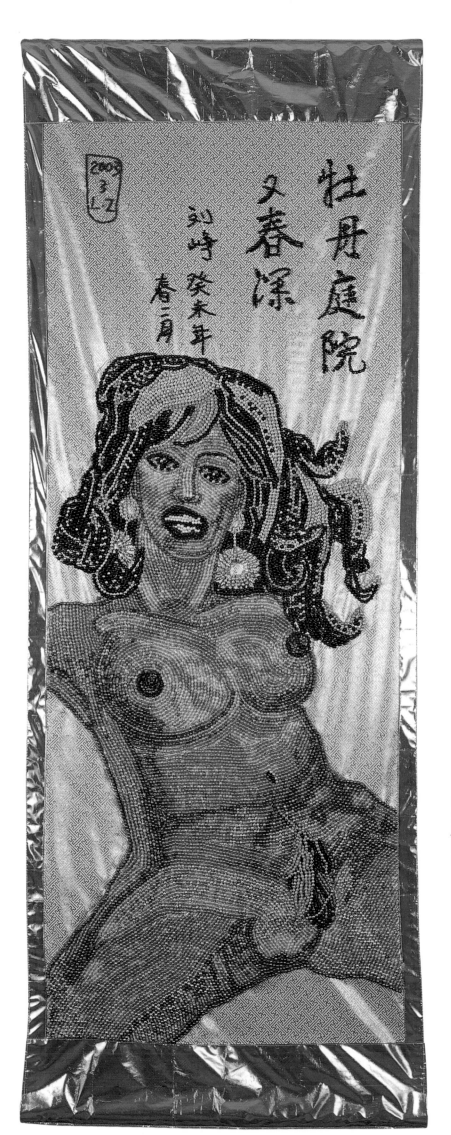

Fig. 49
Liu Zheng
Modern Girl
2003
Beads on silk, 200 x 70 cm

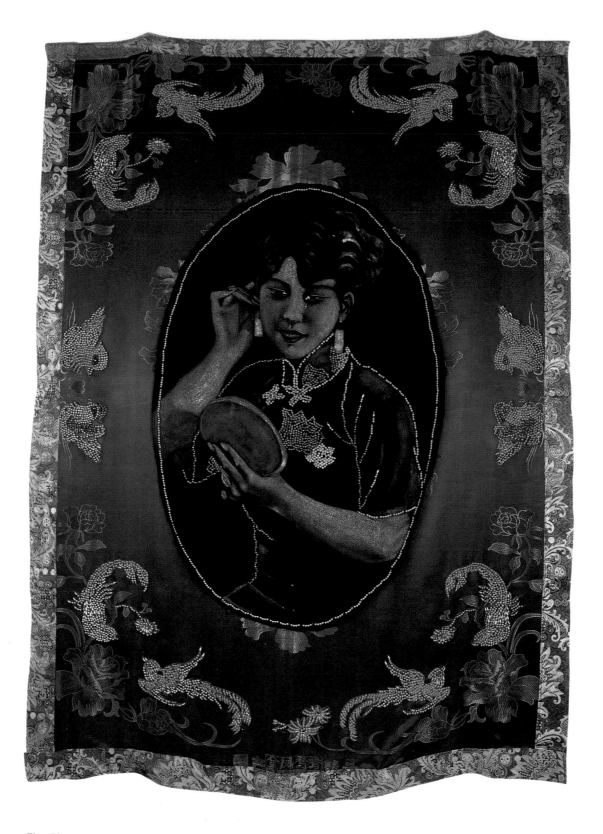

Fig. 50
Liu Zheng
XX Calendar Board
1998
Silk, beads, comforter cover, acrylic,
180 x 130cm

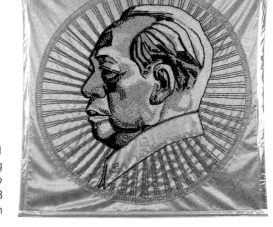

Fig. 51
Liu Zheng
Mao
2003
Beads on silk, 140 x 140 cm

Yang Wei (b.1969)

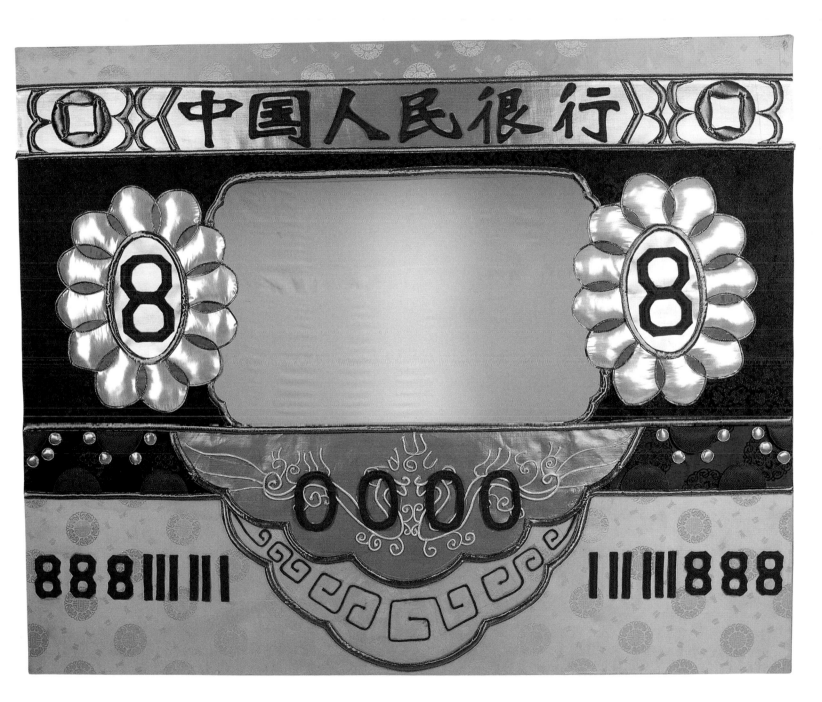

Fig. 52
Yang Wei
Chinese People's X Bank No. 18
Silk, 200 x 150 cm

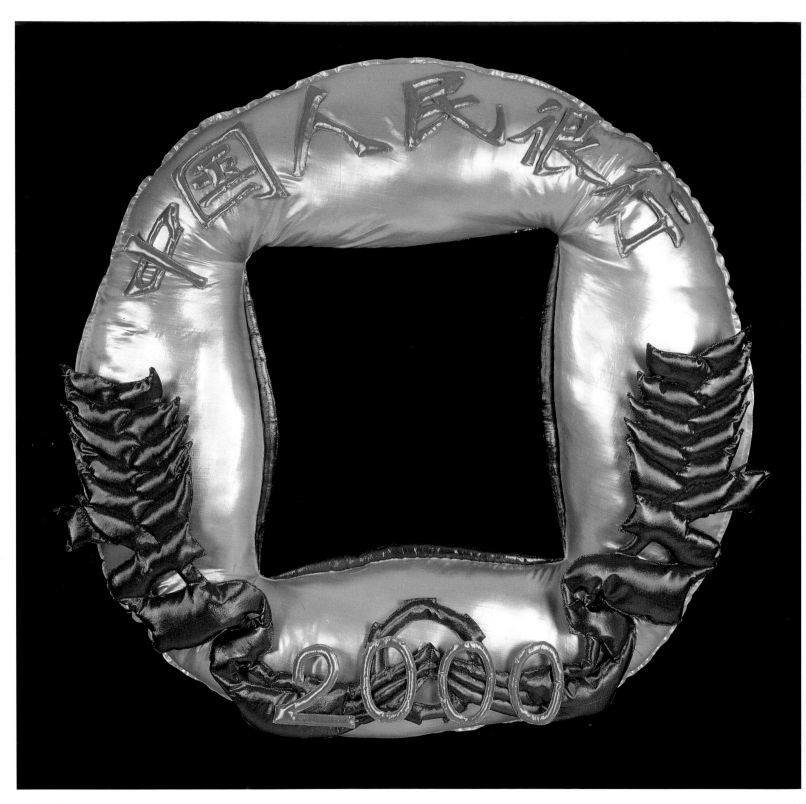

Fig. 53
Yang Wei
Chinese People's X Bank No. 22
Silk, 100 x 100 cm

Hu Xiang Dong

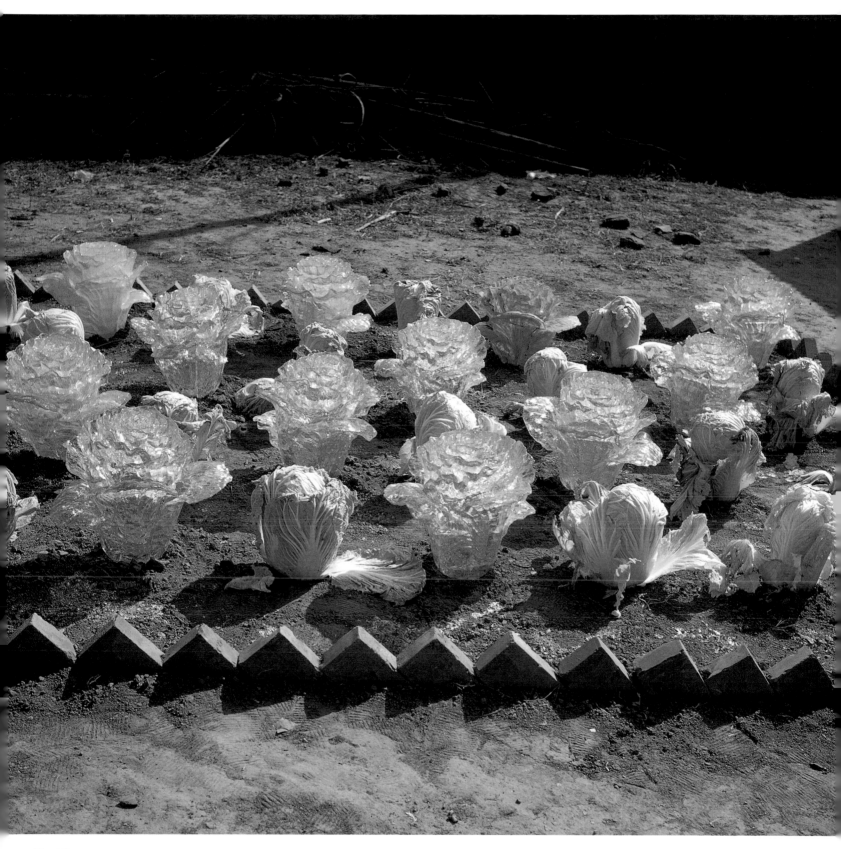

Fig. 54
Hu Xiang Dong
The Ideal Plantation
1998
Synthetic resin, 360 x 240 cm

Wang Jin Song

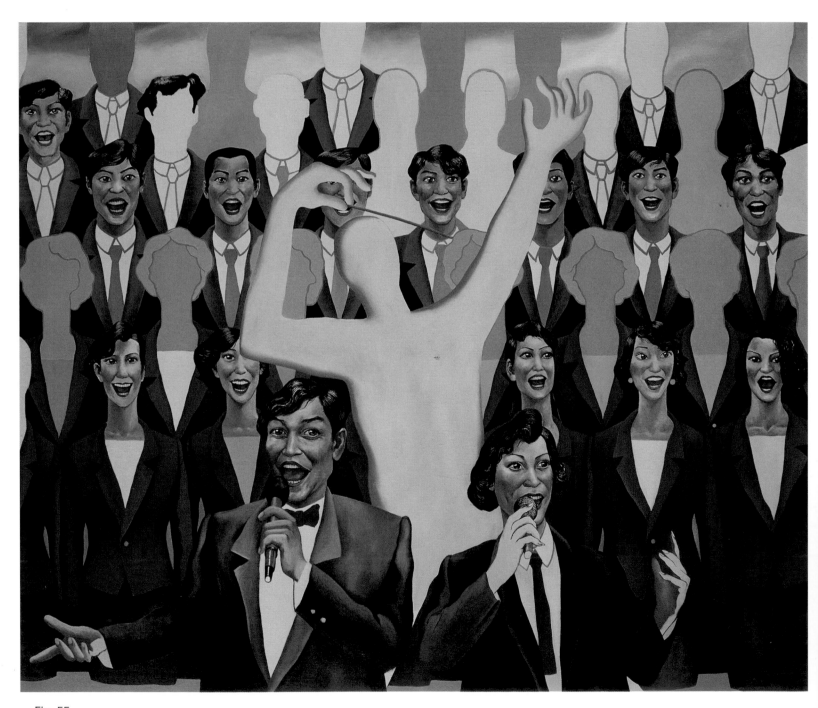

Fig. 55
Wang Jin Song
Chorus (2)
1992
Oil on canvas, 170 c 120 cm

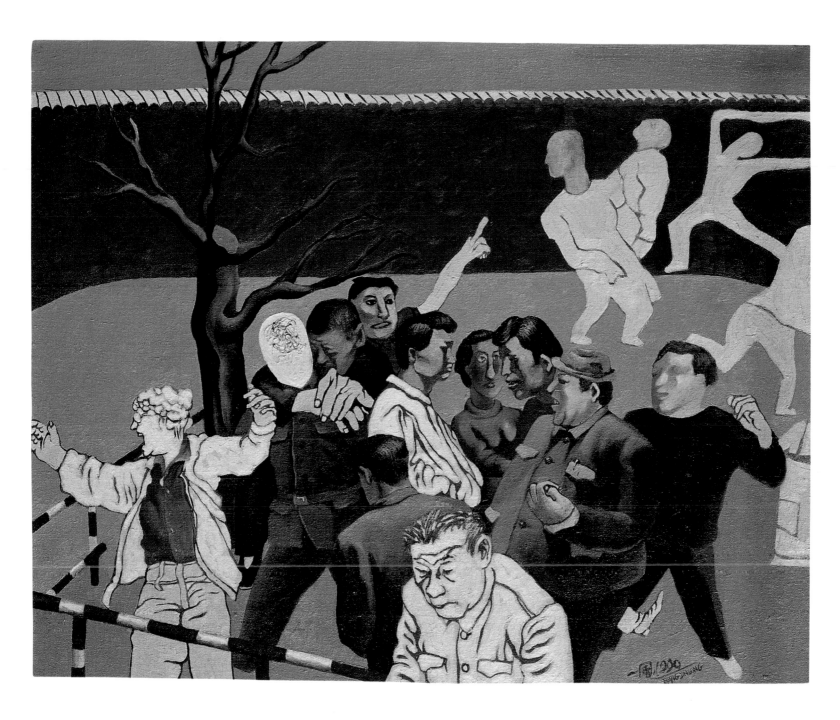

Fig. 56
Wang Jin Song
Take Pleasure in Helping People
1990
Oil on canvas, 50 x 60 cm

Luo's Brother

Fig. 57
Luo's Brother
*Welcome the World's Most
Famous Brands # 4*

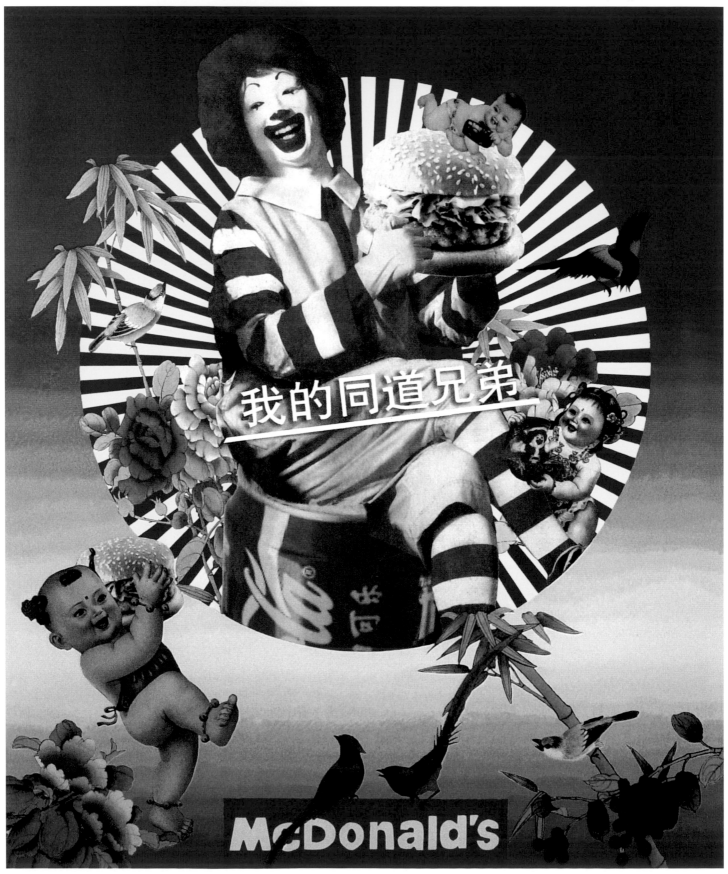

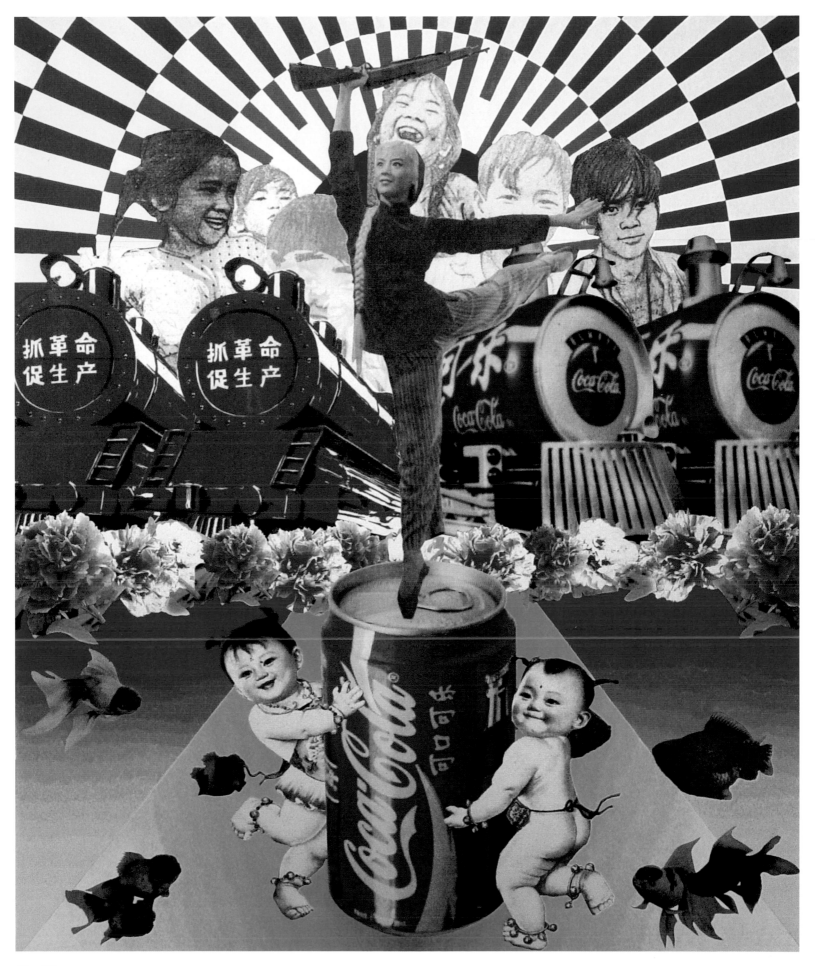

Fig. 58
Luo's Brother
Welcome the World's Most Famous Brands # 3

Feng Zheng Jie (b. 1968)

Fig. 59
Feng Zheng Jie
Romantic Journey N. 21
1997
Oil on canvas, 150 x 190 cm

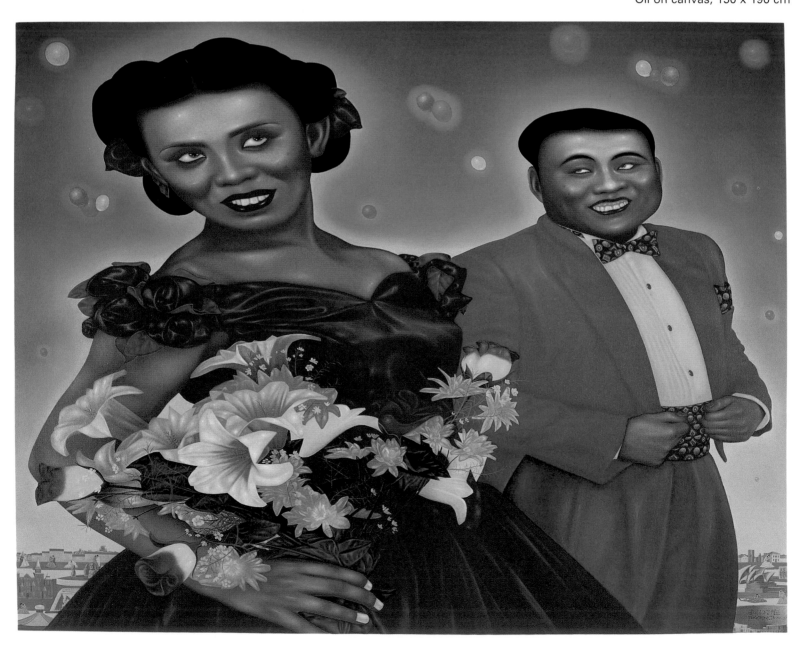

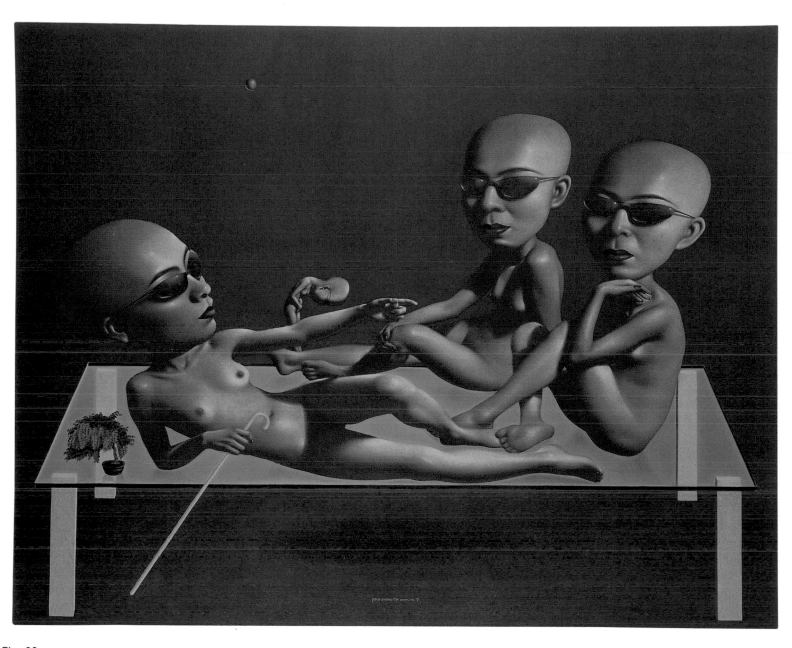

Fig. 60
Feng Zheng Jie
Cool 2000 No. 7
2000
Oil on canvas, 150 x 190 cm

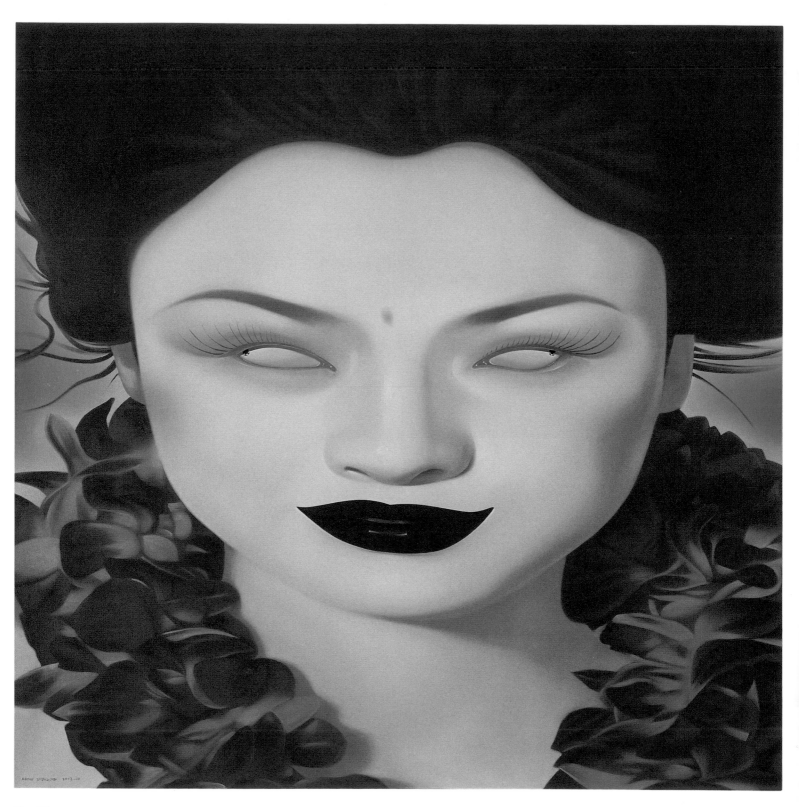

Fig. 61
Feng Zheng Jie
China 2003 No. 18
2003
Oil on canvas, 210 x 210 cm

Wang Yin (b. 1964)

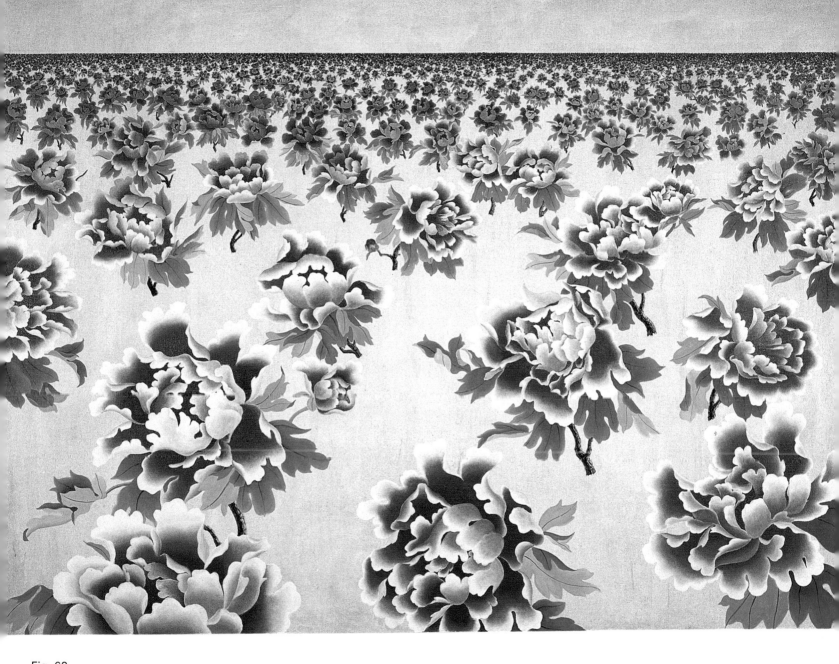

Fig. 62
Wang Yin
Flower
2001
Acrylic on canvas, 180 x 250 cm

Fig. 63
Wang Yin
Sand Storm
2002
Oil on canvas, 180 x 300 cm

Zhang Xiao Gang (b. 1958)

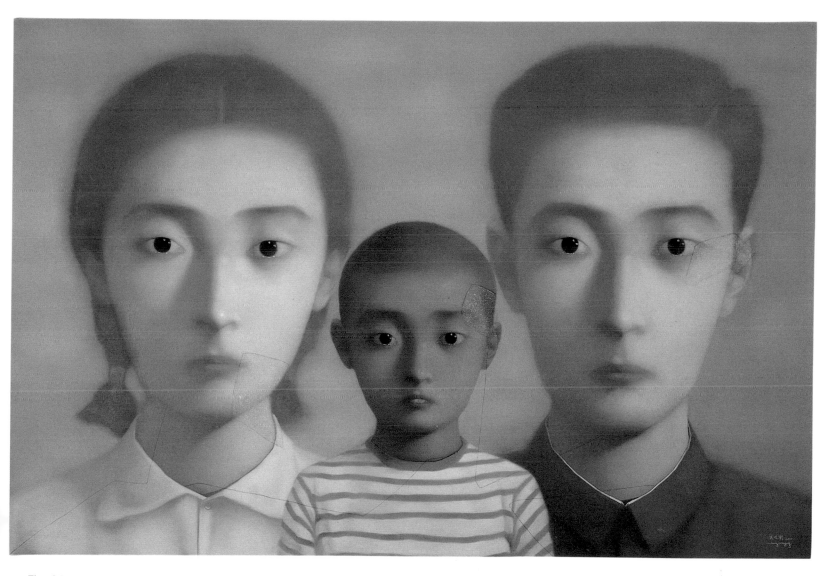

Fig. 64
Zhang Xiao Gang
Blood Line: the Big Family
2001
Oil on canvas, 200 x 300 cm

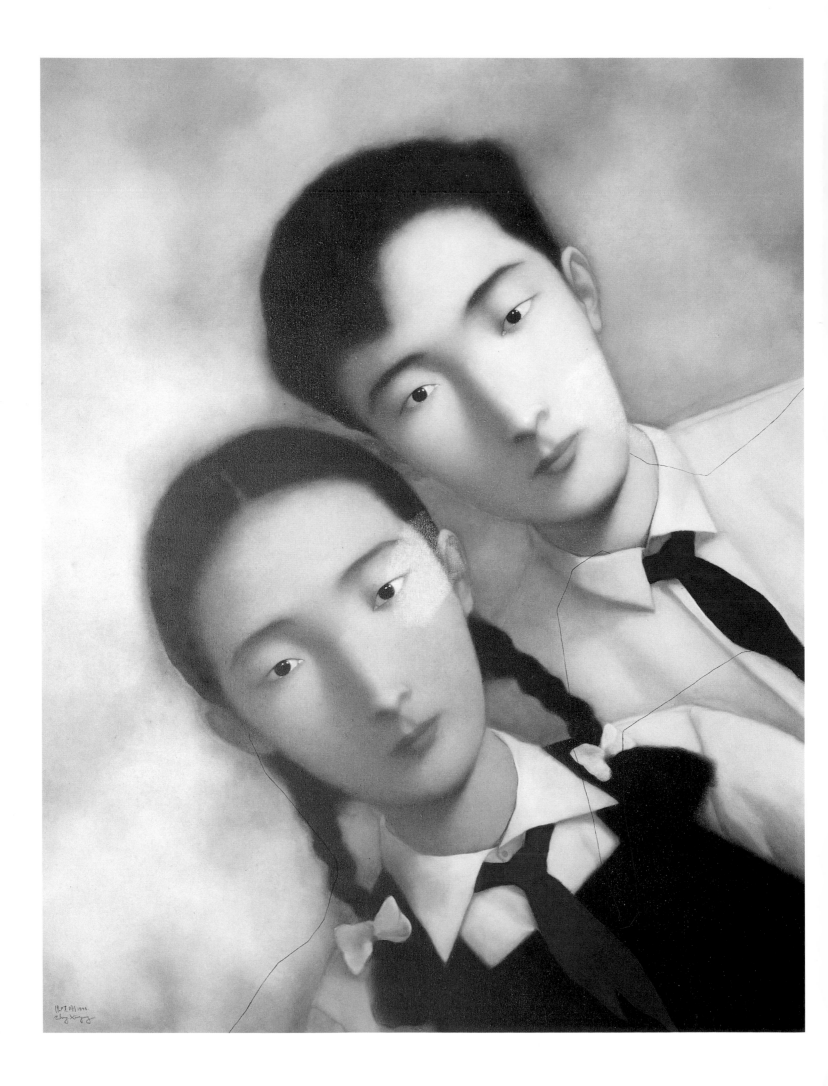

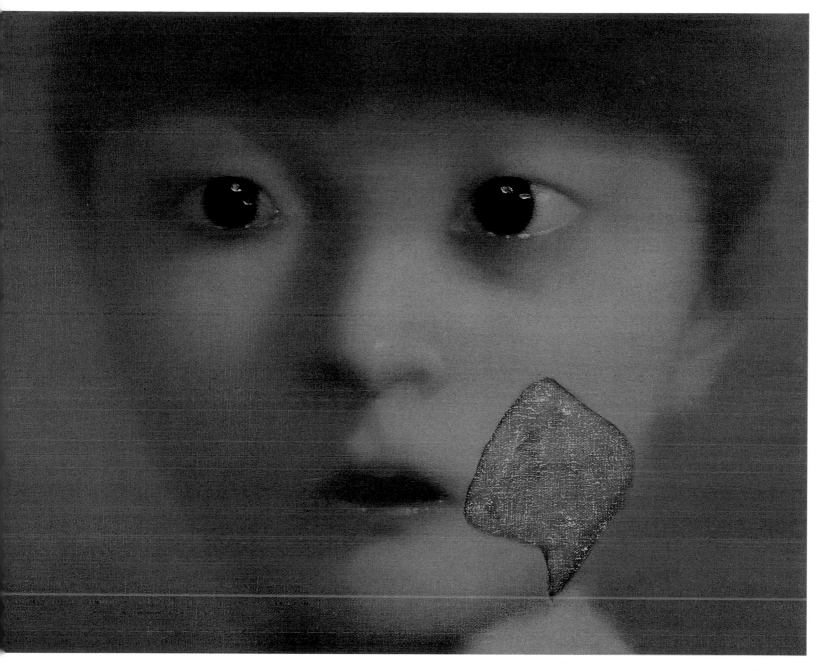

Fig. 66
Zhang Xiao Gang
My Daughter
2000
Oil on canvas, 50 x 60 cm

Opposite page:
Fig. 65
Zhang Xiao Gang
Blood Line: the Big Family
1996
Oil on canvas, 190 x 150 cm

4. The End of the Century: Pluralistic Aspects of China's New Art

After 1992, when the door to the world was opened once again, China finally began to integrate with the modern world. The international global economy and Western pop culture flooded over the country, transforming not only China's economy, but also its social structure, culture, and politics. Cities grew at a rapidly increasing pace and the materialistic desires of the people reached their highest point. Instead of following the 1980s dreams of the intellectuals, the rapid growth of the economy was beyond anyone's control. Intellectuals, knocked to the sidelines by this sudden wave, were speechless. This was the modern era the Chinese had been dreaming about for a century. China's newest art, unleashed by this rapid social and economic growth, seems pluralistic and is flourishing. There has been so much art produced in so short a time that it would take another book to discuss performance art, photography, installation, digital art, body art, and the new media. Here we limit our discussion to painting.

New Art and the Cultural Revolution

It is possible that the Cultural Revolution will become an eternal motif of China's new art. The Chinese, even the most recent generations, cannot avoid history. The China of today is anchored in the past, the most recent past, which has shaped contemporary culture, social values, and even the rules of behavior. Fate has determined what the Chinese have become, and without exception, the artists in one way or another, directly, symbolically or metaphorically, depict the Cultural Revolution. It becomes for them a mine for endless excavation. Following the artists of the early 1990s, artists from the middle of the decade to the end of the century drew even more upon this motif.

Mao Xu Hui (b.1956) **[Figs. 71-73]** and **Zhang Xiao Gang** **[Figs. 64-66]** were the leaders of Southwest artists group when they were part of the '85 New Wave. In the late 1990s, Mao painted a symbolic and metaphoric series called *Scissors* **[Figs. 71-73]**. No matter how ordinary a pair of scissors may look, it has the power to cut off, to hurt. He found in scissors a symbol of the powers controlling the fate of the Chinese people. He painted these symbols both vertically and horizontally; they were heavy and dominant.

Liu Da Hong (b.1963), another painter who depicted the Cultural Revolution within his fantasy world, grew up in that period of history. He compares it to the great revolution of

France depicting two cities, Paris and Shanghai, in a painting called *The Twin City* **[Fig. 75]**. Taking the idea one step further, he compares it with Western religion and painted the *Sacrificial Altar* **[Fig. 74]**, borrowing from classic Western religious painting.

Liu believes that the pursuit of the great ideals of the Cultural Revolution was the same as in the French Revolution. He glorifies the "sincerity" of revolution and criticizes the subreligious insanity. He has painted numerous complex works, including real people and events, myths, legends, bits of memory, plots and stories from heaven to earth, and mortals and immortals in his paintings. One enormous painting became a major project in which literally hundreds and thousands of images were painted. Immediately upon seeing them, any Chinese would understand what he is saying, because every figure, every image, every new or old icon, bears a particular meaning. In responding to the Cultural Revolution, his painting is allegorical and satirical at the same time. **[Figs. 74-75]**

Jing Ke Wen (b.1965) paints the Cultural Revolution in terms of simple nostalgia, creating old themes as if they were found in old photographs **[Figs. 76-77]**.

Photographic (Image) Painting

With today's computers and digital technology, photography and videography have become much easier and simpler processes. In the middle of the 1990s, it was probably for recording the performance art or related reasons that a group of artists in Beijing began to use photography as their main and formal medium. Within a few years, it became fashionable internationally. This led many artists to give up their brushes in favor of the presumably foolproof camera, but many continued to work on canvas. Still, the influence of photography is obvious in their paintings, creating a popular genre called photographic painting. These paintings were directly worked over photographs or digital images.

In this post-industrial era, images from TV, commercial billboards, popular magazines, fashion magazine covers, the internet, and newspapers besiege and shape everyday life. People live in a world of man-made images that become the true reality. The recording of virtually every fragment of human life seems to more accurately reflect its truth. There is

no grand reason, design, or essence in this world; everything is going to vanish. All that will remain will be the aged images from the past. The artists tried to grasp and paint images that are fleeting, chaotic, constantly shifting, diverse, brief and multi-centered.

Zhong Biao's painting has been noticed for some time. He paints collages, combinations of popular commercial advertisements and photography, snapshots of girls in bathrooms. More recently he has painted the juxtaposition of drawings and images, purposely leaving the trace of sketches or paintings on the raw linen canvas. To him, the various images are the memories of the world; he seeks them out directly in history or contemporary life. This is why a *ching hua* vase can occur at the same time as an airplane and a young woman. He creates a world that is nihilistic, chaotic, fragmented, absurd, transient, but also familiar. With dazzling skill he paints finely, making his paintings and his world look like postcards that might be lost or thrown away forever through accident or carelessness. [**Figs. 78-80**]

Xie Nan Xing is an artist who chills you to the bone. His self-contained sentiment and melancholy grab your eyes. His paintings depict a dizzy, blurred, depressed, silent world of illusions that look as if they have been seen through an anamorphic lens. His eyes are the lens of the camera. His paintings always depict a closed space, dark and small, in which nothing is clear but the blurred images of male bodies. Are they masochistic? Engaging in sexual acts? Assaulting? Sometimes the dizzying atmosphere in the painting seems like a drug-induced hallucination. That his blue, blurred world is left to your imagination makes his paintings all the more attractive.

Lately, Xie has painted a series of a single, dead quiet room. In the distorted illusions, a male nude lies on the hard, cold cement floor for no reason. Xie's brush strokes are small and distinct, as if drawn from impressionism. He has even copied the method of the impressionists, repeating a single scene again and again. He obsesses on the effects of light, shadow, and atmosphere through his anamorphic lens, which is different from impressionism. For Xie the distorted reality is his true world. He created six views of the same scene at different times. The nude in this painting was discernible at one moment and gone the next, making it more visionary. Is he quietly staring at a nihilistic vision of emptiness? Or is he staring at unspeakable pain or loneness? When the world and life drift by too fast, he quietly stares at them for a single moment. He slows down and prolongs the instant, transforming it into a psychological eternity. [**Figs. 81-83**]

Shen Xiao Tong (b.1968) paints photos of his family and friends juxtaposed together. He might work with them on computer first, even picking up color and manipulating the images with Photoshop. Then he paints them flat and straight-forward with singular colors on canvas. Trained as a printmaker, he didn't care for the traditions of oil painting. His colors are mostly pastel yellow, blue, pink, and green, which give his paintings a gentle and flat feeling. This may be the

influence of Buddhism, in which he is very much interested. Shen is an intelligent young man with a comprehensive view of the world. His characters look at the viewer with tranquil interest, as if they came from a different world. He has painted their eyes in dark colors, which make one feel somewhat uncomfortable. Buddhism believes that detachment is the realm of freedom. When one is not attached to anything, one has no burning anxious desires, no disappointments. What remains is calm contentment. Even after the turbulent destruction of the Cultural Revolution, Buddhism was not completely annihilated. It may well be the best medicine for life, which has become so overly flooded with material hunger. Shen is one of the Chinese artists who dig deeply into their own culture in search of a cure for the contemporary human life. [**Figs. 84-86**]

Xin Hai Zhou (b.1966), an exceptional painter, also trained as a printmaker, like **Shen Xiao Tong**. They may have been class-mates, since they came from the same school, but he approaches the rapidly growing society and human population in a different way. He paints photos of his friends or people around him, rendering images that are distorted, with big heads and small bodies, their wide open eyes staring as hard as possible at the viewer or something else less tangible. The several people in the same painting are not connected; they are lost deep in their own thoughts, their own troubles. Xin uses tiny, fine lines to paint them, sensuous and intense, almost without color, and, in his later work, nothing surrounds these people but emptiness; no matter how wide open their eyes, they still see nothing. The sicknesses from which humanity suffers in contemporary times, confusion, chaos, indifference, and loneliness, are displayed in his exceptional paintings. Black and white becomes a pure and powerful expression of his idea. [**Figs. 87-89**]

Zhao Neng Zhi paints computerized images of heads, enlarging the image of a head or a part of the head to two meters or more. The skin of a face is pocked with growths that expand and lose their weight, seeming to float in the air. He has almost eliminated all use of color, leaving only grayish-blue. He transformed the normal image of a head into a monster, stimulating the viewer's senses. He called these paintings his *Expression Series*. [**Figs. 90-92**]

Another gifted painter, **He Sen** paints his own snapshots. Chic, young, indolent, sexy, and charming girls are always his main characters, and he depicts their sensuality and delicacy with impressive skill. In the mid-1990s he left their eyes blurred, with the girls lying in bed or on a couch, carelessly holding a stuffed animal in their hands or smoking. He paints with simple and concise flatness; except for the bed or couch, there is nothing in the background. He works primarily with pink, purple, blue, black and white, and gray. His recent works seem to have bigger strokes, and are more realistic. His earlier works were gentle and sensitive, more ambiguous. We can imagine how carefully he observed these girls in front the camera with his gentle eyes, his heart full with love and sympathy. Only later did he become critical, even loathsome. After having lost their faith, is there any conviction that could give support to the life of Chinese youth? Could they find it by

tightly grasping a stuffed animal in their hands? By blowing smoke into the air? By lying on a bed or couch idling away time? Facing the boredom and hollowness of life, he questions himself, and us as well. [Figs. 93-95]

Yang Qian (b. 1959) returned to China from New York at end of the 1990s. He had lived in the East Village for quite a long time, and had a number of shows there. His new works come under the influence of photography as well. He paints photographs of mirrors in dark steaming bathrooms, reflecting primarily the most private moments of young women or prostitutes. It sounds poetic that everything is in a steamy haze, but the numbers on the mirror are metaphoric. His paintings, ambiguous, sexy, and dark, seem to reflect the desires of a male voyeur. [Figs. 96-98]

Sex, Violence, and Social Morality

Sex, violence, and social morality will forever be motifs of art in the contemporary world. For more than half a century under Communism, the Chinese lived like Puritans, so much so that sexual suppression became a social problem. Yet we must recognize that in Chinese traditional culture, because of the influence of Confucianism, sexuality had been always repressed and morbid in mentality. In the past, the interpretation of sex was consistently rendered in metaphoric, metonymic, symbolic, implicit, and complex ways. This, from many points of view, was abnormal. There was a long period of time when Chinese men thought bound feet were sexy. When the Cultural Revolution ended, this form of gender imprisonment was broken once and for all. Sex is no longer a taboo in China. In the '85 New Wave, many artists directly conveyed sex in their work. In Gaudy Art, for example, many dealt with themes of prostitution and solicitation, though the works were considered cheap, vulgar, and blatant in taste.

Ambiguous, dark, and depressing, the hazy sexual depictions in photographic paintings contain the refined and gentle sense of southern Chinese people. The artists play their games by hiding in dizzying light (Xie Nan Xing), behind steam (Yang Qian), or under smoke (He Sen)

Li Ji (b.1963) paints bright and colorful half-naked women without heads. They wear fashionable garments, half exposing bodies as fresh and vivid as their clothes. It is astonishing to see that each of his women hold a monkey in her hand, painted with such delicacy that you can see its hair against the woman's body and skin. His paintings were ambiguous and sexy, even obscene, the touching of the body by the monkey being a substitute for a man's caress. This metonymic depiction is always rendered in the traditional Chinese fashion [Figs. 99-101]

Luo Fa Hui (b.1962) is a metaphoric painter. In traditional Chinese art, the flower always symbolized sex. Luo paints his flowers as did the American painter Georgia O'Keefe, but in a Chinese way. Chinese sex culture is depressingly gentle, dark, and implicit. Luo's roses are dark, wet, gentle, and soft. The petals, half open in soft red light, seem to drip nectar. They are thick and tender with moisture, layer by layer, sometimes with

red speckles on them that look like decay. They have a gentle beauty, but still reek with mortality. In his later work, his roses are glittering and translucent, as charming and delicate as one could ever expect. Chinese sex culture repressed not only the sexuality of women, but that of men as well.

There is an old Chinese tradition of a man taking the role of a woman, writing poems and novels, painting paintings, even playing woman roles on stage. These are metaphoric ways of conveying and releasing suppressed sexual desire. Luo's roses are a woman's sensuality as rendered by a man. Perhaps many Chinese men have the gentleness and delicacy of a woman and, within their culture, are normal and natural. [Figs. 102-104]

Yang Shu's (b.1965) paintings, at first, may puzzle viewers by their ink painting-like mist, while attracting them with their translucent colors and dreamy abstractions. If one's mind is allowed to go off with the artist, it is soon realized that he has led one to his sensual pleasures. He has his private codes and signs, graffiti hidden in the pink, purple, or gray mists. He is relaxed and pleased to unleash his memories and let them wander, here nervously, there dashing, for a moment as joyful as a flower in bloom. He depicts his gentle happiness with sensitive lines and strokes, purposely leaving some empty space on canvas to let the memories go even further. There is a true sense of humanity and true depth of feeling in his paintings, a preciousness needed in contemporary life. [Figs. 105-107]

Ren Xiao Lin (b. 1963) paints what are close to copies of traditional pornography. He paints as if everything is taking place on a stage. Small figures act in a garden scene. The scene is dramatic but vague, because of the size of the characters within it. His circuitous manner makes you want to see more. [Figs. 108]

Deng Jian Jin (b. 1961) paints a series of people in ambiguous relationships. They cuddle together, man and woman, sometimes man and man, woman and woman. They are nude or half-nude in the gleam of the setting sun. He wants to depict a "floating illusion of sexual desire."[1] Painted in a handsome, flowing and spirited manner, his people look relaxed, beautiful, charming, and sexy. [Figs. 109-111]

Yang Shao Bin (b. 1963) loves to paint violence and harm. His paintings are dramatic, with people fighting or beating on each other. As if drawn from an old photo, he manipulates his painting with the uncertain chaos associated with sexual assault. No matter what is happening, you feel the fierce and cruel nature of humankind. Lately, he has painted some broader subjects about the violence to human rights found in international politics, the pain and disaster wrought by wars and invasions, perpetrating political cruelty. [Figs. 112-114]

Song Yong Ping (b.1961), another artist concerned with social morality and the human dilemma, produced some shocking pieces in past years. He was an active leader of the Shan Xi artists group during the '85 New Wave. He is also the brother of **Song Yong Hong**. [see Figs. 39-41]

For some of his work, he has used photographs of his parents when they were bound up with illness and on their last legs. These pictures revealed the bitterness and misery, the cruelty and mercilessness of human life, which produce inescapable despair and helplessness. He astounded the world by displaying his parents' naked old, disease-wracked bodies, and exposing the bottles and tubes that dangled from his father's genitals. He also put himself into the picture, presenting himself experiencing the pain together with his parents. In the Chinese moral tradition, taking care of one's parents is the child's responsibility and obligation. Like the principles of heaven and earth, so children have to go through the torture with their parents. The artist questions his heart and challenges the moral tradition, but he can't offer any answers. Song Yong Ping's work not only stimulates your eyes, but also pierces your heart. [Figs. 115-117]

Women's Art

In the Communist ideals Chinese women can "hold up half the sky." Women were to be treated equally with men in politics, economics, and social status. They were modeled as "Iron Girls" (see Fig. 7) who were neutral in terms of gender, no different from men. After the Cultural Revolution, even though there were many changes, Chinese women didn't have an issue with women's right as in the West. Consequently there were more works about the search for the woman-self and, of course, the expression of sexual desires and rights.

Shen Ling is a bold and straightforward painter. It is difficult to keep oneself from laughing when viewing her paintings. Among the common subjects she paints is the sexual life. The men in her paintings are always shriveling up, while the girls were awakening and full of fighting spirit. She paints openly, boldly and resolutely, using strong colors and a good deal of humor and fun. No other woman in Chinese history has dared to show the fondness and enjoyment of the sexual life as openly or as passionately as she has. She has swept away the rotten, dark, and depressing odors of the traditional sex culture, winning her a lot of applause. [Figs. 118-120]

Cai Jin (b.1965) is an excellent and energetic painter. Her *Banana Plant* series depicted women's souls and inner desires. The banana plant was painted like the human body, with red flesh that was knotty and full of stains; it trembles, expanding and contracting on her canvas. Her brush flowed, rolled, and stretched with ease and verve over those naked flesh-like plants, tempting the viewer to go off with her into this sensuous experience. Her sensitive inner desires and energy seem to explode off the canvas in a manner seldom encountered in Chinese woman's art. The only story is that of the true soul and a woman's instinct, which makes her art very attractive and exceptional. [Figs. 121-123]

Yu Hong (b. 1966) has been searching for women's self-identity in her recent paintings. To illustrate the social environment, she painted a series her own photographs from childhood to adulthood. [Figs. 124-126]

Pan Ying (b.1962) is an outstanding ink painter. She paints ribbons that are graceful and delicate, typical characteristics of women. She tries to move away from the "Iron Girl" model and back to a womanhood that was once again wholly feminine. The tangled ribbons reveal her gentle and beautiful mind. She paints in ink without any color, which is surprisingly striking. [Figs. 127-129]

Liao Hai Ying, sculpts sex organs, of both sexes, as plants or blooming flowers, giving them a new life with all the hairy details. These works are too brave and audacious for Chinese society, but they have brought her respect. She continues to make sculptures that were a mixture of human and plants and are both sexual and absurd. [Figs. 130-133]

Feng Jia Li's girls look at you directly, holding you in their fascinated gaze. She paints them in red face, the kind of makeup that might have come from the Cultural Revolution or Peking Opera. There are patterns and colors from traditional folk art on the clothes the girls wear and in the backgrounds. Under her brush, these young women are sexy and provocative, but confident and brave. Even though they wear the country girl clothes, they are modern women of the new China. Compared to the typical "Iron Girl" model (see Fig. 7), these young women have given up the revolutionary ideals or dreams, and believe in themselves. They can be whoever they want to be, do whatever they want to do. The red makeup seems a joke. [Figs. 134-137]

Liu Hong (b.1956) seemed to be falling into endless thinking and doubts. The dislocation of women's role in society confused this generation. Liu has tried to figure it out. Her paintings are dark and absurd. Her naked or half-naked women are blinded by a piece of red scarf. Not only do the scarves obstruct the vision of the women in the paintings, they also obstruct the viewer. When facing with the blinded woman and her metaphoric language, they can't think logically. Chinese women's wounds, their disorders, become lost memories that can't be recalled. No one knows or cares in this world. The only attention comes from the women themselves; their thinking and doubts become murmurs to themselves. Liu's paintings revealed Chinese women's painful and perplexing process of searching for their identity. [Figs. 139-141]

"Children" Paintings

Many artists take children as their main motif or paint with a childlike manner. Two who do so are the famous brothers **Guo Wei** and **Guo Jin**. **Guo Wei**, the eldest, paints from photographs of his daughter; however, all you see is the ferocious and brutal human nature of contemporary life. He paints concisely and fluently, with sure strokes on sparse backgrounds, using little color. The many short lines, seemingly scratched on the photograph, hint at an uneasy and nervous psychological state. The girls in the paintings are playing, naughty and willful; their cruelty and the lack of mercy are metaphors of the relationship between contemporaries. [Figs. 142-144]

Guo Jin (b.1964), Guo Wei's younger brother, seems gentler. His paintings are colorfully mottled, creating a bizarre illusion. Children are portrayed as playing and acting as though they are in an absurd enchanted dreamland. The memories of childhood, the deepest dreams and unspeakable thoughts and feelings that are held in a secret corner of everyone's heart, are found in his paintings. He paints kaleidoscopically, mottling with a fine texture. His works express a sentimental, nostalgic view of time and of life's passing, and imply something about the absurdity of contemporary life and reality. They display an emptiness that may not be completely grasped, but still will enchant the viewer. [Figs. 145-147]

Tang Zhi Gang uses children as his main motifs in satirizing the Cultural Revolution and the present politics. His intention is very clear. Children are having national meetings, military meetings, making decisions, and setting policies; in short they are ruling China. [Figs. 148-150]

Liu Yie (b.1964) lived in Germany for a while. His paintings resemble a children's cartoon. He has two favorite things in his paintings. First, he reflects the style of the Cultural Revolution, which is red and filled with romantic happiness. Of course, he grew up during that time, and fell under the influence of the feverish, almost religious, romantic wave. He paints his little people on a red background as if on a stage, where they are dancing, smoking, brandishing swords and guns, or longing for beautiful ideals with tears rolling down their faces. Liu's second icon is Mondrian. You see his influence everywhere in his paintings. [Figs. 151-153]

Huang Yi Han (b. 1958) and Xiang Ding Dang (b. 1973) represent the new generation, those born after the Cultural Revolution. Huang's installation called Uncle McDonald Is Coming to Town! directly reflects the intrusion of American pop culture and Japanese animé cartoons. [Figs. 154-155] Xiang was interested in Disney's characters. He places their statues on lotus bases, as if they were gods. He is also very much into video games and his work illustrates how those games occupy the life of China's newest generation. [Figs. 156-157]

After 1990, Western pop culture flooded over China. In ten short years there was no big difference between Chinese youth and the young people outside of China. They played the same video games, ate the same food, watched the same TV shows and movies. The Internet and the computer speeded up this process. Chinese pop culture has become more and more cartoon-like, child-like, and entertaining. Adults, as well as children, are finding their spiritual lives decomposing in this simple, shallow, and lazy entertainment. Did Xiang and Huang try to alarm people?

New Expressionism

Jiang Hai (b.1961), who has been producing shocking pieces for more than twenty years, paints gigantic group paintings. People are amazed at his energy, like a volcano that could endlessly erupt. There are distorted, depressed nudes in his paintings. His large, bold brush strokes seem to be exploding out of his heart, layer by layer, from left to right, as chaotic as a knot of entangled hemp with dazzling colors, creating a strong visual impact. Along with the rapid economic growth, the city became more crowded, complex, noisy, grotesque, and gaudy. In this fast growing modern society, Jiang has always been a solitary, sorrowful observer on the fringes of the society. The more difficult it is to fit in, the more solitary he becomes. His highly expressionistic paintings are symbolic imageries of his intense emotions, revealing the conflicts and dilemmas between humanity and the society. [Figs. 158-160]

Lin Chun Yan (b.1962) returned to China from Australia in the 1990s. He may be gentler than Jiang, but he seeks to express the same thing. He frees his figures, lets them fly, stretching into the air. His strokes are thick and textured, with gestures similar to those in ink painting. He uses singular color, pure and bold, and very attractive. He paints heads as vegetables, creating highly absurd metaphors. [Figs. 161-163]

Bao Le De (b. 1959) came to U.S. in 1989, and has been living and working in the Boston area for more than a decade. When involved with the '85 New Wave, he experimented with collages mixed with painting. His large collage piece Sun Flower was included in the famous China/Avant-Guard exhibition in Beijing. Abstract Expressionism has been always his genre. His paintings, in brilliant colors, are painted boldly and dynamically, with gestures that are clearly influenced by traditional Chinese calligraphy. Perhaps the distance between the United States and China made him think more about his own culture, for he fell in love with ink painting, the beauty of black and white. He uses a lot of black in his paintings. Bao continues his experiments with collage that began fifteen years ago, gluing rice paper on canvas layer by layer, then painting over the result. He is a painter full of an inner energy that emerges in every stroke. His new collage paintings are gentle, but quietly powerful. [Figs. 164-166]

Zhou Chun Ya went back to China after graduating from a German art school. He is an oil painter known for his vivid anthropomorphic green dog paintings. The dogs, painted in huge dimensions, represent various of his contemporaries. He paints them fluently, with the charm of ink painting, though the influences of German expressionism are evident. There is nothing in the background. We may never know why he picked green, but the green bodies of his dogs contrast with their red genitals and tongues making them seem fresher, even sexy. [Figs. 167-169]

Jia Di Fei (b.1957) paints the crowded city. There are always noisy, jam-packed streets in his paintings, which make them dazzling in color and give them a restless quality. [Figs. 170-172]

Fragments and Fantasies

Zeng Hao (b.1963), a painter infatuated with the details and fragments of life, seems afraid of losing them and collects them for his paintings. His works portray a chaotic and fragmented world that goes beyond normal space and time. He marks the time and date as he records a particular scene,

objects, or people. Life, for him, is an absurdly fragmented process, which has no logic. [**Figs. 173-175**]

Sun Liang also is obsessed with a mystical and fragmented world. His paintings seem rooted in ancient Eastern mythology and the legends of ghosts and monsters. In them, people are mixed with animals as allegories with symbolic meanings. Sun's paintings are mystical, but exquisite and attractive. [**Figs. 176-178**]

Like Zeng, **Yang Jin Song** (b.1971) loves the details of life but in different way. He puts his double-faced figures into a chaotic and fragmented world, creating paintings that are fresh and romantic. [**Figs. 179-180**]

New Experimental Ink Painting

During the '*85 New Wave*, there was a shocking article by art critic Li Xiao Shan, in which he stated: "Chinese ink painting has reached its ultimate end." As we discussed earlier, from the beginnings of the last century to the Cultural Revolution, Chinese artists had been continually engaged in the reformation of traditional ink painting. Li's article argued that there was nothing more to mend, that it needed a fundamental transformation. During the "Culture Fever" of the 1980s, intellectuals were passionate about building a new culture. Traditional culture was seen as a burden from the past; if it were possible to abandon it, the sooner the better. They didn't realize there was nothing left to discard after fifty years of fundamental reformation and the destruction of tradition. But Li's article triggered ink painters to think more deeply and reckon more with the details of tradition.

In Chinese painting, there always has been a concept of *Bi-Mo* in which *Bi* is the brush, *Mo* is the ink. What this really refers to is the magical or delicate transformation of ink on rice paper through the application of the exquisite techniques of the ink brush. The transformation becomes *Yi Jing*, an energetic flowing of rhythmic vitality through which the artist reveals his *shing-ching*, an abstract ideal for a very long time in Chinese art history. Chinese intellectuals looked to it as their spiritual realm, the accomplishment and practice of life, the poetic meaning and feeling of life and the world. Traditional Chinese ink painting is about the revealing of *shing-ching*. It has been always a subjective matter, never objective. As discussed before, Chinese ink painting had never been realistic; it is *Shie Yi*, the ideogrammatic writiing of thoughts. For more than one hundred years, Chinese artists had been trying to get rid of *shing-ching* and *Bi Mo*, trying to paint, like Western painters, as realistically as possible. After the Cultural Revolution, what remained was the medium of ink painting: ink, brush, and rice paper, and some traditional methods of handling the medium.

In the 1980s, **Gu Ying Qing** (b.1959) tried to transform realistic ink painting into something new by bringing Western modernism into the tradition of Chinese ink painting. It is obvious that he was influenced by Matisse, Gaughin, Klimt, Modigliani, and others. He manipulated his paintings by mixing oil pastel, wax, and pigments, making them look thicker, modern, and colorful. While his work is fresh and Westernized, at the same time Gu has maintained the fine traditional technique of the ink media. The delicate brush lines and tint of ink and colors are shown everywhere in his painting. [**Figs. 181-183**]

Zhu Xin Jian is a painter who reveals his *shing-ching* directly and openly in his paintings. Instead of the fine, traditional *shing-ching,* he depicts the ordinary, exploring the popular and garish tastes. He exposes his cynical and unrestrained life style without disguise, through his sexy southern, small town girls, and the lover's remarks on the painting which lacked all feelings of love and poetry. He returns to the tradition of *Bi-Mo*, and is not realistic at all. [**Fig. 184**]

Li Jin (b. 1958) is another true revealer of *shing-ching*. He bares his soul in his paintings. In this time of a market economy, he has immersed himself in the life of consumption, and seems to be in love with it. While he clearly enjoys it and and is sympathetic to it, he also ridicules it. There are many women and feasts, joys, miseries, loves, and sensual desires, as well as comedy in his paintings. More recently, he has turned to gigantic depictions of Chinese food, painting hundreds of dishes. The materialistic desire overflows to an extreme in his food paintings, some of which are more than ten meters long. He doesn't mind taking the trouble to record all the recipes beside the dishes, a mannerism that became his commentary on the paintings. He keeps the *Bi-Mo* tradition, painting in the way of traditional ink painters. He tints ink or color, draws fine lines, fills colors, and wields his brush with facility and freedom.

His humorous and fun-filled visions of life make his art interesting, and show his own hedonism. His sincerity toward life and world, and the humanity in his art can be shared by any human being in today's world, which makes his work all the more precious. [**Figs. 185-187**]

Li Xiao Xuan (b.1959) is totally infatuated with the painting of nightmares, so much so he seems never to awaken. He depicts city life as if in a another world where the relationship between the inhabitants is merciless and absurd. There are the unbearable crowds: people, animals, and cars, buildings that seem paralyzed, like "corpses" lying about everywhere, as chaotically as a hopelessly tangled heap. The city is a big prison. When his characters try to soar into the sky or climb a tree, we know they will find it impossible to escape.

Li has experienced earthquakes, witnessed ruinous disasters, and endured the deaths of his family, experiences that have haunted him all of his life. His paintings are dark and absurd, filled with despair. He can be very sensitive or nervous, spicy and biting, or sarcastic and mocking. He is almost the first ink painter in Chinese art history to paint deep psychological truths.

Li has solid traditional painting skills. No matter how much he has borrowed from Western expressionism, he has never given up that tradition. He uses all kinds of brush techniques, manipulating them meticulously, as can be seen in every stroke *(Bi)* and tint of ink *(Mo)*. The emptiness and fullness of

ink, the penetration of heavy ink, the thickness and concise-
ness of his lines, and the expression of the distorted figures
have made his art exceptional. [Figs. 188-190]

Hai Ri Han (b. 1958), a talented Mongolian ink painter, trained
in Beijing. Perhaps it is because Mongolian blood runs
through his veins that his art is so unusual compared with
anything that came before it. Something that Chinese ink
painters would never have in their paintings is the wild and
free nature of the Mongolian.

Hai's people and animals are free, dreamily wandering on the
grasslands, in the woods, or beside the streams. They appear
to be in complete harmony with nature. His women are sexy
and graceful, as if goddesses often fly across the paintings.
His animals are quick-witted; their eyes wide open, they often
emerge near the women. As a Buddhist who believed in gods
and the soul and *samsara*, Hai let his world become an
allusion of the past, present, and future life. You can feel an
almost mythic humanity in his paintings. He painted them as
simple and unadorned as Chagall, as freely distorted as
Picasso.

His outstanding ink painting technique allows him to manipu-
late fine lines and tints of ink and colors effortlessly. At the
same time the influences of Buddhist mural paintings and the
folk arts of the grasslands can be found in his paintings. This
wildness, unrestrained freedom and religious mystique make
his art unique and brilliant. [Figs. 191-194]

Feng Bin (b.1962), a brave reformer, is not only smart but also
open minded and progressive. He paints *gong-bihua* in a
totally different way. *Gong-bihua,* one of the oldest kinds of
Chinese painting, uses meticulous strokes to paint fine details
with bright colors. Tibetan temples and blurred figures are
Feng's main subjects. He usually uses cotton rather than silk
or rice paper; rendering in perspective, but flatly, turning
architecture into abstract geometric patterns. His colors are
extravagant and even decorative, sometimes using gold foil,
but without much detail. His paintings appear modern and
fresh. The blurred figure hurrying past the building is mysteri-
ously interesting, not just because of the contrast created
between the background (solid form) and the foreground
(blurred figure), the motion and stillness, but also because of
its ambiguity. [Figs. 195-197]

Zhou Yong (b. 1962) strictly maintains the medium of tradi-
tional ink painting, but fundamentally deconstructs tradition.
There is no *Bi* and *Mo*, and, of course, no *shing-ching*. Even
though he paints with ink and brush, there is no traditional
technique involved. He paints ink posters, interpreting con-
temporary life and social values. Inspired by Pop Art, he wants
his art to be perceived directly as advertisements involving
human life, and so displays his works at bus stops [Fig. 198].
In his work he uses short, thick lines to outline his people and
objects, tinted color in small areas, and writes slogans such as
"I want a breast implant." [Figs. 198-201]

At the time that Gu Wen Da experimented with a very new
approach to ink painting in the *'85 New Wave*, there were

many other ink painters doing the same thing. They called
themselves experimental ink painters. Under the "Culture
Fever" and the effect of Li Xiao Shan's criticism, artists tried
to step out of the integrated and erudite traditional art
system, to make something new and modern.

Zhang Yu (b.1959) is an advocate and one of the leaders of
non-representational ink painting. Keeping the traditional
techniques of ink painting, layer by layer, he tints ink and
produces new imagery, a depiction of Chinese ancient
philosophy, *Yin-Yang* or the explanation of the universe. His
Bi-Mo doesn't reveal any *shing-ching*, or his emotions. His
series, *Divine Light,* is exquisitely and meticulously painted,
and reveals the consciousness of the universe. Lately he has
experimented with mixed media and made collage painting
by using newspapers, pencils, white paint, and the like. The
News series consists of his new experimental works. He has
not only broadened the scope of the medium, but the
subjects as well. [Figs. 202-204]

Liu Zi Jian's (b.1956) paintings are abstract spaces painted
on rice paper. [Figs. 205-206]

Fang Tu's (b.1963) works seem mixed with both abstract and
figural elements. There are geometric patterns, and discs
and nets. He has tried to broaden the medium by using
acrylic paint, but it is the ink and his fine traditional technique
that make his paintings look more charming. [Figs. 207-209]

In **Wei Qing Ji**'s (b.1971) paintings, viewers hardly see the
traces of traditional ink painting. He makes collages with
newspapers, prints, magazines, acrylics, tea, pencils, and
silk. He paints his memories, fragments of life or dreams, as
if he picked them up just by stretching out his hand. They
appear loose and naïve, and sometimes symbolic. Ink is one
of the media he uses with facility and freedom. [Figs. 210-
212]

Liang Quan (b. 1948) is an exceptional artist working in the
medium of rice paper collages. First, he paints light ink on
strips of rice paper, then glues them together. The edge of
every layer of rice paper creates gentle and delicate lines.
Surprisingly, that reveals the intriguing beauty of tinting ink
and the softness and translucence of the paper. His paintings
have a quiet and gentle appearance. Lately, when he has
used tea and coffee instead of ink, he has produced the
same beauty. He is the one who uses abstract genre to
reveal the beauty of *Bi-Mo.* [Figs. 213-214]

Chen Xin Mao (b.1954) makes idea art using ink and rice
paper. He paints short lines on a page from a book of rice
paper until the page becomes completely blurred. He
repeats this through fifty pages which he called *History
Book, Wrong Edition*. [Figs. 215-216]

Qin Feng (b.1961), who now lives and works in the United
States, spent ten years in Germany. He tries to transform
calligraphy into abstract expressionist painting. Often he
picks one stroke or two, and works on it with all of his
energy. There is a lot of *Bi*, but not much of *Mo*, which

means that his energy can be seen through the strokes in an expressionistic way, but not the magical or delicate transformation of ink on rice paper, even though he paints with ink on rice paper a great deal. He apparently wants to distance himself from traditional ways, as have so many artists we already have discussed. [Figs. 217-219]

The New Academic Art

China's new art was born from the academic art system. In the 1980s the eight art schools trained all of the "rebels." The rigid teaching traditions of the schools developed solid painting skills in the new artists. This is why there are still so many paintings in China's new art, after most of the world's mainstream artists gave up their brushes long ago.

As times changed the academic system gradually opened up and reformed itself. Today a rebel might even become the president of an art school or the chairman of an art department. The schools still maintain the traditional study of paintings from all places and times, including China's own traditions, and use them in training new artists. But today's schools have become good environments for supplying the most recent ideas and information about art and exchanging them with the world outside. The trend in Chinese art educatioin is more toward the idea than the skill.

As early as the end of the 1970s, before the *'85 New Wave*, the first group in school started the fire. **Luo Zhong Li**'s (b.1948) *The Father* [**Fig. 67**], a photo-realistic portrait of a peasant, created a sensation. **Chen Dan Qing**'s series on *Tibet* was also a hit at that time. [**Fig. 68**]

It was obvious that the new academic artists wanted to tell a story totally different from that being told in the Cultural Revolution Art. Their work corresponded with the emergence of "Trauma Painting." Trauma Painting drew from the popular literary trend of the time, depicting the tragic experience and spiritual wounds brought to people by the years of chaos. **Cheng Cong Lin [Fig. 69], Wang Long Sheng** (b.1944) [**Figs. 220-221**], **He Duo Ling** (b.1948) [**Figs. 70, 232-234**], **Ai Xuan, Gao Xiao Hua**, and **Wang Chuan** were among the outstanding Trauma painters.

At the end of the 1970s and the early 1980s, when the American artist Andrew Wyeth was introduced to China for the first time, his simple, concise, sentimental, lonely style immediately attracted the young painters. Perhaps it was fate that it coincided with the rise of Trauma paintings; his influence can be seen in most Trauma paintings of that era. Americans probably never thought that Andrew Wyeth would have such major influence outside of his country. Trauma Painting inspired future generations as well. **Zhao Kai Lin** (b.1962) is one of the painters. [**Figs. 222-223**]

Luo Zhong Li continued in his Chinese Regional style after the sensation of "Father." Mostly he paints peasants and country life. His style is becoming heavier and more un-adorned. [**Figs. 224-225**]

Fig. 67
Luo Zhong Li
The Father
1980
Oil on canvas,
216 x 152 cm

Chen Dan Qing

Fig. 68
Chen Dan Qing
Go To Town
1980
Oil on canvas, 75 x 50 cm

After 1989, there was little difference between the artists inside or outside of the academic system. Many artists we discussed previously are now working and teaching in art schools.

Shi Chong (b. 1963) is an artist with superb skills that are beyond most people's understanding. Many artists puzzle about how he paints. Part of the process involves having his models do performance art that he designs, which he then paints on canvas. Performance art itself is conceptual art, and people are astonished to see it painted in oil. In the performance he always puts his models in uncomfortable environments, under water, wrapped in plastic, or covered with plaster powder, perhaps making the viewer feel ill-at-ease. The human condition and life's dilemmas, are his primary concerns. **[Figs. 226-228]**

Xin Dong Wang (b. 1963) paints peasants and the people who live in the fringes of city life, a rich genre that calls forth the best of his unique style. His stark portraits capture their souls and temperament. With the rapid growth of the cities, farmers flooded into them looking for jobs. How were they to face those changes and conflicts? Under Xing's brush, his people are confused, kind-hearted, apathetic, honest, and foolish. He reveals their humanity, expressing his generous, kind concern and respect. There is no romantic or poetic meaning, nor any intellectual pursuit, just simple, unadorned, and true gentle feelings that will move the viewer. **[Figs. 229-231]**

He Duo Ling (b. 1948) is a gifted painter. As early as the period of Trauma Painting, people were surprised to see his romantic and poetic paintings. He has been always an intelligent, romantic painter. By the end of seventies he had come under the influence of Andrew Wyeth, and his style turned more delicate. Lately his palette has become even cooler as he embarked in different directions. His subjects are concentrated on the nude, both of adults and infants, memories that seem like faded patterns on a old wall. He loves to use neutral colors, rich and subtle. His beautiful technique is always apparent in his paintings. **[Figs. 232-234]**

Liu Hong Yuan, an amazing painter with outstanding skills, trained in the best art school in Beijing. She is very much into the tradition of Beijing opera and the Qing dynasty (1644-1911) culture that was at the same time splendid, depressing, and a little peculiar. Her paintings not only display traditional patterns and forms, but interpret the essential and sometimes dark side of the old culture. She uses classic techniques of European oil painting that are seldom seen anywhere in the world today. She paints the first several layers totally in white, building up thickness, then adds glazed and toned colors, making her paintings look as if they are sculpted on the canvas. Her enormously detailed works consist of every jewel worn by her lady, the embroidery patterns of her clothes, the porcelains and fruit blossoms on the tables. Her bizarre, absurd, and classic paintings will always haunt you. **[Figs. 235-236]**

Cheng Cong Lin

Fig. 69
Cheng Cong Lin
X Day, X Month, X Year
1979
Oil on canvas, 202 x 300 cm

Fig. 70
He Duo Ling
The Spring Braze is Awakening
1979
Oil on canvas, 95 x 130 cm

Su Xin Ping (b. 1960) trained as a printmaker. His lithography is unique. He works in a simple, unadorned style that probably was born of his life experiences in Inner Mongolia. His paintings are bold and ingenuous; their gentle and quiet energy always holds the eye and captures the imagination. **[Figs. 237-239]**

Leng Jun (b.1963). With perfected realist skills, Leng is a precisionist whose paintings challenge one's visual ability. He paints ordinary objects with a cold starkness, moving to the ultimate limitations of work done by hand and pushing photo-realism to the extreme. **[Figs. 240-242]**

With excellent skill **Fan Bo** paints the people of the city and captures the confusion and chaos of urban life. [**Figs. 243-245**]

Ma Lin (b. 1963) paints with great detail, and has solid skills in realistic painting. He chooses, however, to bring a surrealistic edge to his painting, interpreting the anxiety and unease of his subjects, and capturing their frightened moods. His people and horses are caught in that moment just before a storm arrives. [**Figs. 246-248**]

Since oil painting was introduced to China, realism has dominated painting. After the Cultural Revolution, there were many artists who studied and researched all aspects of abstract painting, exploring new styles and media. They have produced many fine new works that both draw upon the larger world and differ markedly from it.

Shang Yang (b.1942) constantly explores new meanings in his art. His paintings illustrate the sickness he sees in contemporary society and culture. In the *Big Landscape* series, he painted a volcano to symbolize the social crisis that was weighing upon his heart. He went back to tradition, searched the roots and painted *Dong-Qi-Chan Plan*, transforming a masterpiece of Dong Qi Chan (1555-1636) into something different by mixing hand painting and computer works. His paintings warn that the relationship between humankind and nature is in danger. While he was working on the piece, the SARS epidemic was occurring; he hand copied the recipes for an herbal soup for curing the disease onto the painting instead of an original poem. [**Figs. 249-251**]

Ming Jing's (b.1960) paintings have the charm of both ink painting and oils. The rhythms of his painting are created through tension and looseness, with sensitive fine lines and bold textured brush strokes making strong gestures. He manipulates bright and dark, black and white, thickness and thinness, emptiness and fullness in a masterly way that looks effortless. You can always sense his nature, drifting lightness unattached to anything, the handsome and free, and the romantic, poetic, and even humorous, in his art and wonder how he could retain his purity and detachment in the contemporary world. [**Figs. 252-254**]

Zhang Jing Sheng (b. 1940) is a devoted painter who has spent many years in the study of color. There are influences from impressionism in his paintings, but he has his own style. He tries to reveal the intensity of color, often working with a palette knife to let his colors reach their most brilliant and richest point. He paints in layers, alternating the thick and the thin to give his colors a dynamic tension. There are also clear influences from ink painting, seen in the way he manipulates the emptiness and fullness, the tinting of colors, the flowing of energy as would an ink painter. [**Figs. 255-257**]

Zhu Jin's (b. 1959) paintings are so naïve and pure, having the beauty of great wisdom in a dull and unadorned appearance, that one can't help falling in love with them. His technique is unique, using red, yellow earth, terra alba, ink, and gum resin as his media. He really wants to offer a pure and simple world, materially and fundamentally, and there is nothing simpler than earth, of course, and no comparison between the beauty of nature's color and texture and things man-made. He cleverly combines his media, then outlines the shapes, surpassing nature. [**Figs. 258-260**]

Qi Hai Ping (b. 1957) paints abstract oils, applying the philosophy and techniques the *Bi* tradition of Chinese calligraphy. As discussed before, *Bi* is the exquisite technique of using the ink brush to reveal the painter's energy and the beauty of the ink through the gestured strokes. The *chi* (energy) and *du* (intensity) create the variations of *yin-yang*, and an unexpected rhythmic vitality. He has almost abandoned colors, and uses black and a little white, stroke by stroke, crisscrossing each other to depict the rhythmic vitality. The difference between him and Jackson Pollock is that he used brushes on canvas rather than the dripping of paint, with more energy, gesture, and intensity in every stroke. His paintings, enormous in size, appear integrated and erudite. [**Figs. 261-263**]

Sha Jin (b. 1955) is a Mongolian painter who studied oil techniques in Japan for four years. He paints in mottling colors resembling ancient cave paintings. His people and horses walk in the grasslands in a free and relaxed way. Evidences of the influence of Mongolian folk art are seen in his work, though he paints them thickly in bright, pure, strong colors. [**Figs. 264-266**]

The work of painter **Ding Yi** (b. 1962) challenges one's visual experience. He paints small, square crosses on a large pieces of paper or fabric, creating an irrational absurdity out of rational deliberation, thereby reducing the meaning of a complex form to meaninglessness. [**Figs. 267-268**]

Tan Gen Xiong (b. 1952) and **Yang Jin Song** (b. 1955), are painters who experiment with diverse media, and intend their abstract works to be more materialist. **Tan** tried line, charcoal, oil, acrylic, carbon and canvas. [**Figs. 269-271**]

Beginning in 1991, **Yang** studied art in France for six or seven years. His works were featured in shows at large and small museums throughout Europe and the United States, before he returned to China in 1997. His abstract works are sometimes collages and sometimes look like Chinese ink painting. Though he is very much an abstract expressionist, one can find oriental elements in his paintings. [**Figs. 272-274**]

[1] Unpublished art statement sent to me in 2004.

Mao Xu Hui (b.1956)

Fig. 71
Mao Xu Hui
The Opened Scissors
1999
Oil on canvas, 150 x 180 cm

Fig. 72
Mao Xu Hui
Half Upside Down Scissors
2000
Oil on canvas, 180 x 130 cm

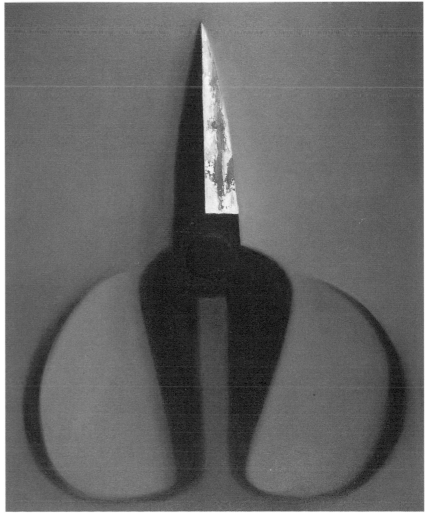

Fig. 73
Mao Xu Hui
Vertical Red Scissors
2000
Oil on canvas, 145 x 120 cm

Liu Da Hong (b.1963)

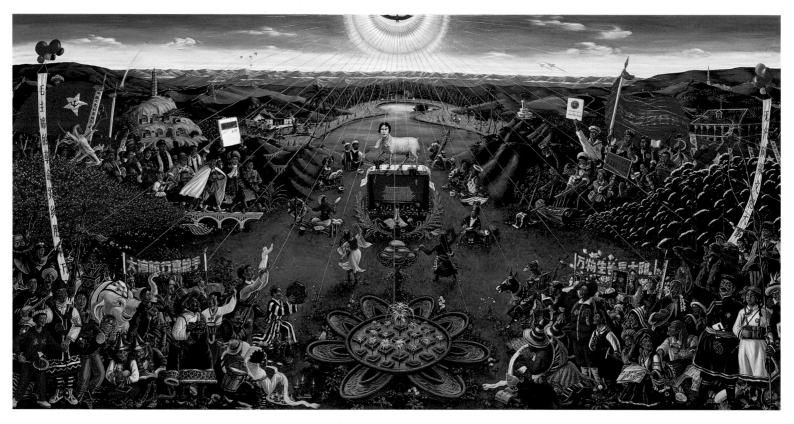

Fig. 74
Liu Da Hong
Sacrificial Altar
2000
Oil on canvas, 200 x 100 cm (1 of 3)

Opposite page:
Fig. 75
Liu Da Hong
The Twin City (pair)
1998
Oil on canvas, 240 x 100 cm x 2

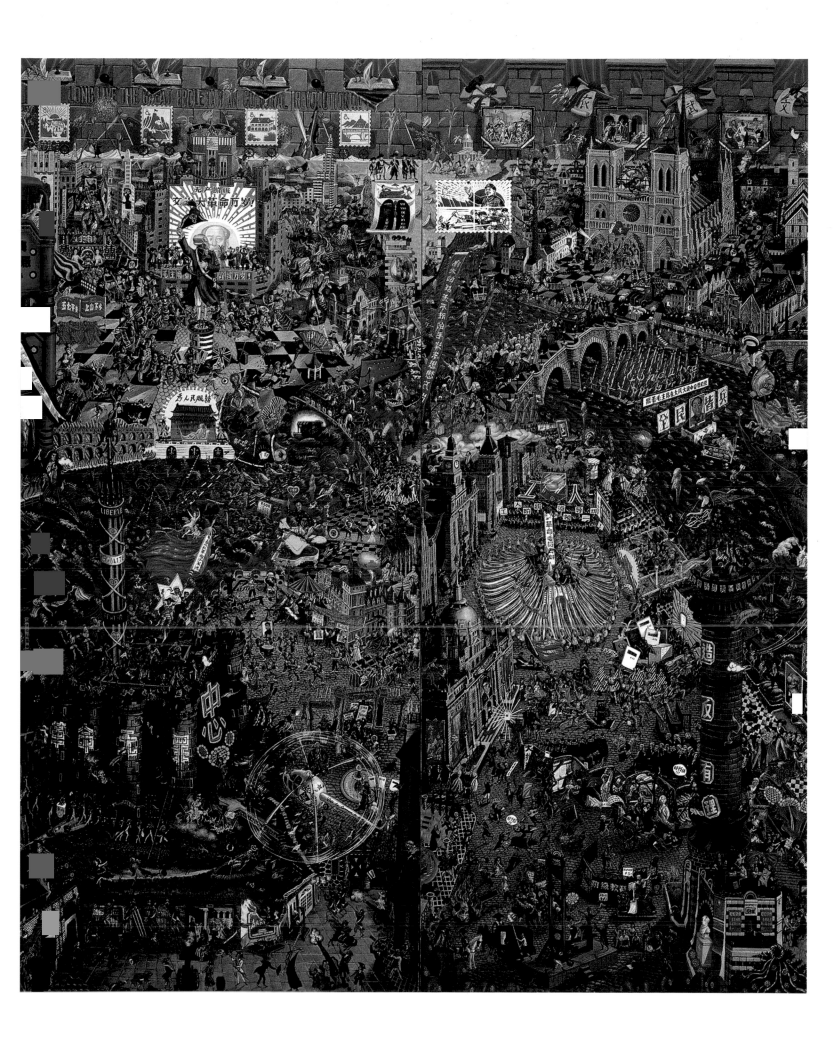

Jing Ke Wen (b.1965)

Fig. 76
Jing Ke Wen
Together 2003, No. 2
2003
Oil on canvas, 200 x 150 cm

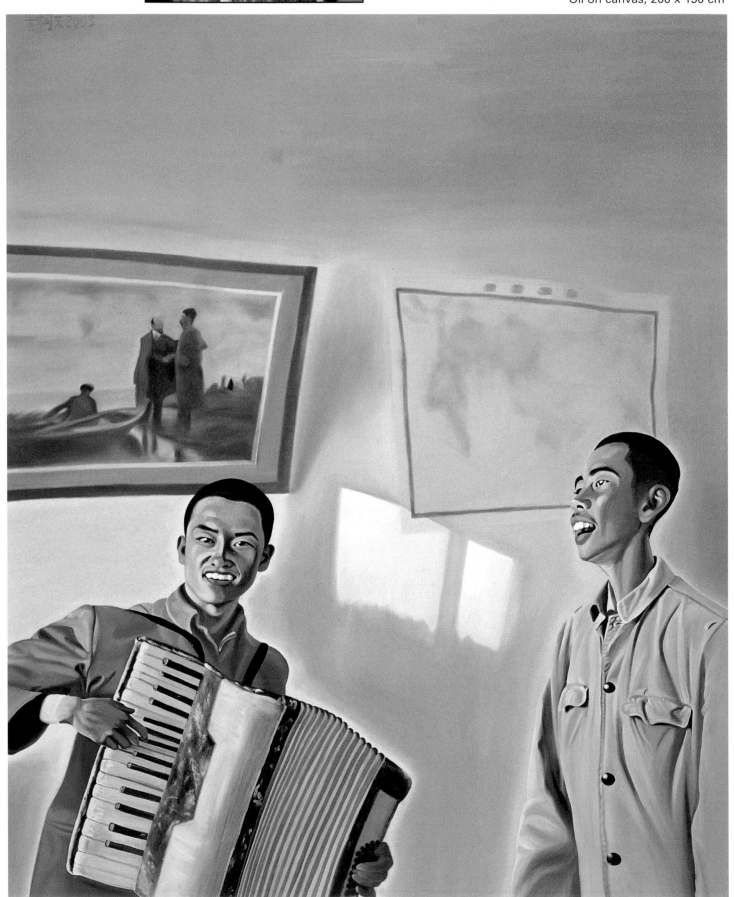

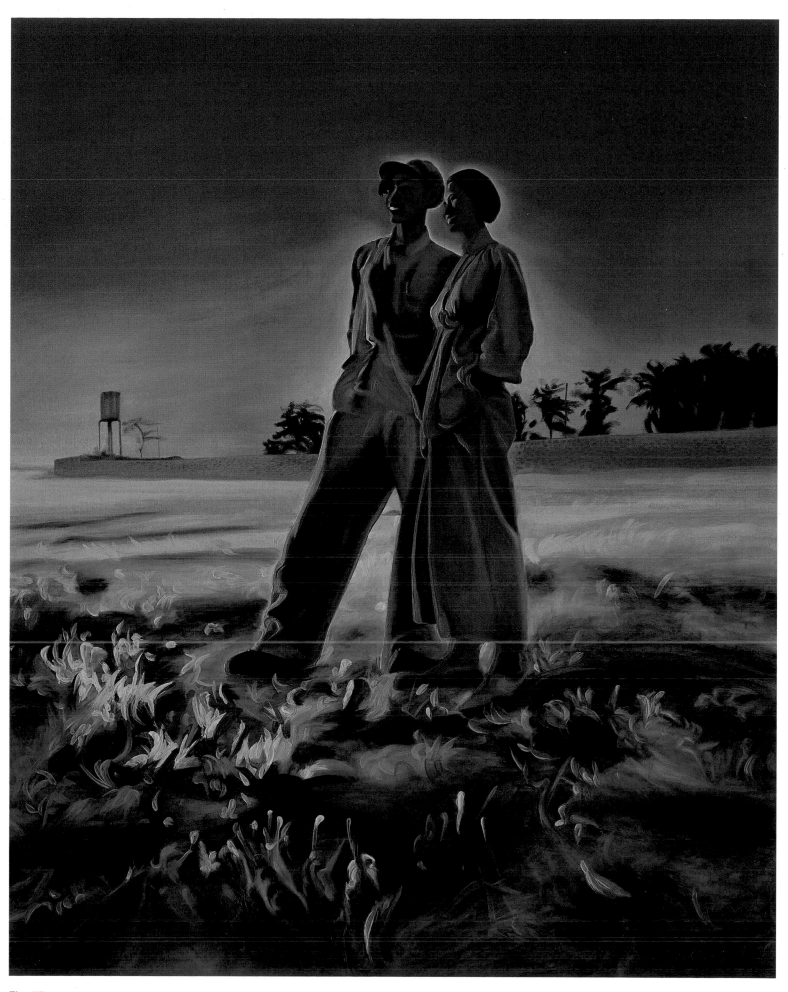

Fig. 77
Jing Ke Wen
Together 2003. No. 1
2003
Oil on canvas, 190 x 150 cm

Zhong Biao

Fig. 78
Zhong Biao
*Prosperity Brought by the
Dragon and the Phoenix*
2001
Oil on canvas, 130 x 97 cm

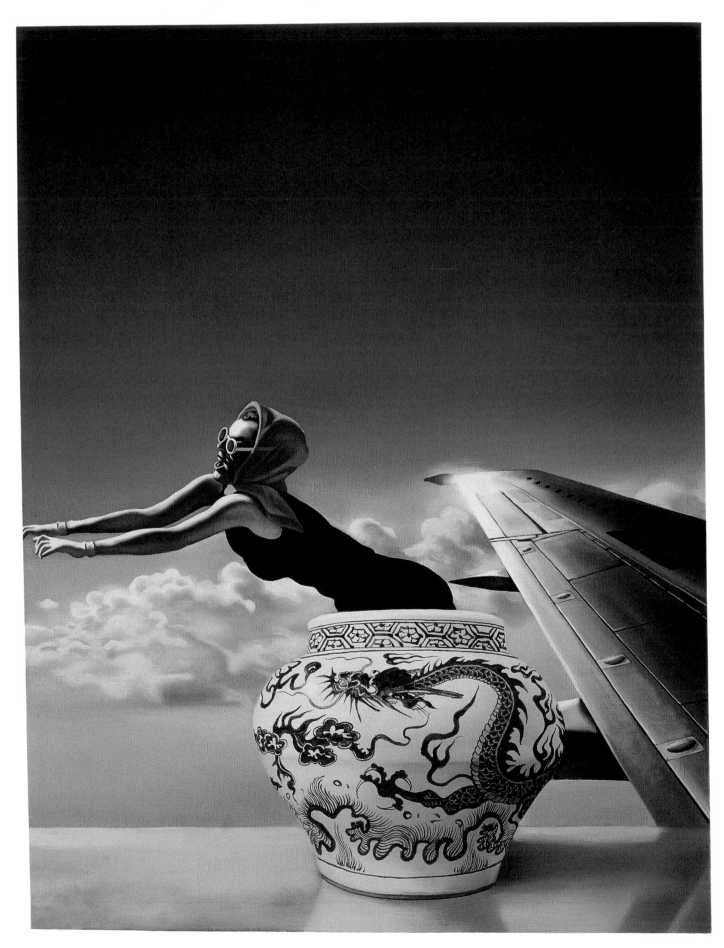

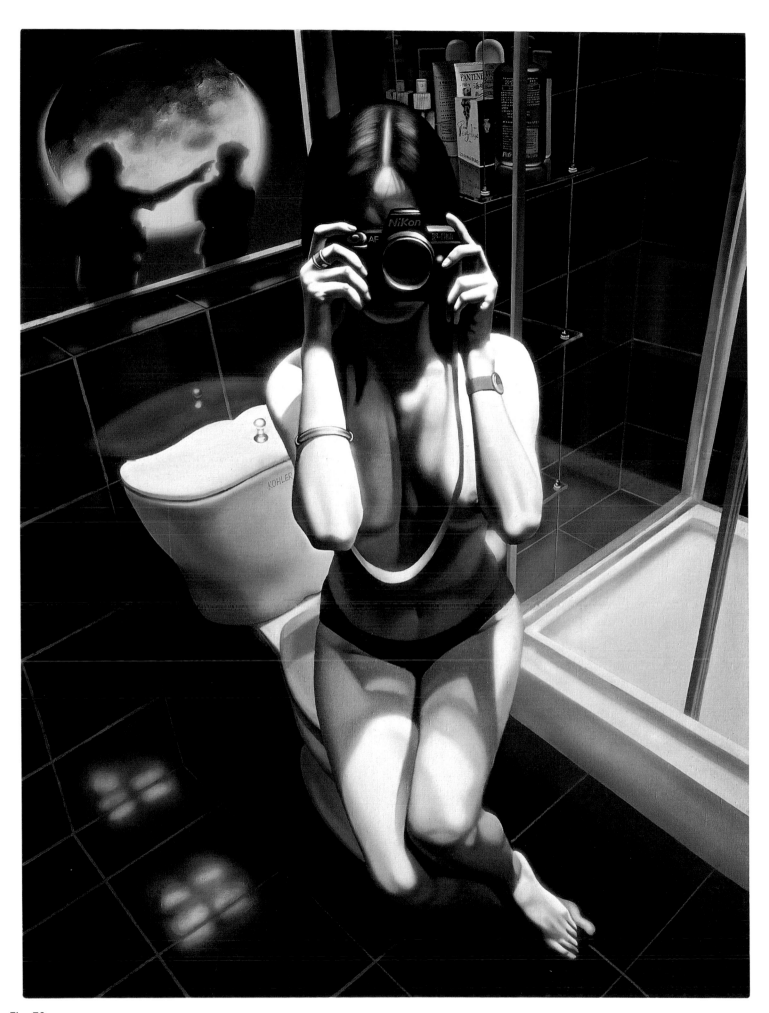

Fig. 79
Zhong Biao
Dark Lens
2002
Oil on canvas, 200 x 150 cm

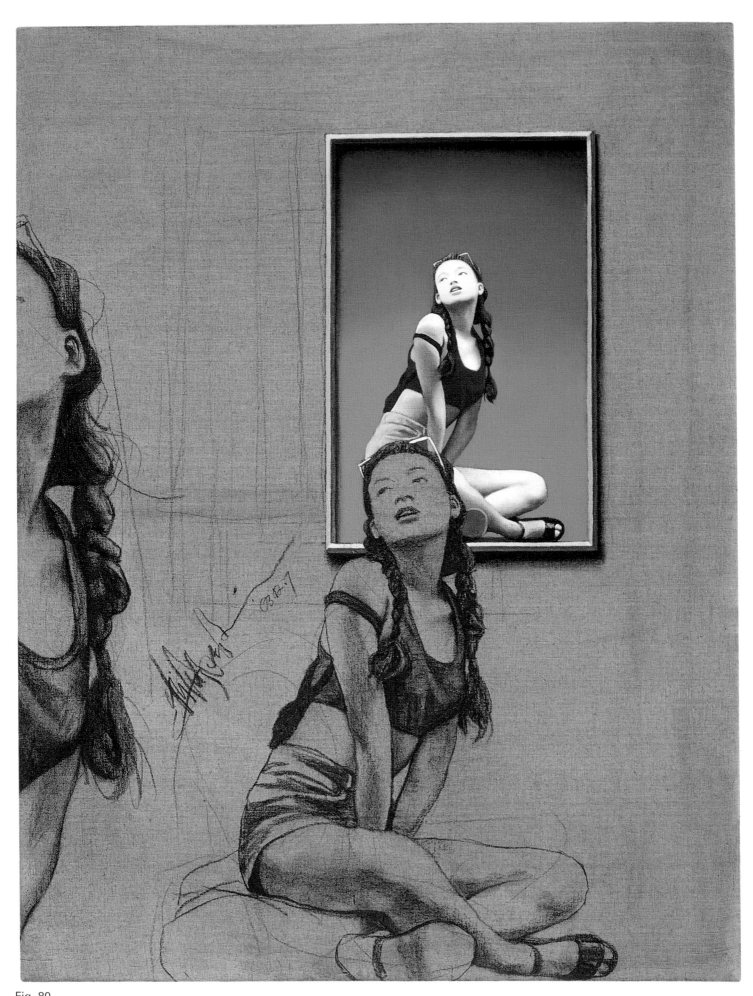

Fig. 80
Zhong Biao
Star S
2004
Charcoal and acrylic on canvas, 130 x 97 cm

Xie Nan Xing

Fig. 81
Xie Nan Xing
Untitled Series No. 1
2002-2003
Oil on canvas, 150 x 360 cm

Fig. 82
Xie Nan Xing
Untitled Series No. 3
2002-2003
Oil on canvas, 150 x 360 cm

Fig. 83
Xie Nan Xing
Untitled Series No. 4
2002-2003
Oil on canvas, 150 x 360 cm

Shen Xiao Tong (b.1968)

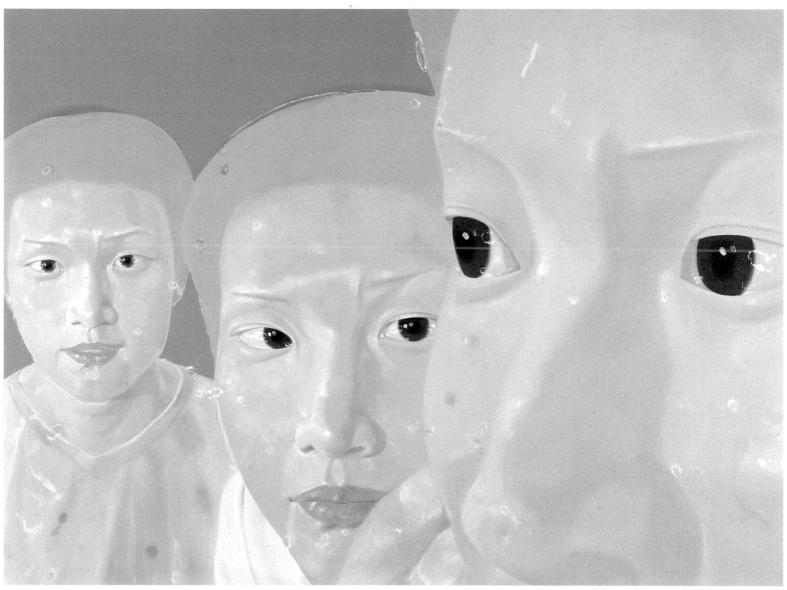

Fig. 84
Shen Xiao Tong
Images 2002. No. 19
2002
Oil on canvas, 110 x 150 cm

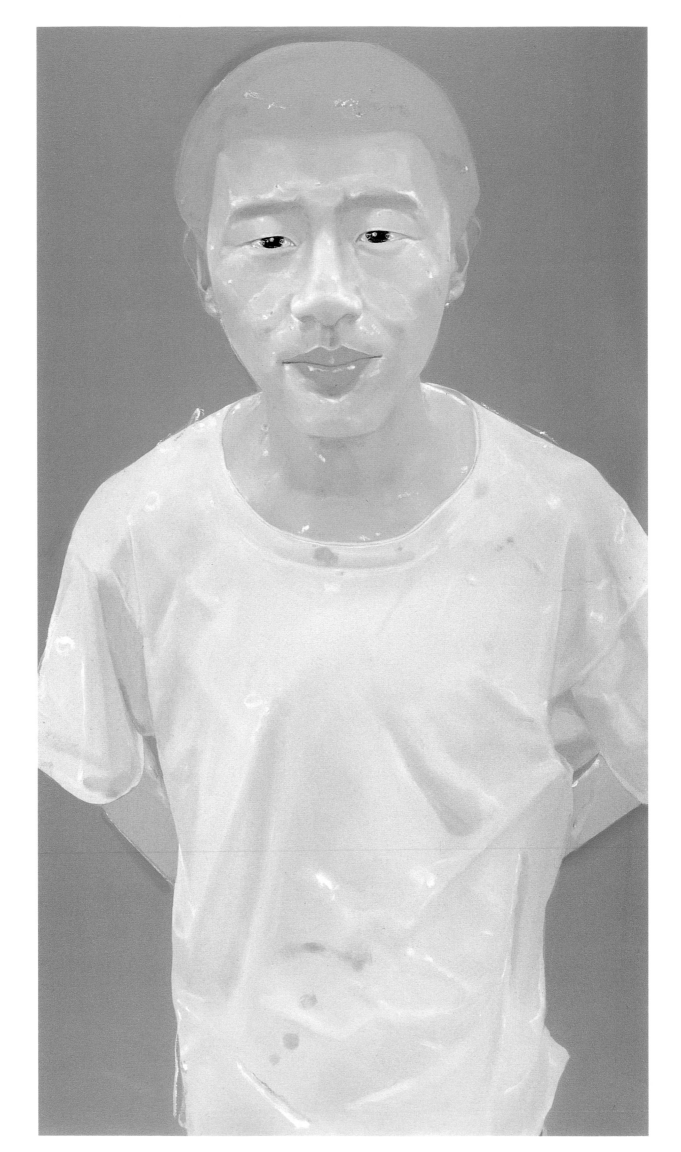

Opposite page:
Fig. 85
Shen Xiao Tong
Images 2002. No. 4
2002
Oil on canvas, 150 x 80 cm

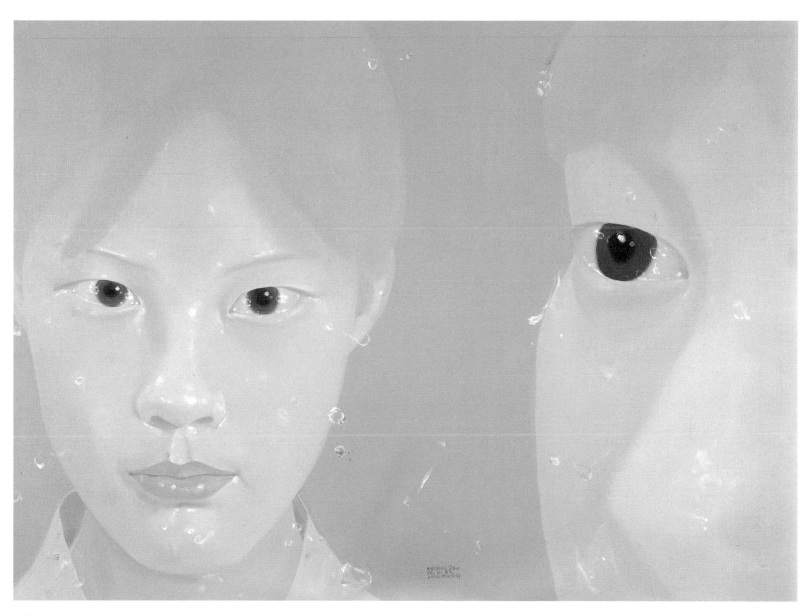

Fig. 86
Shen Xiao Tong
Images 2002. No. 17
2002
Oil on canvas, 110 x 150 cm

Xin Hai Zhou (b.1966)

Fig. 87
Xin Hai Zhou
What's Up? No. 3
2002
Acrylic on canvas, 125 x 200 cm

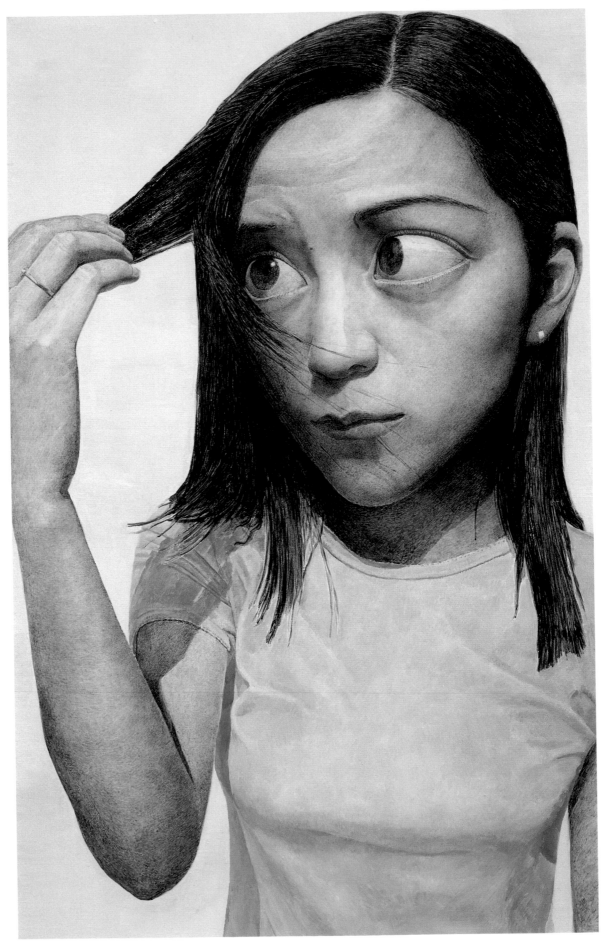

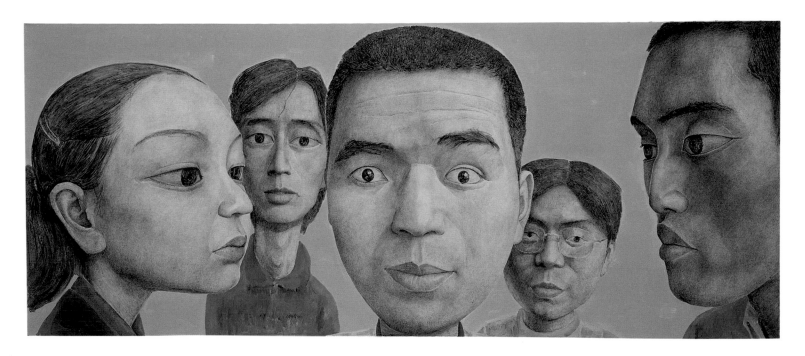

Fig. 88
Xin Hai Zhou
Alter. Youth No. 6
2001
Acrylic on canvas, 125 x 300 cm

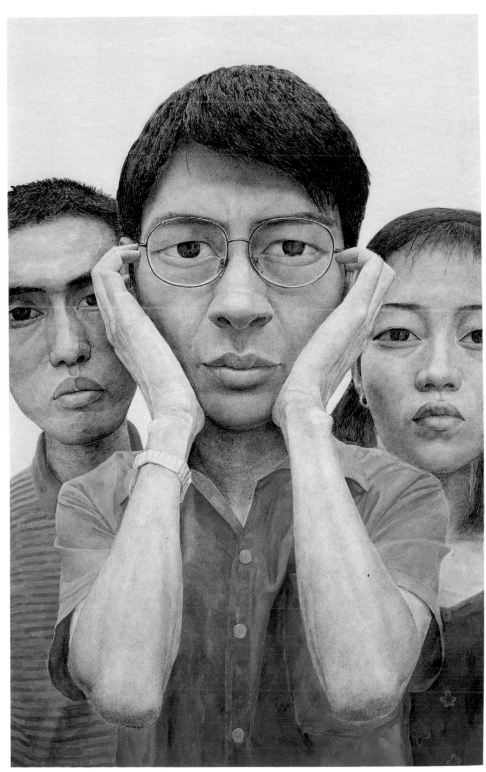

Fig. 89
Xin Hai Zhou
What's up? No. 2
2002
Acrylic on canvas, 125 x 200 cm

Zhao Neng Zhi

Zhao Neng Zhi's
studio

Fig. 90
Zhao Neng Zhi
The Expression Series 2003 No. 15
2003
Oil on canvas, 230 x 180 cm

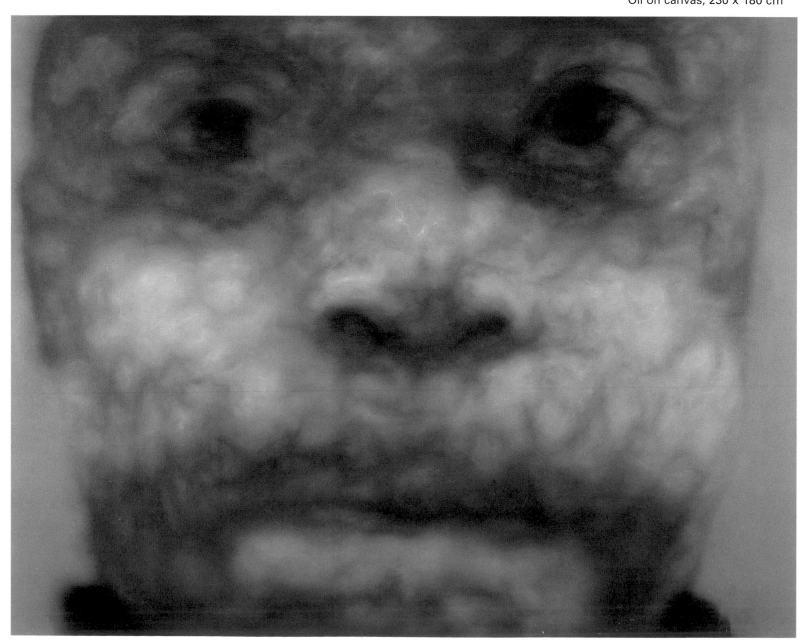

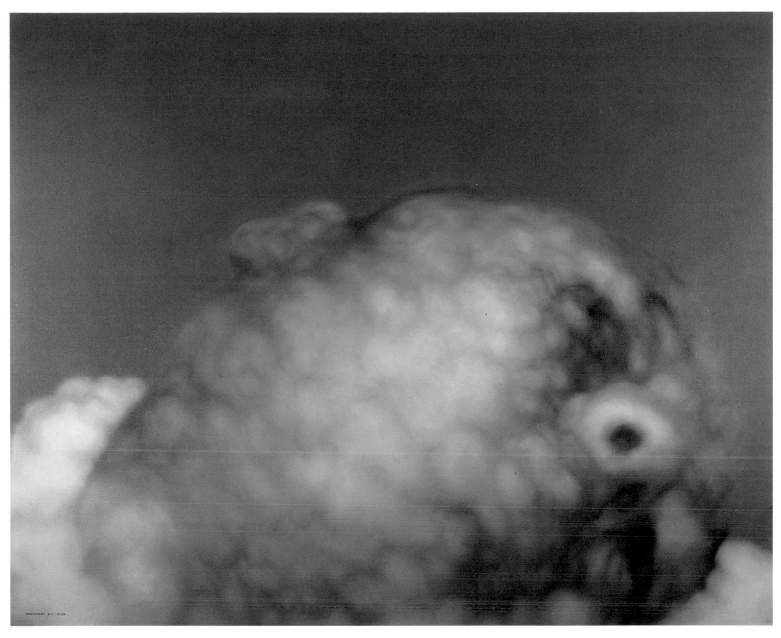

Fig. 91
Zhao Neng Zhi
The Expression Series 2001 No. 2
2001
Oil on canvas, 200 x 250 cm

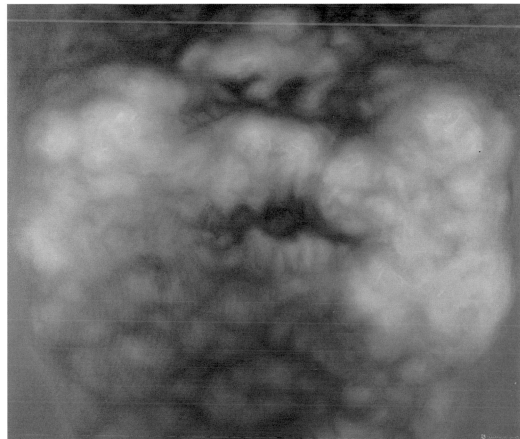

Fig. 92
Zhao Neng Zhi
The Expression Series 2003 No. 10
2003
Oil on canvas, 180 x 230 cm

He Sen

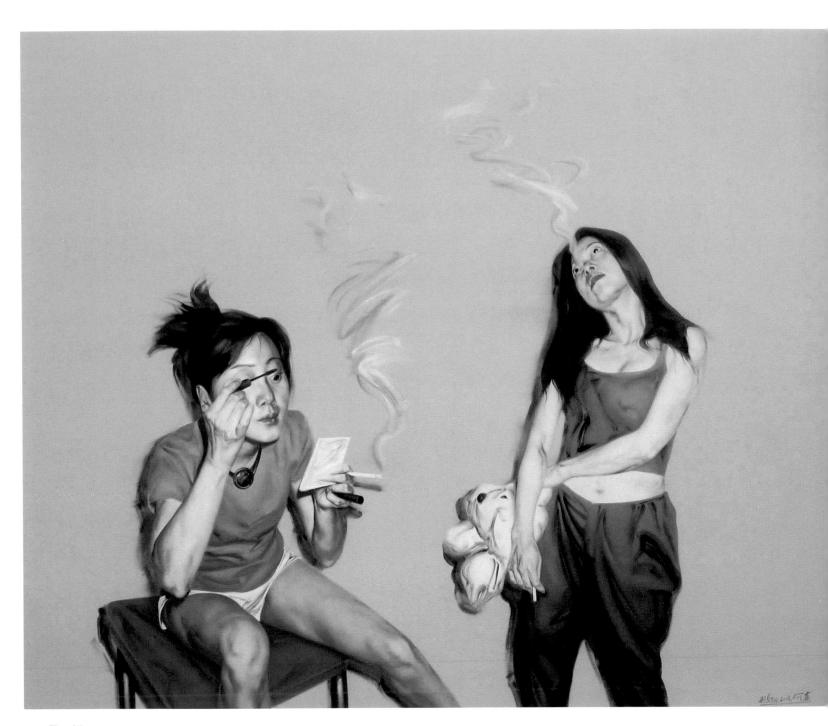

Fig. 93
He Sen
Two Girls No. 1
2003
Oil on canvas, 200 x 250 cm

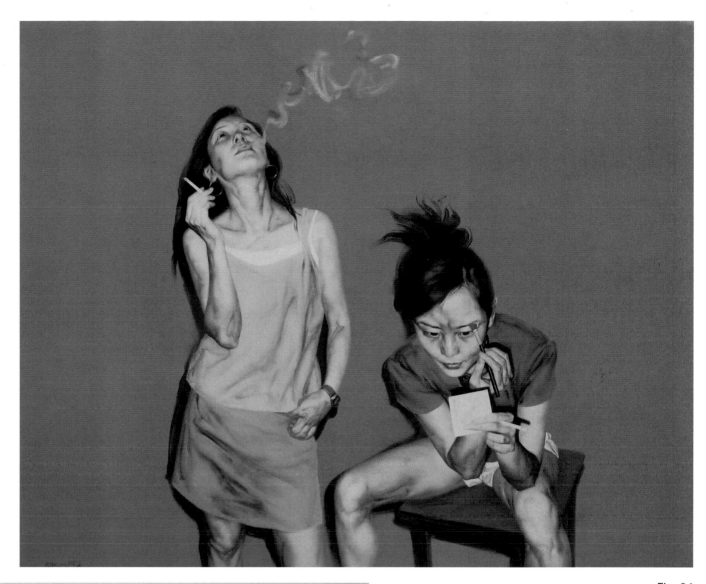

Fig. 94
He Sen
Two Girl No. 3
2003
Oil on canvas, 200 x 250 cm

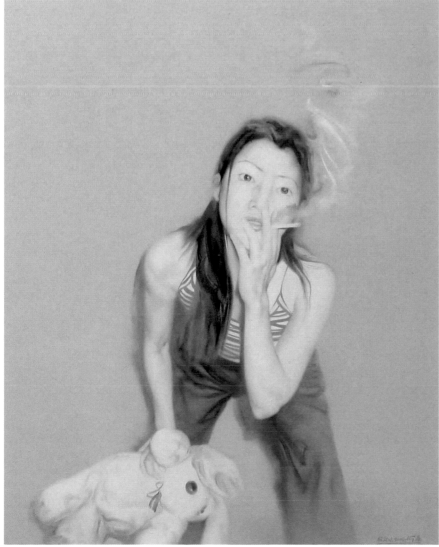

Fig. 95
He Sen
Girl Smoking
2004
Oil on canvas, 80 x 100 cm

Yang Qian (b. 1959)

Opposite page, top:
Fig. 97
Yang Qian
Hotel Bathroom #13
2003
Oil on canvas, 110 x 150 cm

Opposite page, bottom:
Fig. 98
Yang Qian
Hotel Bathroom #27
2004
Oil and digital print on canvas,
150 x 225 cm

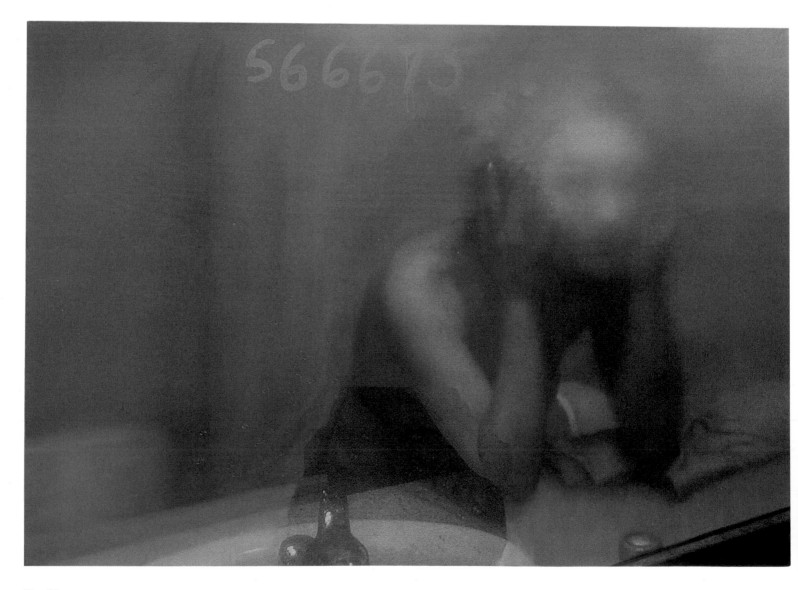

Fig. 96
Yang Qian
Woman with Mask #3
2004
Oil and digital print on canvas, 150 x 200 cm

Li Ji (b.1963)

Fig. 99
Li Ji
Pet 2004 No. 2
2004
Oil on canvas, 200 x 150 cm

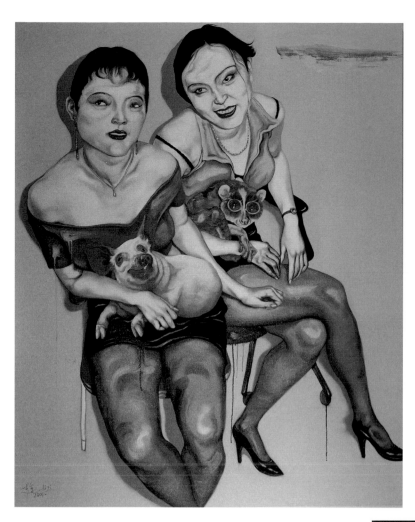

Fig. 100
Li Ji
Girls and Slow Loris
2001
Oil on canvas, 162 x 125 cm

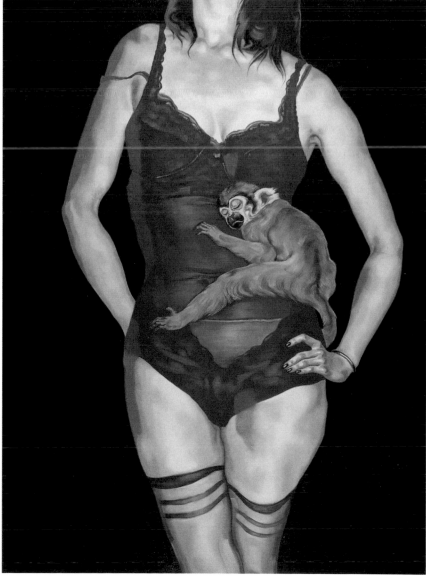

Fig. 101
Li Ji
Pet 2004 No.1
2004
Oil on canvas, 200 x 150 cm

Luo Fa Hui (b.1962)

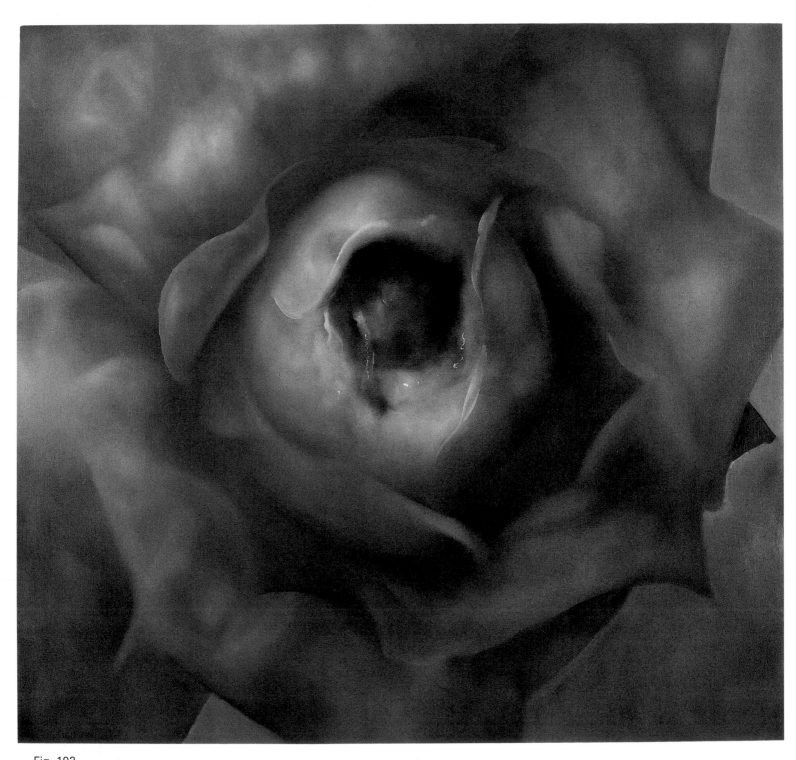

Fig. 102
Luo Fa Hui
Rose 2002 No. 06
2002
Oil on canvas, 160 x 150 cm

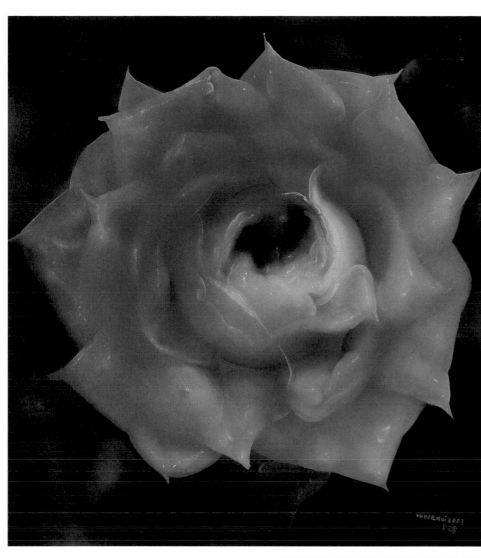

Fig. 103
Luo Fa Hui
Blue Rose
2003
Oil on canvas, 39" x 43"

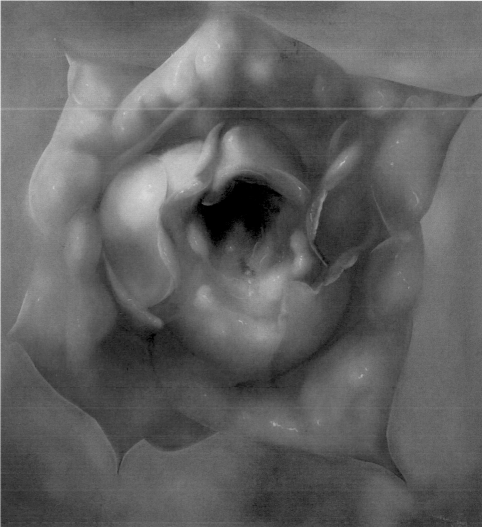

Fig. 104
Luo Fa Hui
Green Rose
2003
Oil on canvas, 39 x 43"

Yang Shu (b.1965)

Yang Shu with
his son

Opposite page, top:
Fig. 106
Yang Shu
Painting 2004 No. 12
2004
Acrylic on canvas, 150 x 110 cm

Opposite page, bottom:
Fig. 107
Yang Shu
Painting 2004 No. 11
2004
Acrylic on canvas, 70 x 90 cm x 4

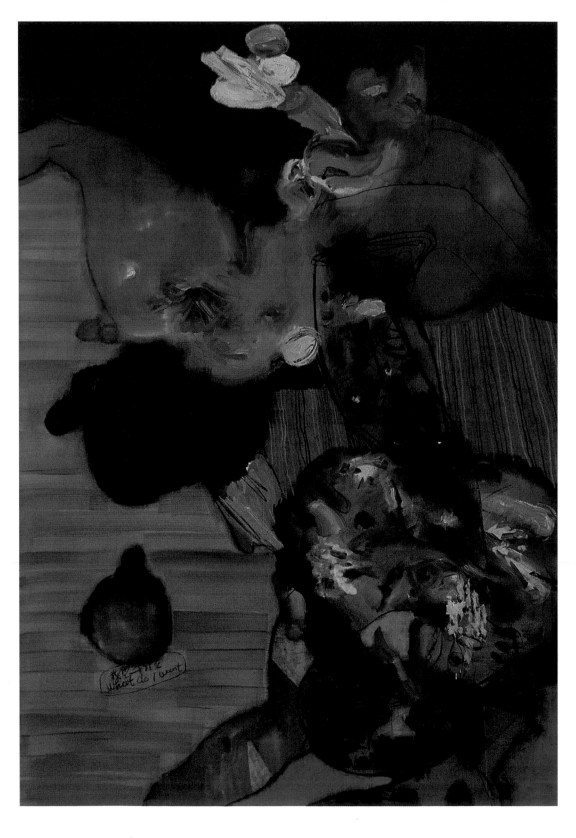

Fig. 105
Yang Shu
Painting 2004 No. 7
2004
Acrylic on canvas, 260 x 180 cm

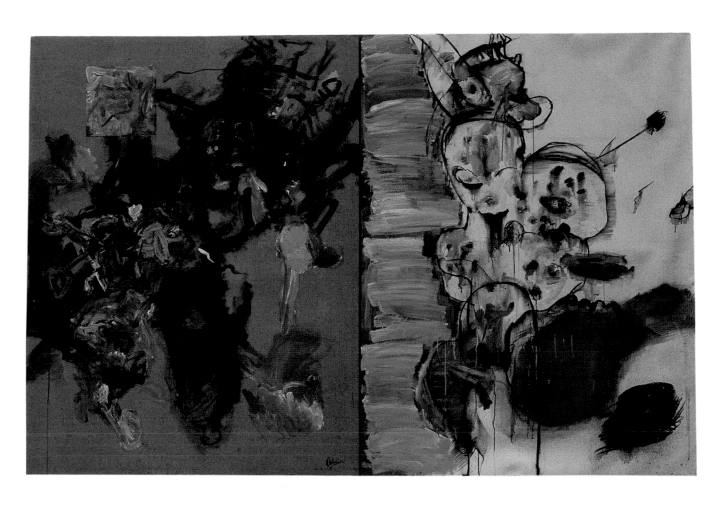

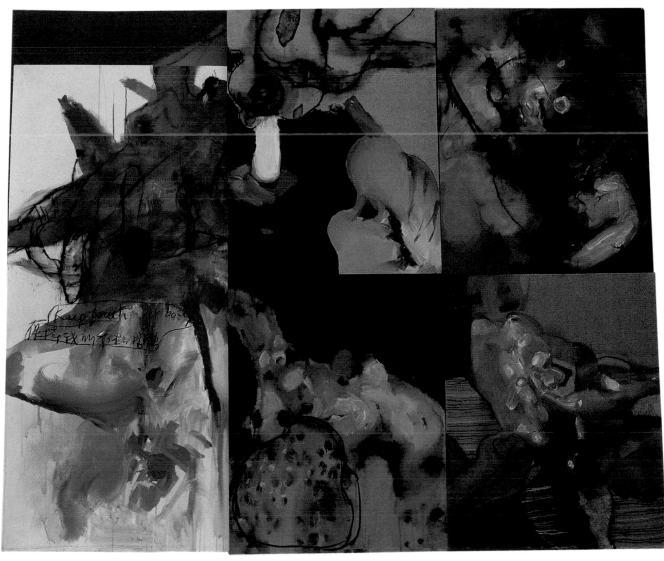

Ren Xiao Lin (b. 1963)

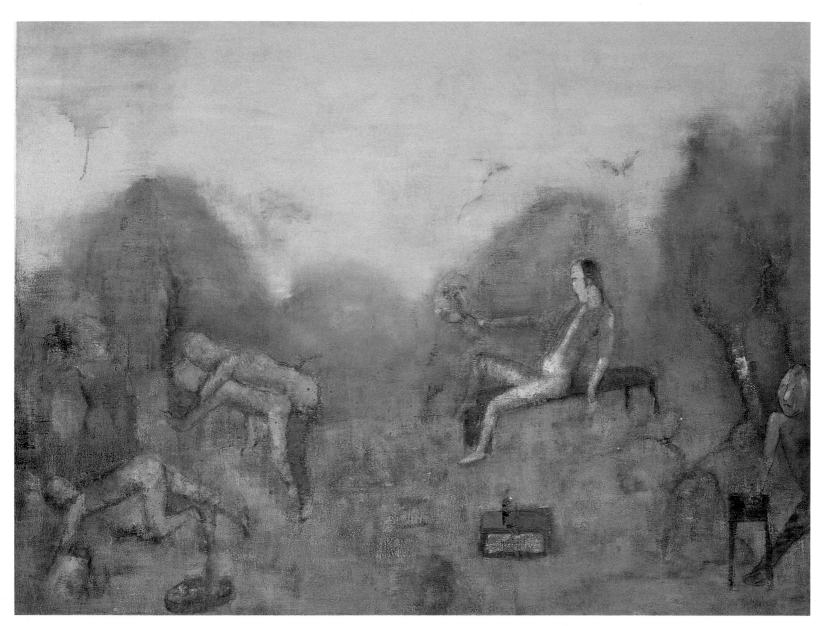

Fig. 108
Ren Xiao Lin
The Land Is the Same as in the Past (2)
2002
Oil on canvas, 200 x 150 cm

Deng Jian Jin (b. 1961)

Fig. 109
Deng Jian Jin
Why the Sunset Makes Us So Beautiful
No. 17
2004
Oil and acrylic on canvas, 260 x 190 cm

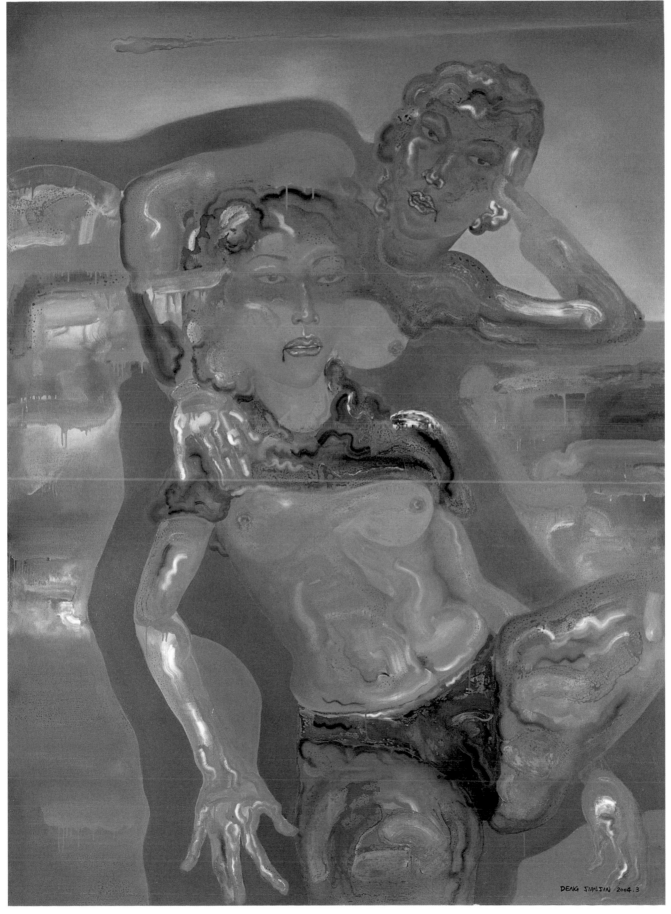

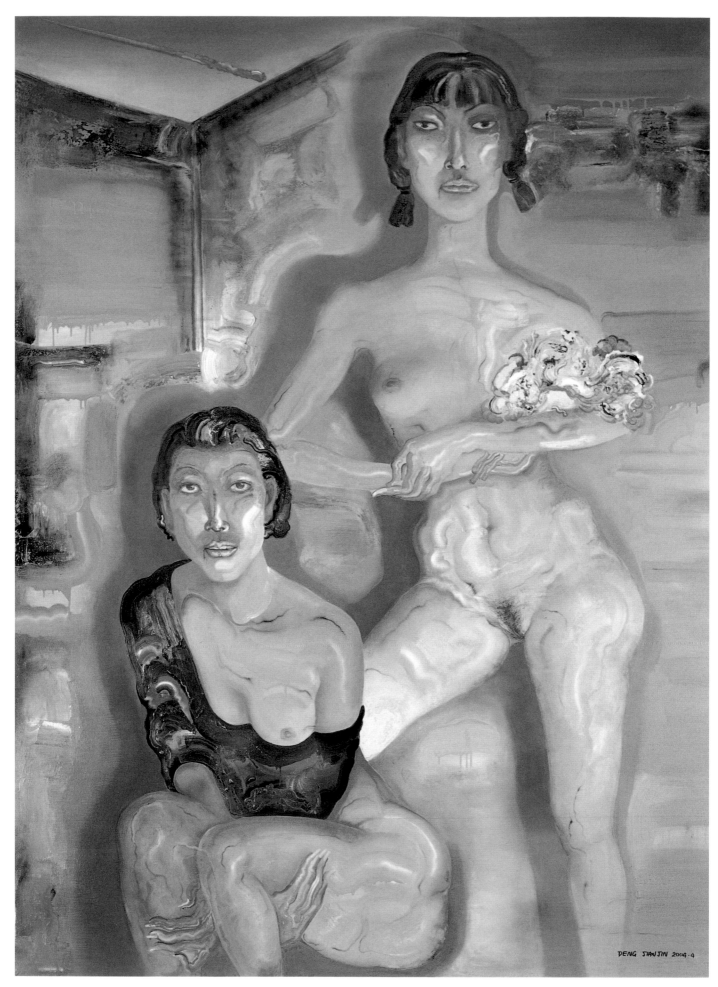

Fig. 110
Deng Jian Jin
Why the Sunset Makes Us So Beautiful No. 19
2004
Oil and acrylic on canvas, 260 x 190 cm

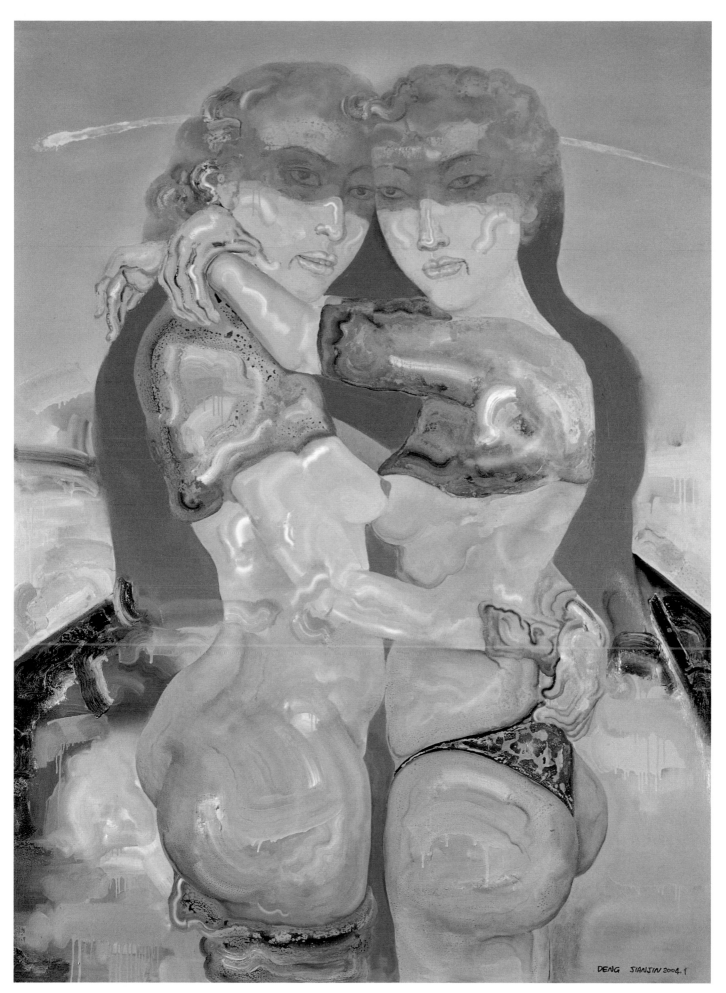

Fig. 111
Deng Jian Jin
Why the Sunset Makes Us So Beautiful No. 18
2004
Oil and acrylic on canvas, 260 x 190 cm

Yang Shao Bin (b. 1963)

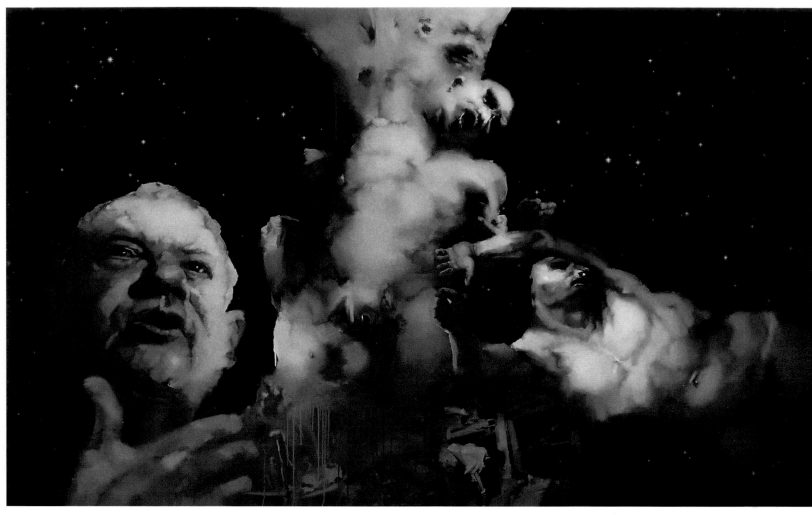

Fig. 112
Yang Shao Bin
Trinity
2004
Oil on canvas, 210 x 350 cm

Fig. 113
Yang Shao Bin
Who Are Screaming
2004
Oil on canvas, 210 x 250 cm

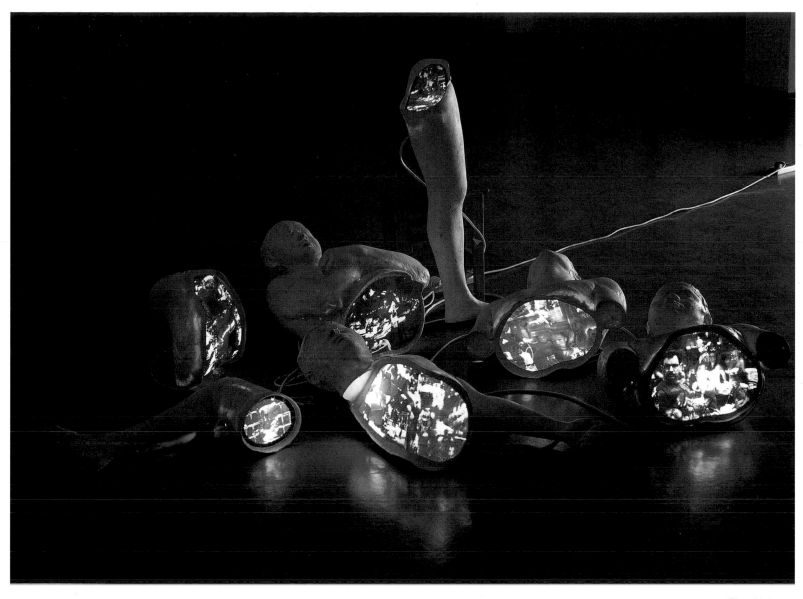

Fig. 114
Yang Shao Bin
Seven Parts of the Body
2004
Sculpture

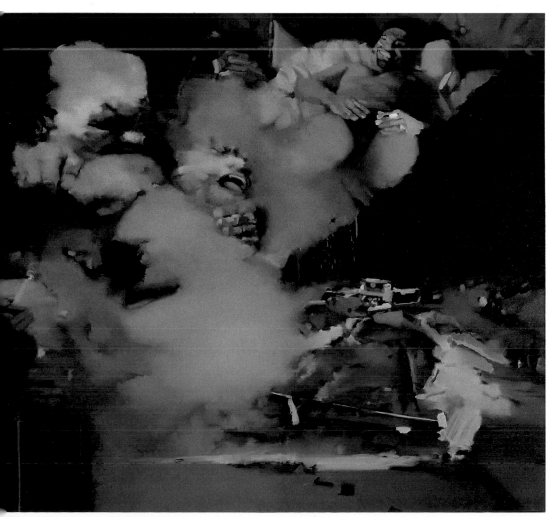

Song Yong Ping (b.1961)

Fig. 115
Song Yong Ping
My Parents
1998-2000
Photograph

Fig. 116
Song Yong Ping
My Parents
1998-2000
Photograph

Fig. 117
Song Yong Ping
My Parents
1998- 2000
Photograph

Shen Ling

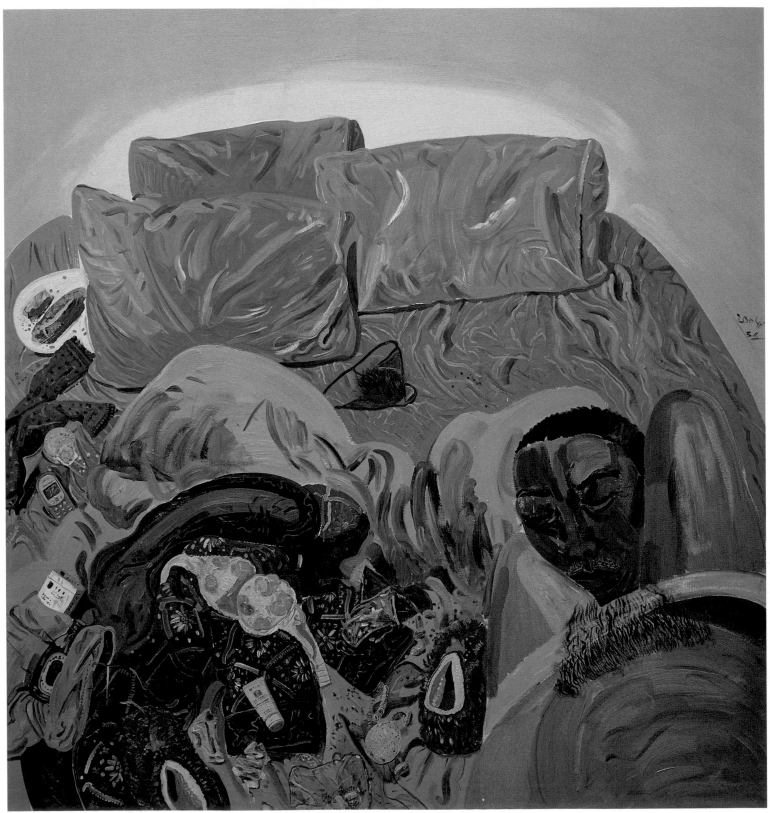

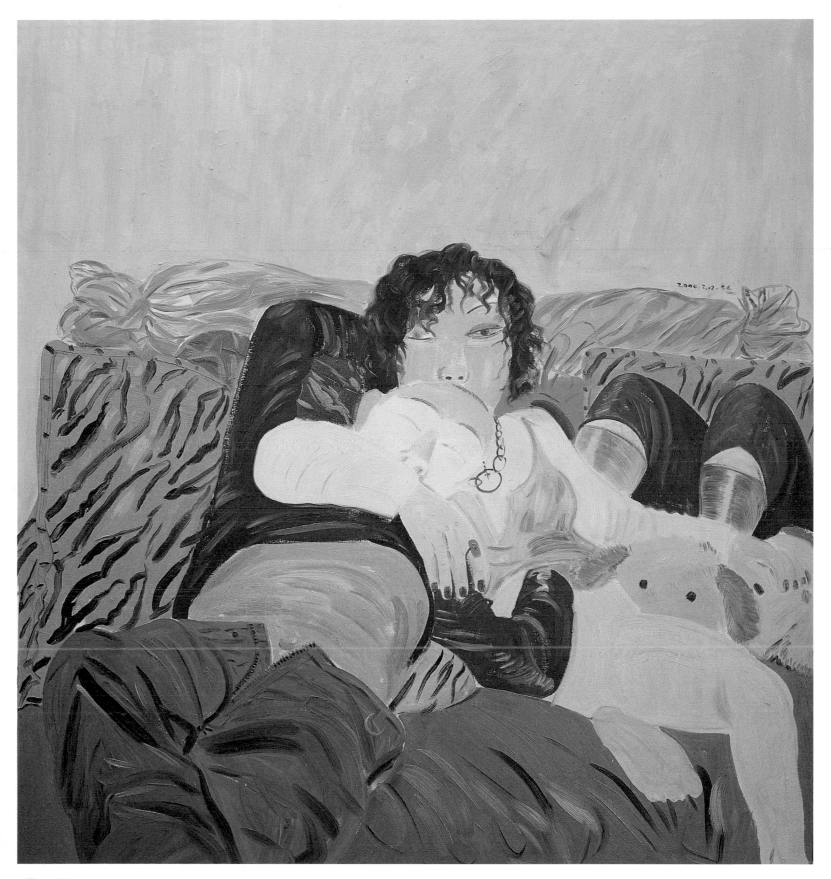

Fig. 119
Shen Ling
Have A Hug in the Spring Time
2004
Oil on canvas, 170 x 180 cm

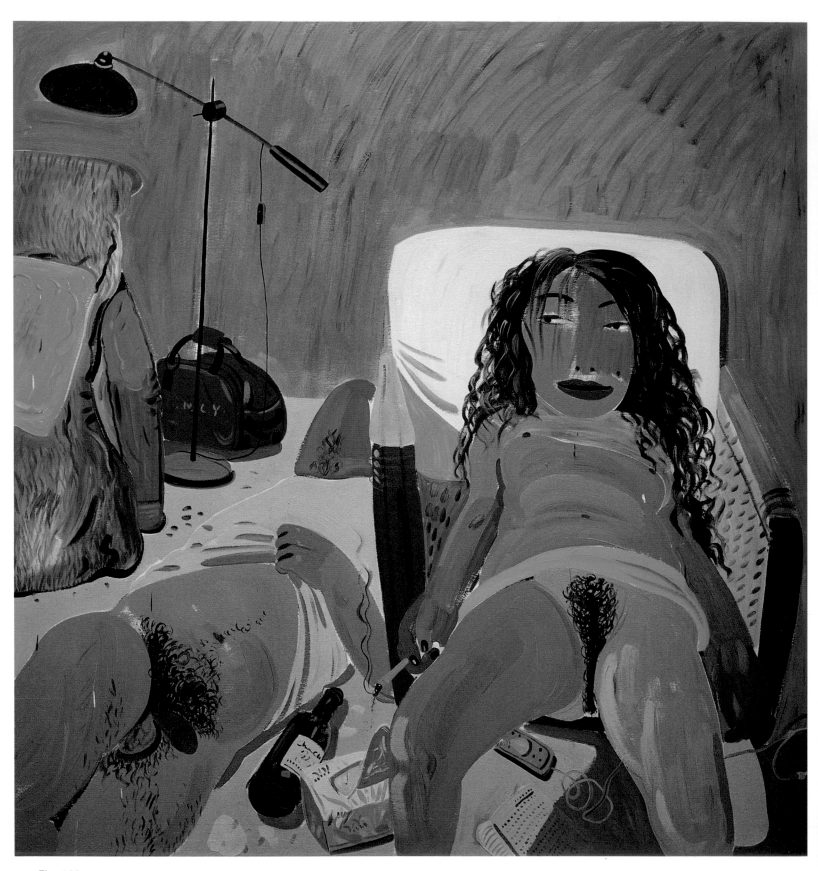

Fig. 120
Shen Ling
Purple
2003
Oil on canvas, 170 x 180 cm

Cai Jin (b.1965)

Fig. 121
Cai Jin
Banana Plants No. 207
2003
Oil on canvas, 152 x 142 cm

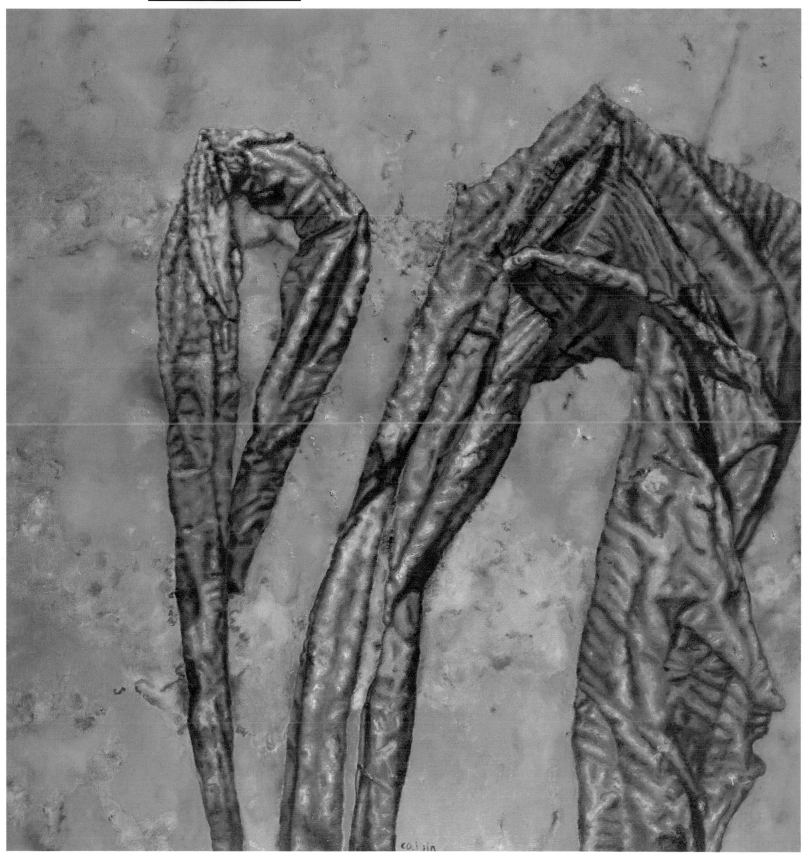

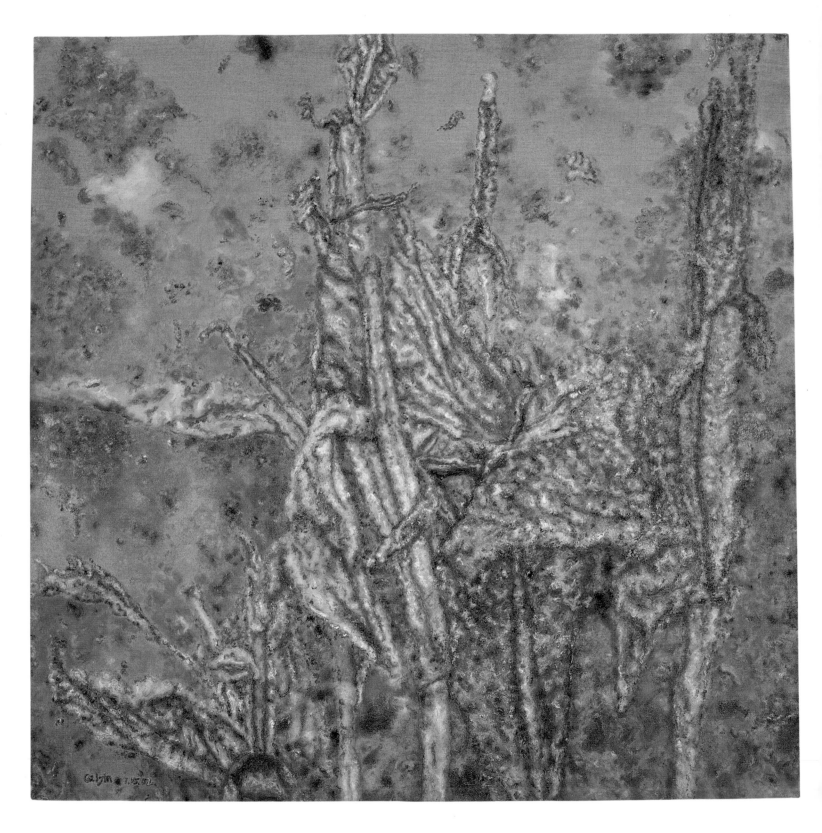

Fig. 122
Cai Jin
Banana Plants No. 175
2002
Oil on canvas, 150 x 150 cm

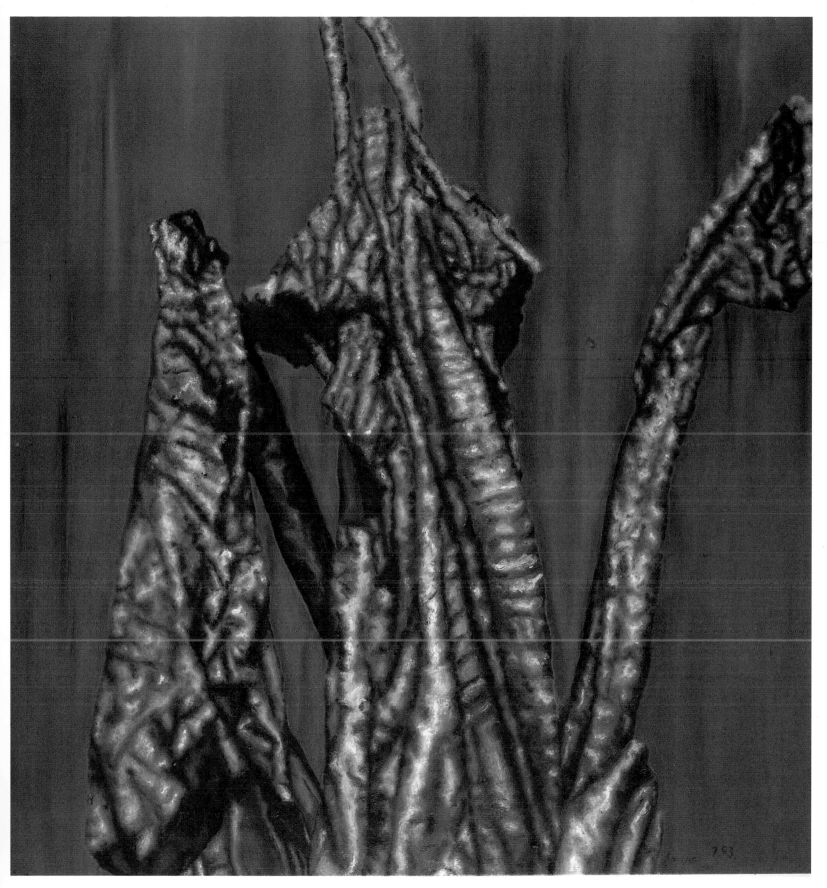

Fig. 123
Cai Jin
Banana Plants No. 208
2003
Oil on canvas, 152 x 142 cm

Yu Hong (b. 1966)

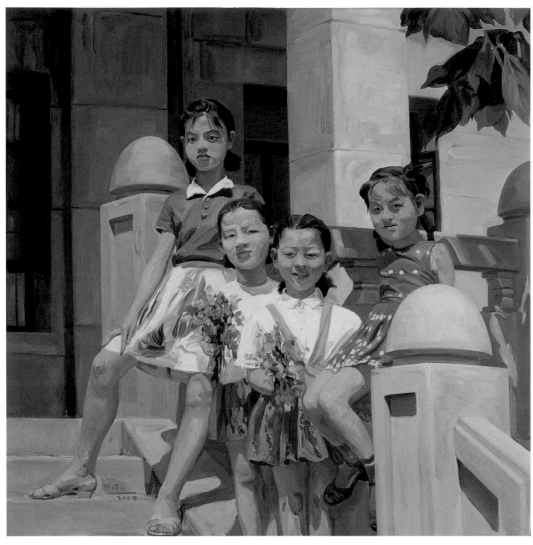

Fig. 124
Yu Hong
Witness to Growth: 1977, Yu Hong was 11 years old
Acrylic on canvas, 100 x 100 cm

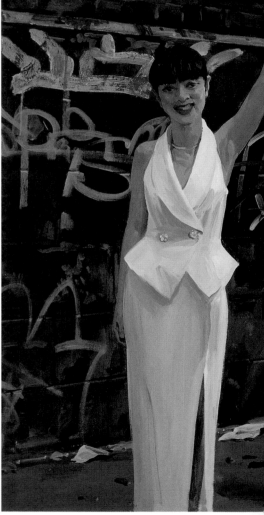

Fig. 125
Yu Hong
Witness to Growth: 1993, Yu Hong was 27 years old
Acrylic on canvas, 100 x 100 cm

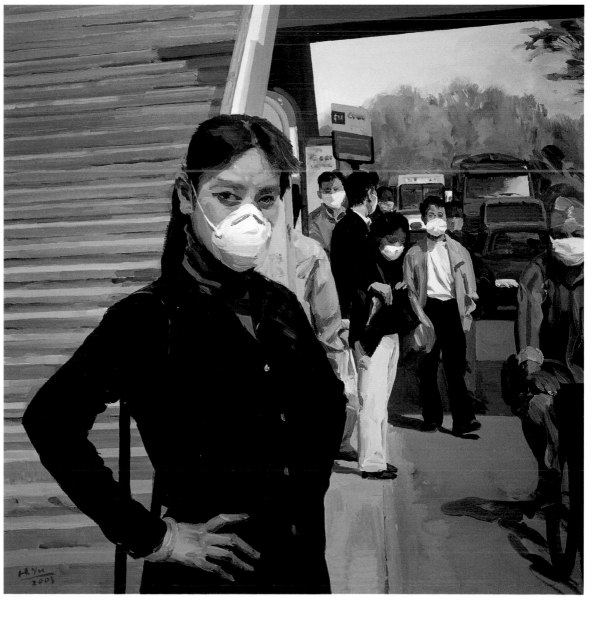

Fig. 126
Yu Hong
Witness to Growth: 2003, Yu Hong
was 37 years old
Acrylic on canvas, 100 x 100 cm

Pan Ying (b.1962)

Fig. 127
Pan Ying
Fabrication No. 51
1997
Ink on rice paper, 174 x 90 cm

Fig. 128
Pan Ying
Fabrication No. 53
1997
Ink on rice paper, 174 x 90 cm

Fig. 129
Pan Ying
Fabrication No.54
1997
Ink on rice paper, 174 x 90 cm

Liao Hai Ying

Fig. 130
Liao Hai Ying
A Snap Shot in front of Tiananmen
1997
Oil on canvas, 130 x 103 cm

Fig. 131
Liao Hai Ying
Emotional Tie
1995
Glass fiber and hair, 85 x 55 cm

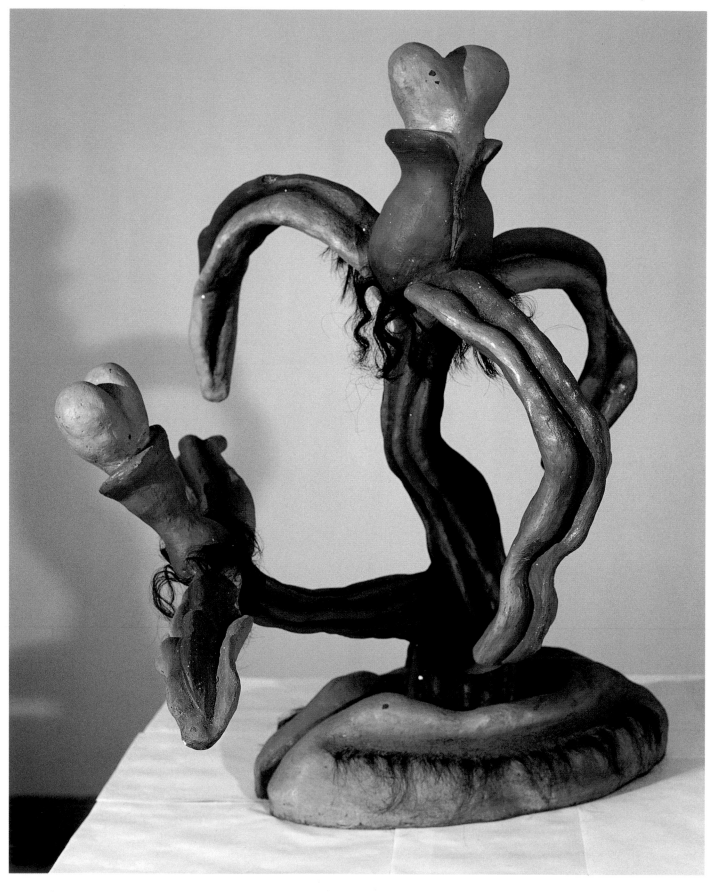

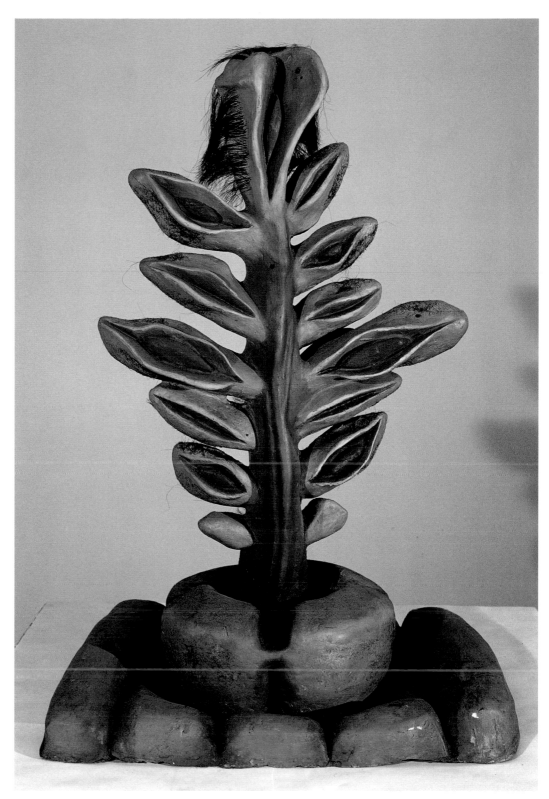

Fig. 132
Liao Hai Ying
The Bride
1995
Glass fiber and hair, 85 x 50 cm

Fig. 133
Liao Hai Ying
Young Ladies
2003
Glass fiber, 230 x 80 cm

125

Feng Jia Li

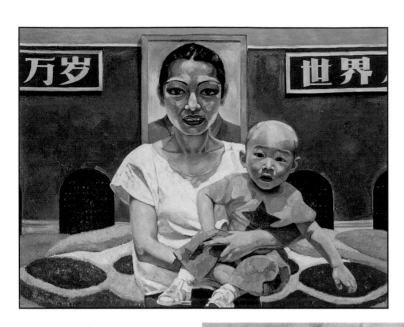

Fig. 134
Feng Jia Li (self-portrait)

Opposite page, top:
Fig. 136
Feng Jia Li
*The Flower Patterned Com-
forter with Golden Pheasant*
Design
1997
Oil on canvas, 130 x 103 cm

Opposite page, bottom:
Fig. 137
Feng Jia Li
*The Girl-friend Wearing Curly
Pins*
1997
Oil on canvas, 130 x 103 cm

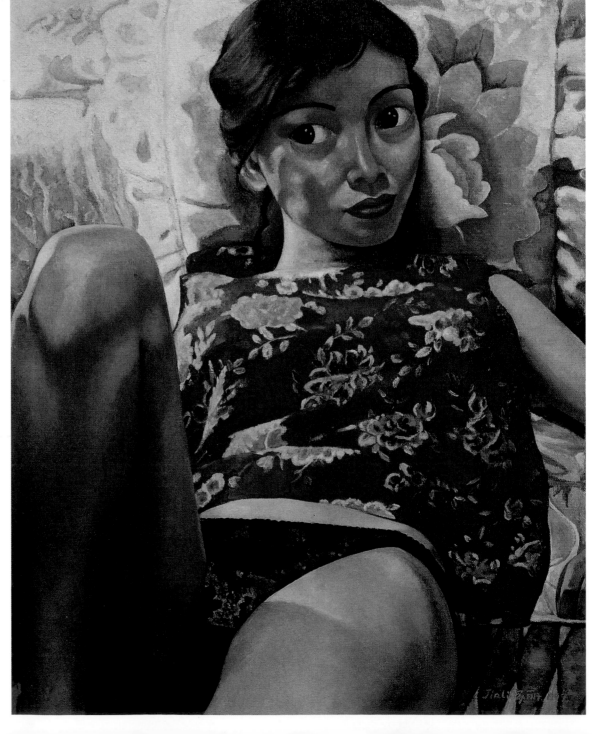

Fig. 135
Feng Jia Li
The Flower Patterned Pillow
1997
Oil on canvas, 72 x 60 cm

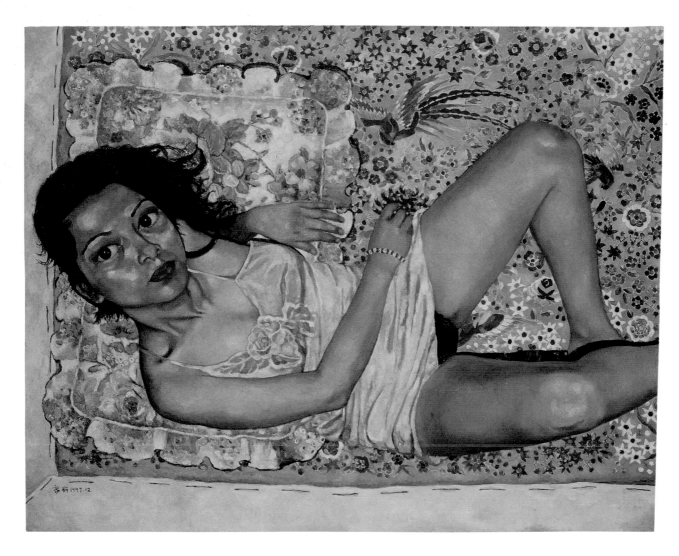

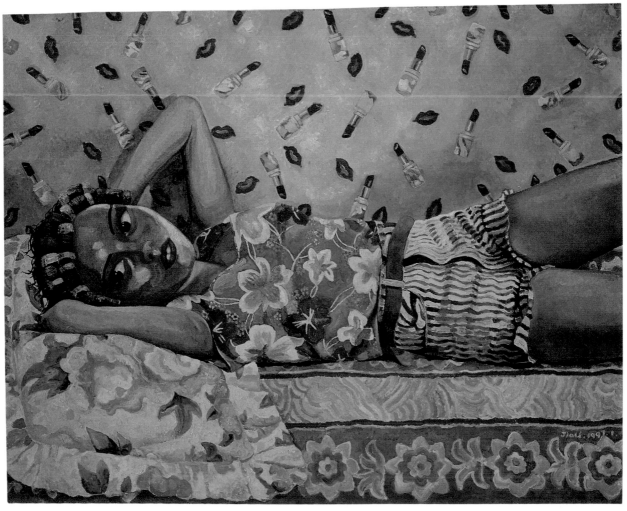

Liu Hong (b.1956)

Fig. 139
Liu Hong
Murmurs to Self No. 2
Oil on canvas, 76 x 76 cm

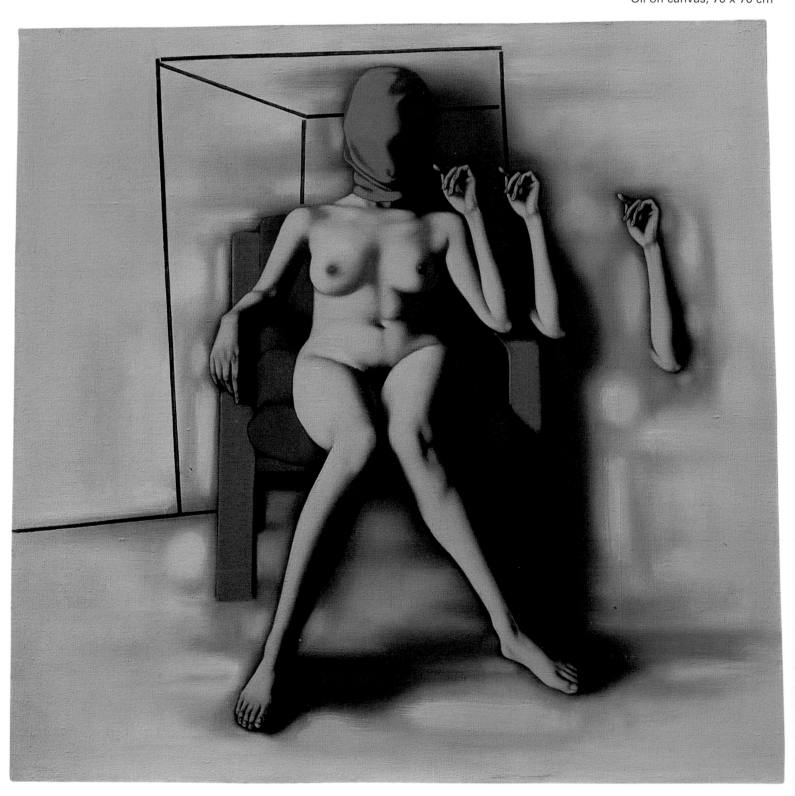

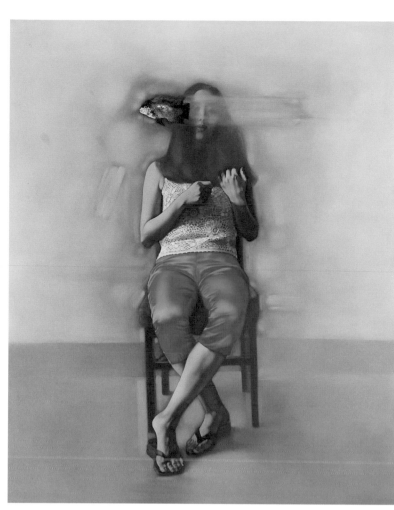

Fig. 140
Liu Hong
Can't Recall No. 1
Oil on canvas, 182 x 150 cm

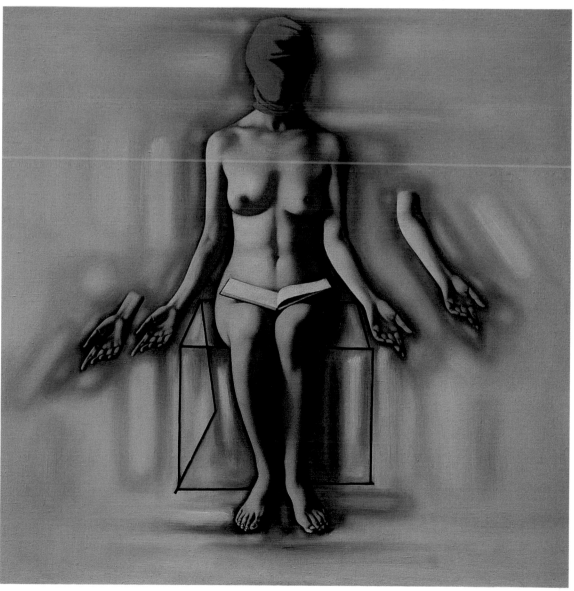

Fig. 141
Liu Hong
Murmurs to Self No. 1
Oil on canvas, 76 x 76 cm

Guo Wei

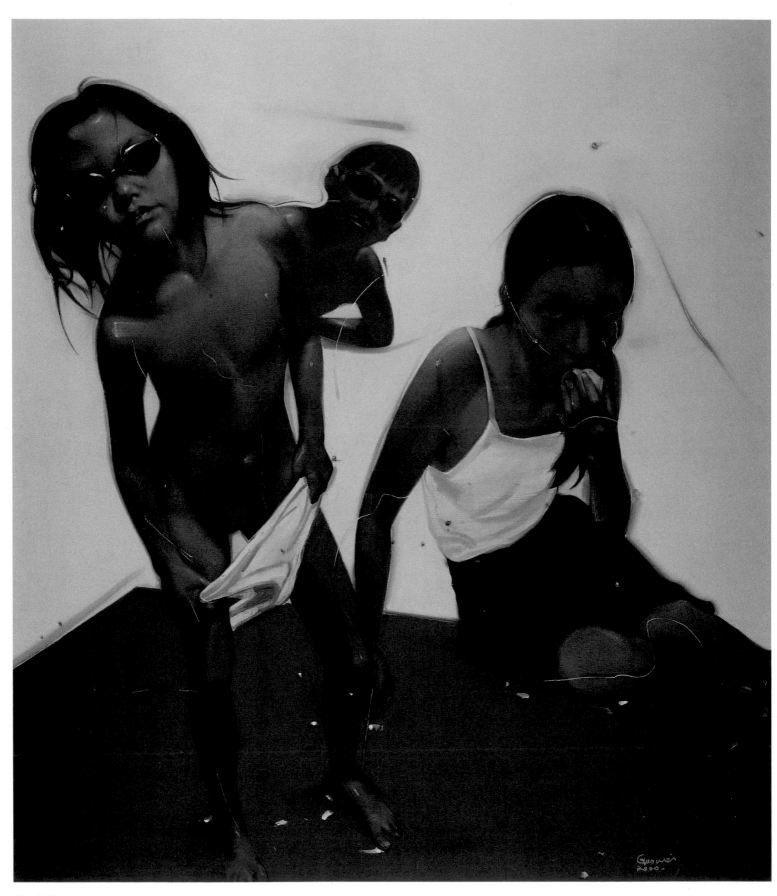

Fig. 142
Guo Wei
The Nameless Drama No. 10
2000
Acrylic on canvas, 200 x 180 cm

130

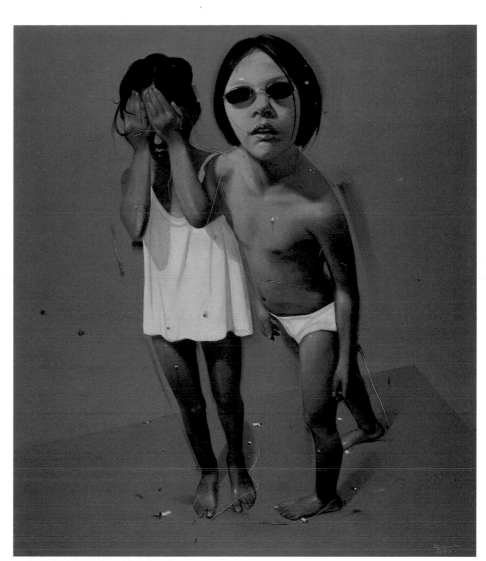

Fig. 143
Guo Wei
The Nameless Drama No. 6
2000
Acrylic on canvas, 200 x 180 cm

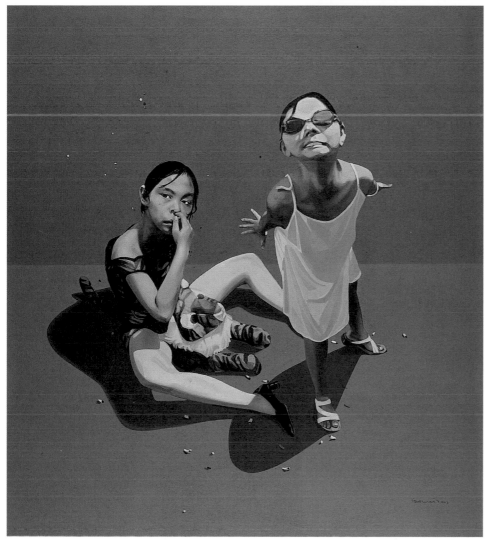

Fig. 144
Guo Wei
The Nameless Drama No. 11
2000
Acrylic on canvas, 200 x 180 cm

Guo Jin (b.1964)

Fig. 145
Guo Jin
Children Play No. 8
2002
Oil on canvas, 145 x 115 cm

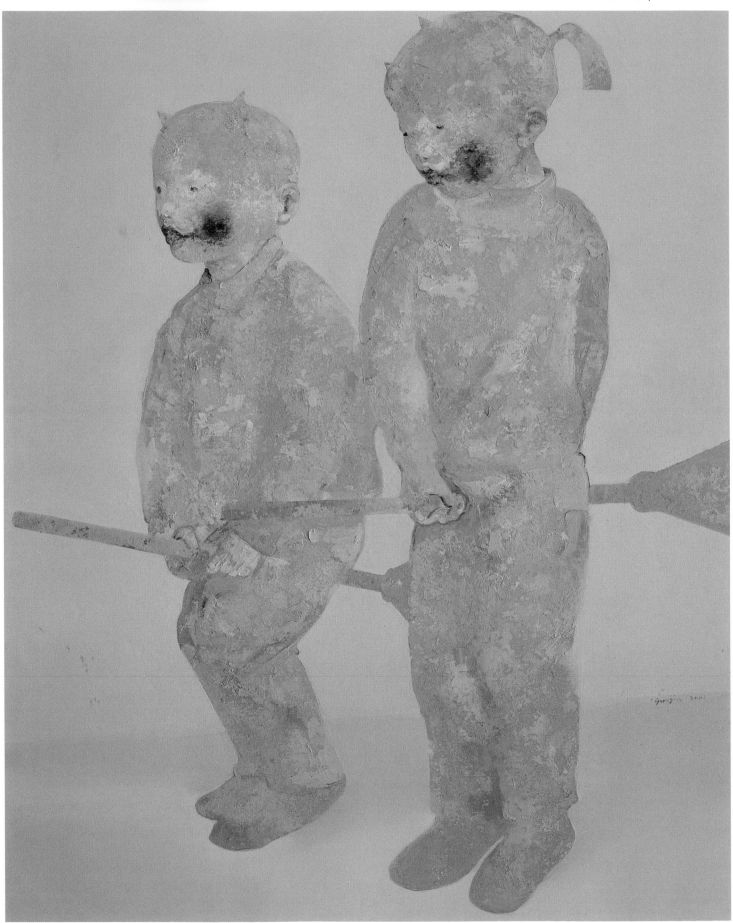

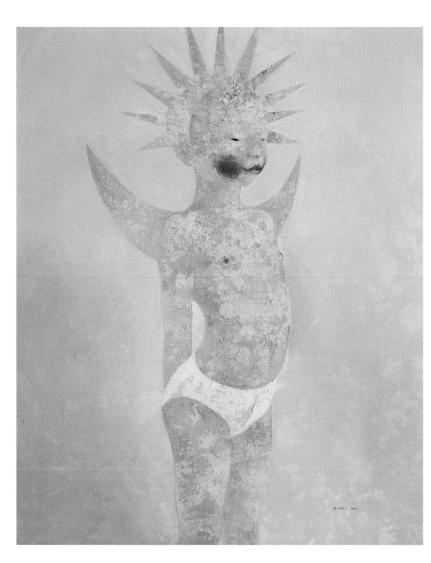

Fig. 146
Guo Jin
Child Portrait No. 6
2002
Oil on canvas, 145 x 115 cm

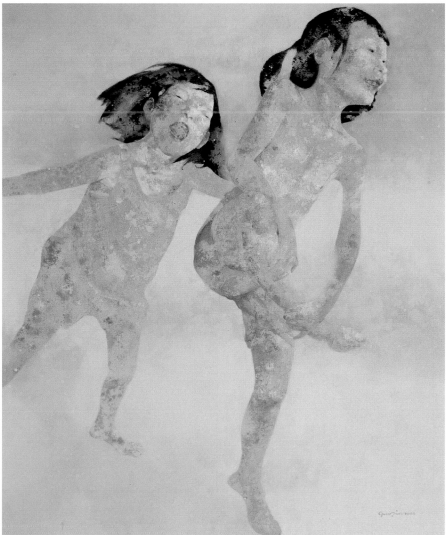

Fig. 147
Guo Jin
Frolic
2003
Oil on canvas, 180 x 150 cm

Tang Zhi Gang

Fig. 148
Tang Zhi Gang
Children's Meeting Series No. 2
2003
Oil on canvas, 163 x 130 cm

Opposite page, top:
Fig. 149
Tang Zhi Gang
Children's Meeting Series No. 1
1999
Oil on canvas, 162 x 130 cm

Opposite page, bottom:
Fig. 150
Tang Zhi Gang
Children's Meeting Series No. 3
2003
Oil on canvas, 162 x 130 cm

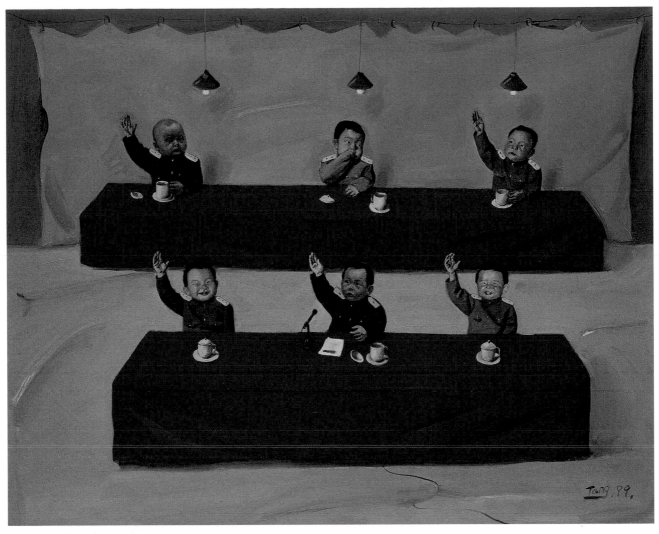

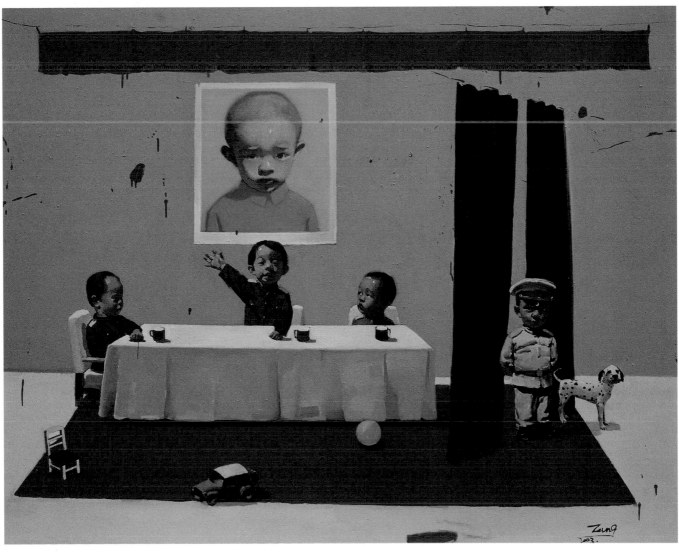

Liu Yie (b.1964)

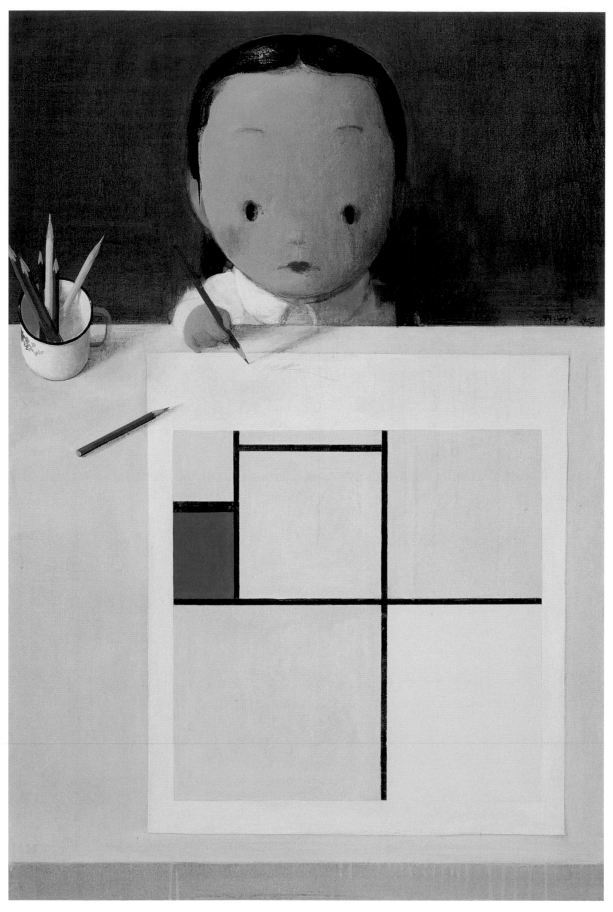

Fig. 151
Liu Yie
She and Mondrian
2003
Acrylic on canvas, 120 x 80 cm

Fig. 152
Liu Yie
Taking off
2003
Acrylic on canvas, 30 x 20 cm

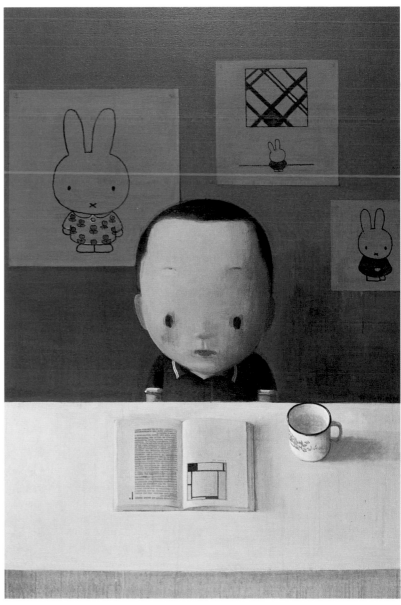

Fig. 153
Liu Yie
Mondrian, Dick Bruna, and I
2003
Acrylic on canvas, 120 x 80 cm

Huang Yi Han (b. 1958)

Fig. 154
Huang Yi Han
Uncle McDonald's Coming to Town!
1997
Installation

Fig. 155
Huang Yi Han
We Are the Kids Who Never Grow up
1995
Statues of children and flying saucers

Xiang Ding Dang (b. 1973)

Fig. 156
Xiang Ding Dang
From Human to Monster and from Monster back to Human
1999
Installation/performance/photography/recording
Materials: video game player, youngsters on the street,
masks

Fig. 157
Xiang Ding Dang
Unique Cartoon
2002
Installation: cartoon statue made of glass fiber reinforced
plastic, model

Jiang Hai (b.1961)

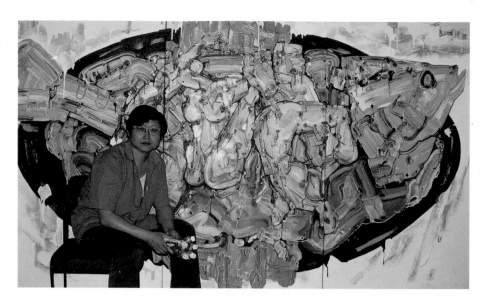

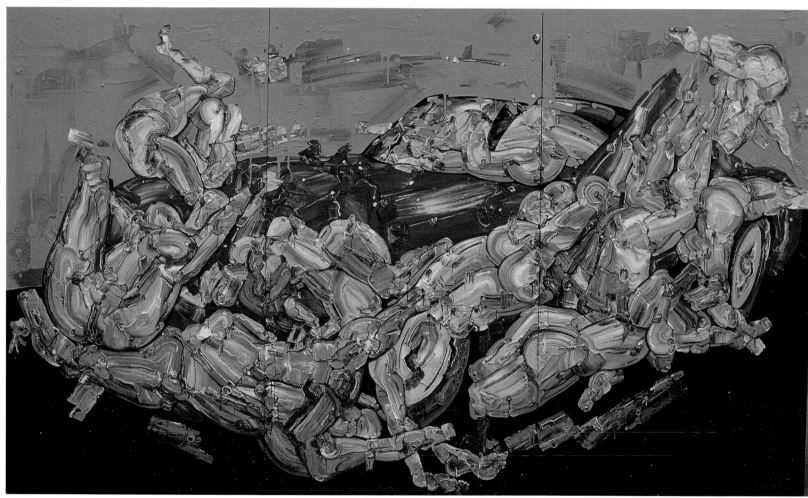

Fig. 158
Jiang Hai
Play. Ballet (2)
2002
Oil on canvas, 300 x 100 cm

Opposite page, top:
Fig. 159
Jiang Hai
The Word with Human - "Zhong"
2004
Oil on canvas, 130 x 115 cm

Opposite page, bottom:
Fig. 160
Jiang Hai
Play. Barbecue (1)
2004
Oil on canvas, 300 x 180 cm

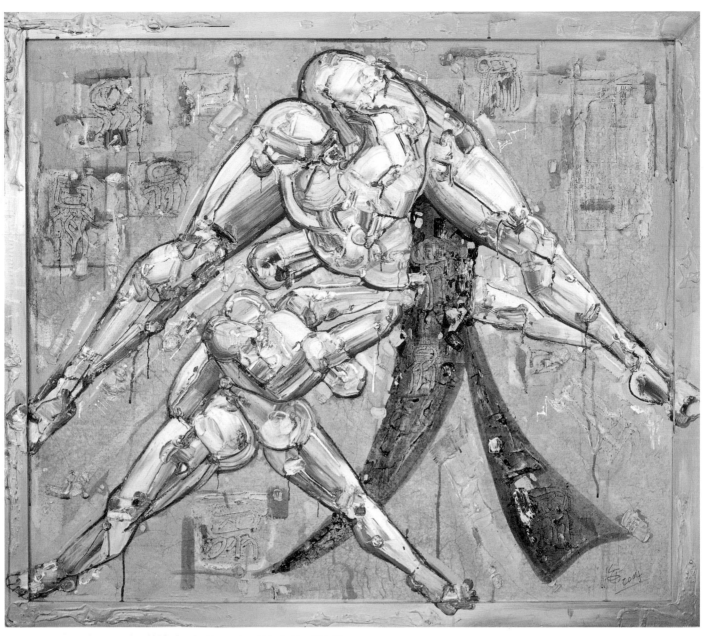

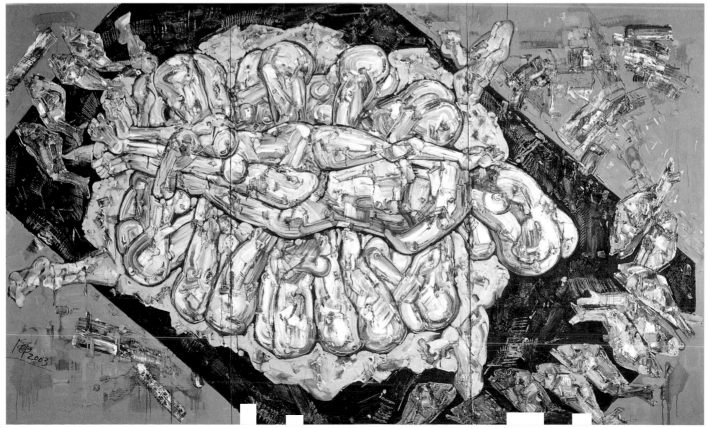

Lin Chun Yan (b.1962)

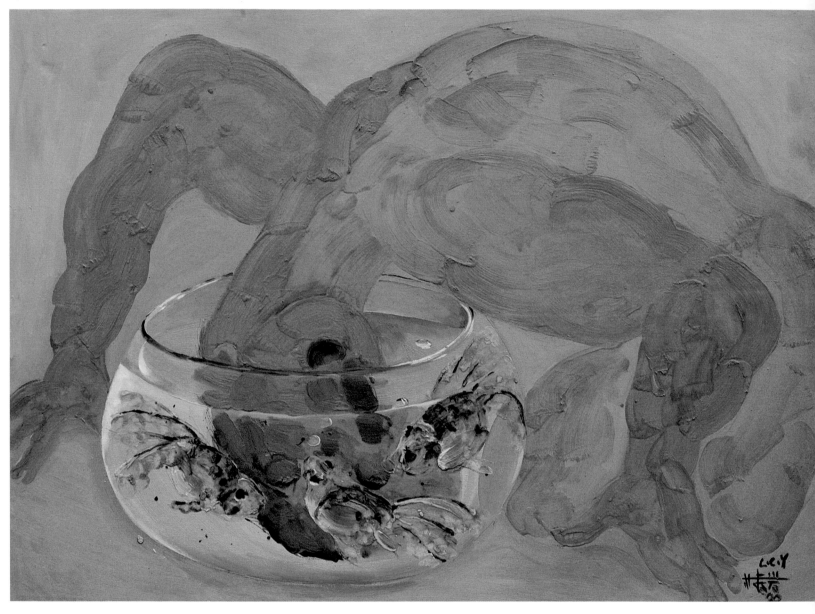

Fig. 161
Lin Chun Yan
Invader
1999
Oil on linen, 63" x 47"

Opposite page, top:
Fig. 162
Lin Chun Yan
Garlic
2000
Oil on linen, 74" x 63"

Opposite page, bottom:
Fig. 163
Lin Chun Yan
Turnip
2000
Oil on linen, 74" x 63"

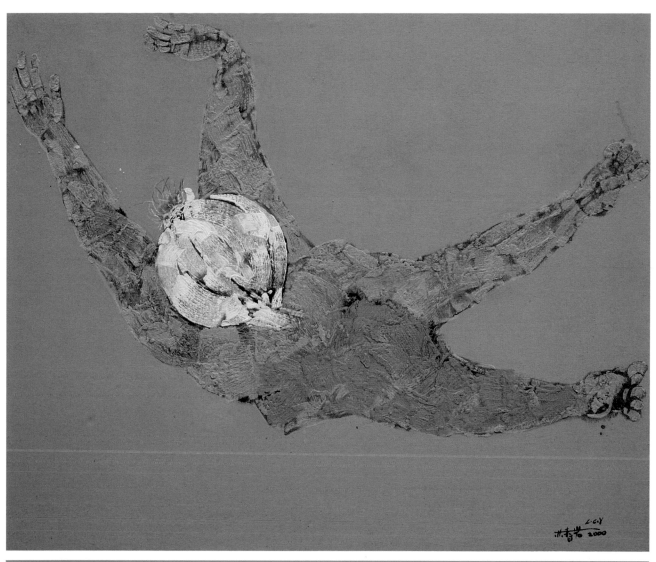

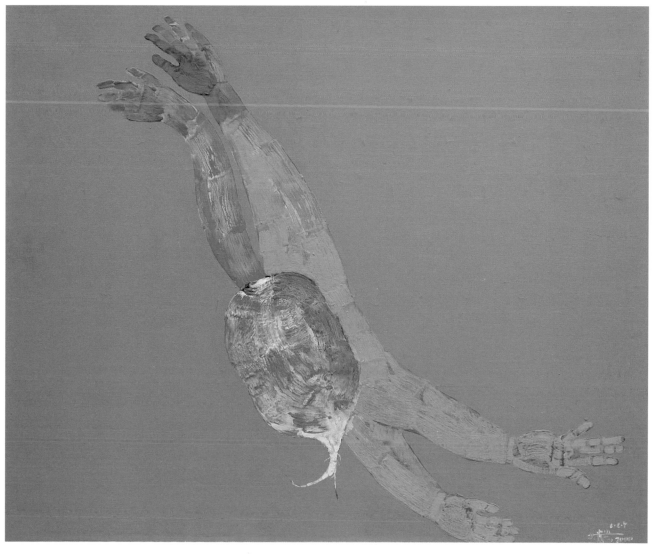

Bao Le De (b. 1959)

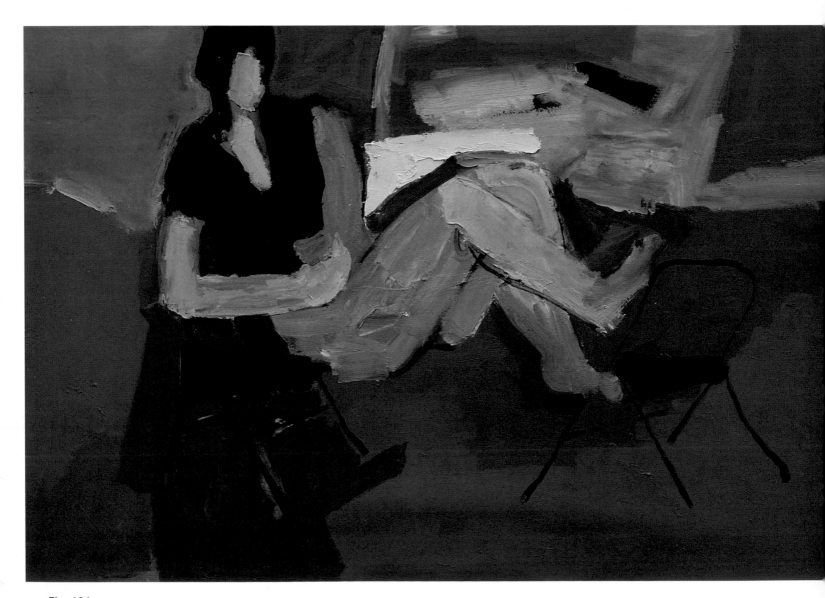

Fig. 164
Bao Le De
Green Tea
2003
Oil on canvas, 48" x 70"

Fig. 165
Bao Le De
Dancer No. 1
2003
Oil on canvas, 30" x 57"

Fig. 166
Bao Le De
Walker No. 1
2003
Oil on canvas, 39" x 48"

Zhou Chun Ya

Fig. 167
Zhou Chun Ya
Green Dog Series No. 2
2001
Oil on canvas, 250 x 200 cm

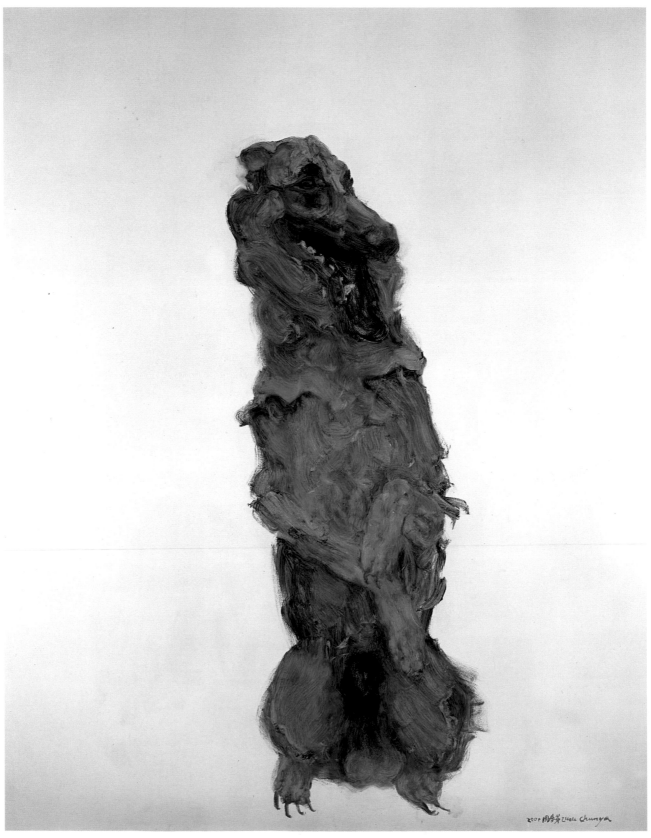

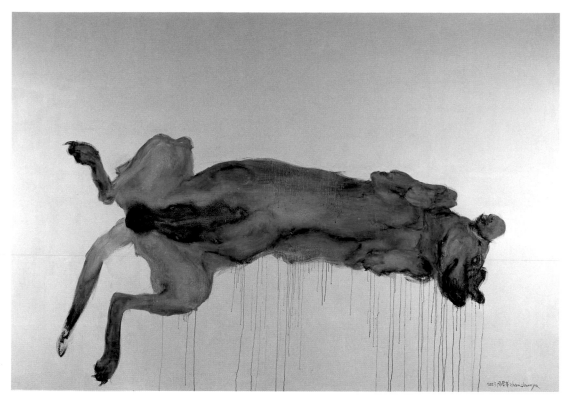

Fig. 168
Zhou Chun Ya
Green Dog Series No. 23
2003
Oil on canvas, 220 x 320 cm

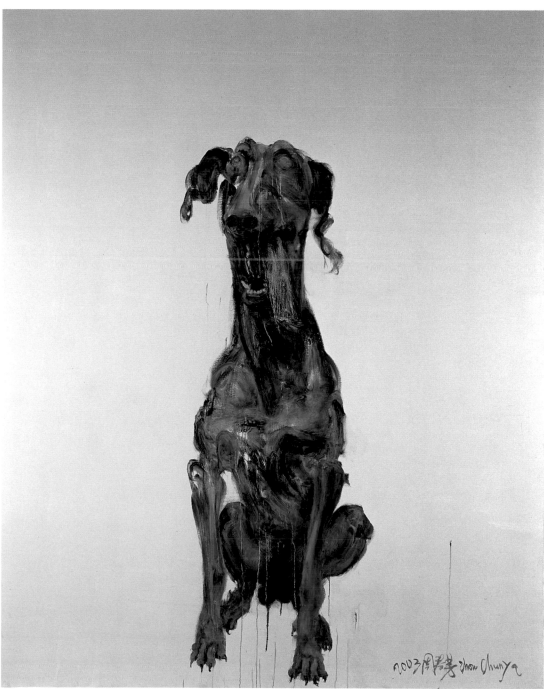

Fig. 169
Zhou Chun Ya
Green Dog Series No. 27
Oil on canvas, 250 x 200 cm

Jia Di Fei (b.1957)

Fig. 170
Jia Di Fei
Zebra Lines across the Street
2001
Oil on canvas, 200 x 200 cm
200 AAA

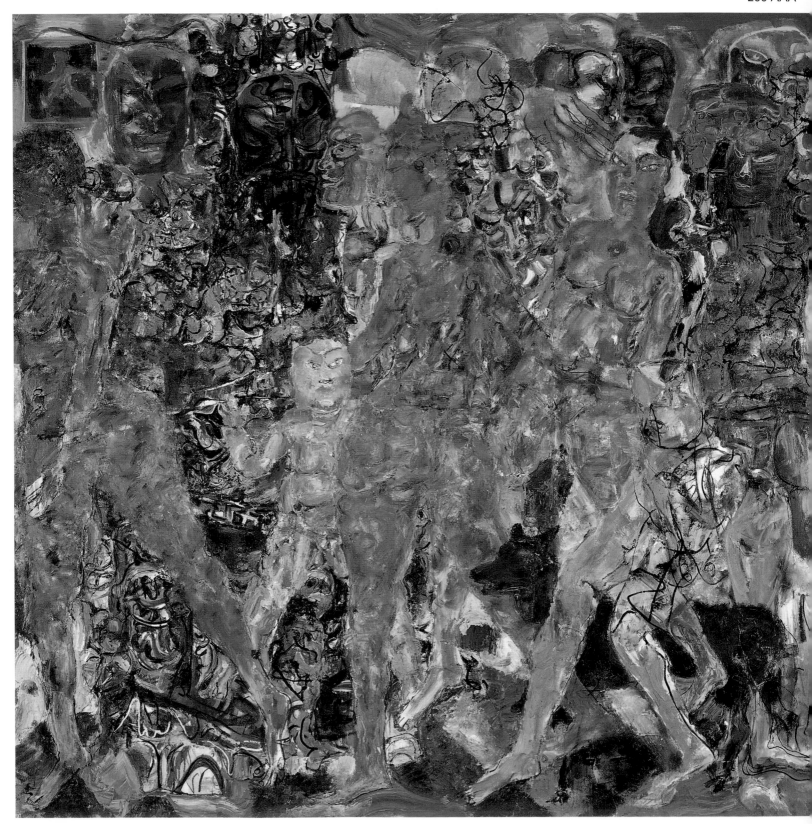

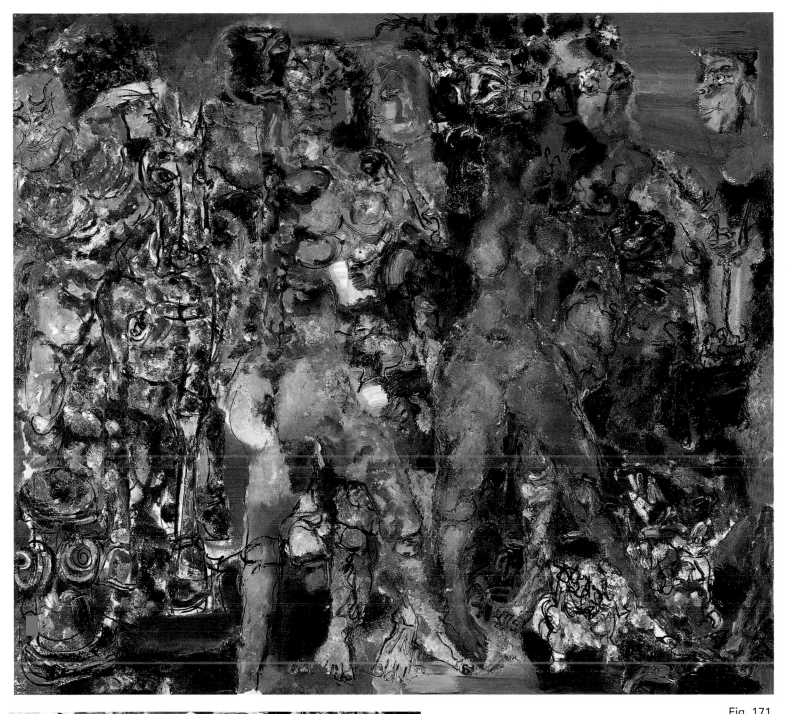

Fig. 171
Jia Di Fei
The Intersection
2001
Oil on canvas, 200 x 175 cm1

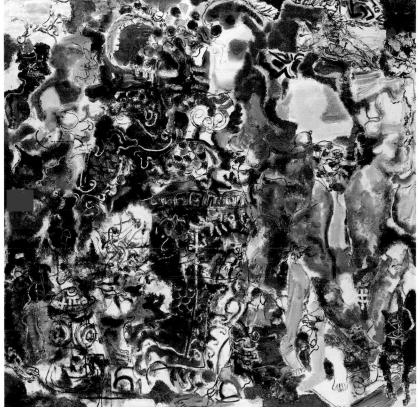

Fig. 172
Jia Di Fei
Zebra Lines across the Street
2001
Oil on canvas, 200 x 200 cm

Zeng Hao (b.1963)

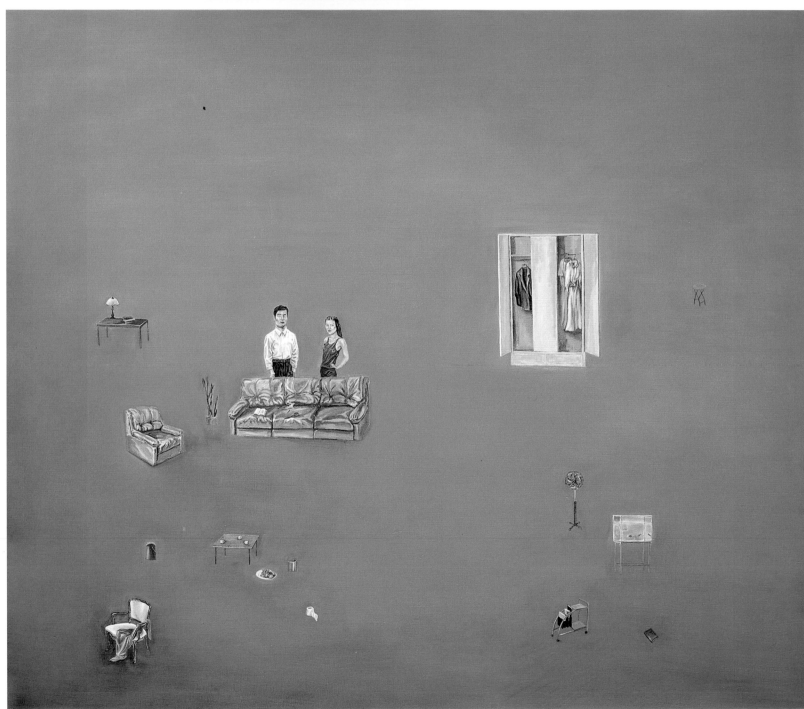

Fig. 173
Zeng Hao
July 8th
Oil on canvas, 175 x 200 cm

Fig. 174
Zeng Hao
August 25, 2003
Oil on canvas, 250 x 310 cm

Fig. 175
Zeng Hao
Nov. 30, 2003
Oil on canvas, 240 x 180 cm

153

Sun Liang

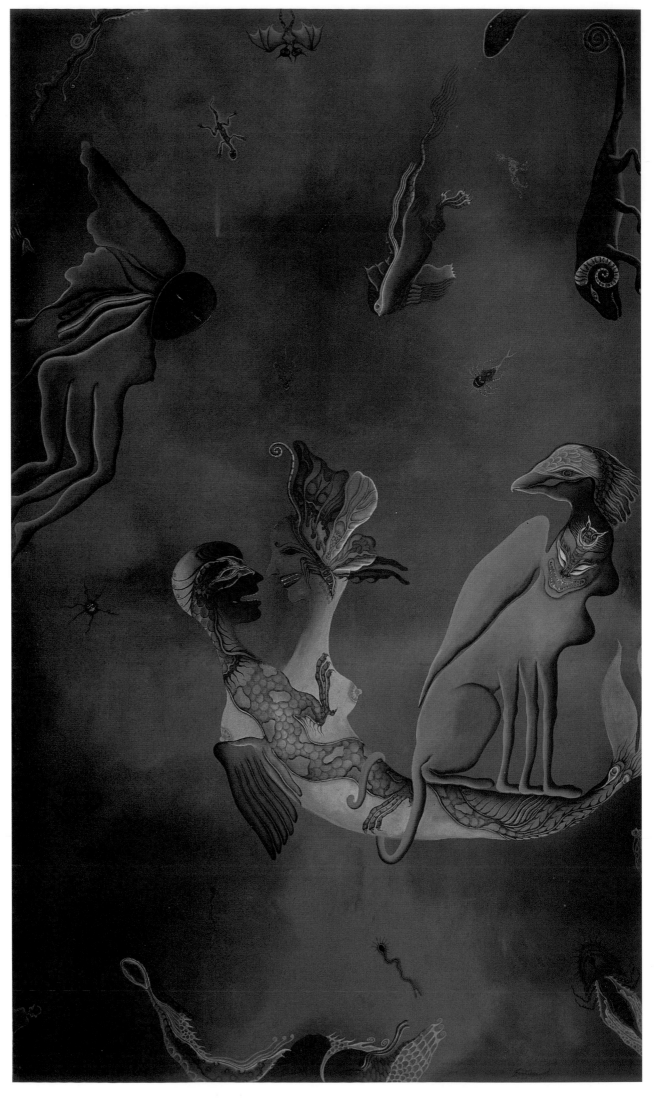

Fig. 176
Sun Liang
Wings
1999
Oil on canvas, 200 x
110 cm

154

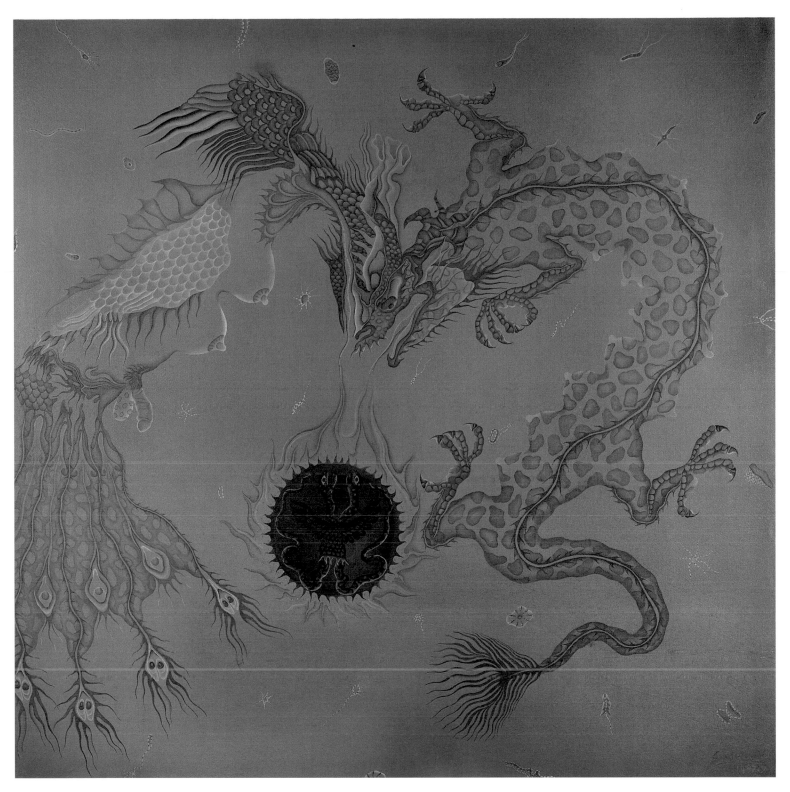

Fig. 177
Sun Liang
Turning
1998
Oil on canvas, 110 x 110 cm

Yang Jin Song (b.1971)

Fig. 179
Yang Jin Song
Nov. 2002
2002
Oil on canvas, 180 x 230 cm

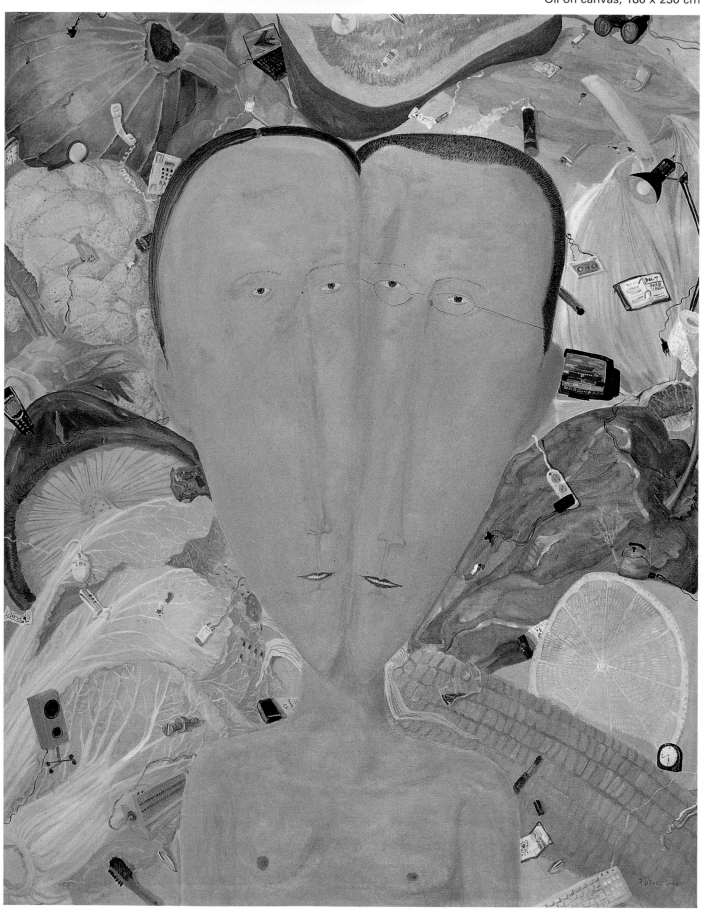

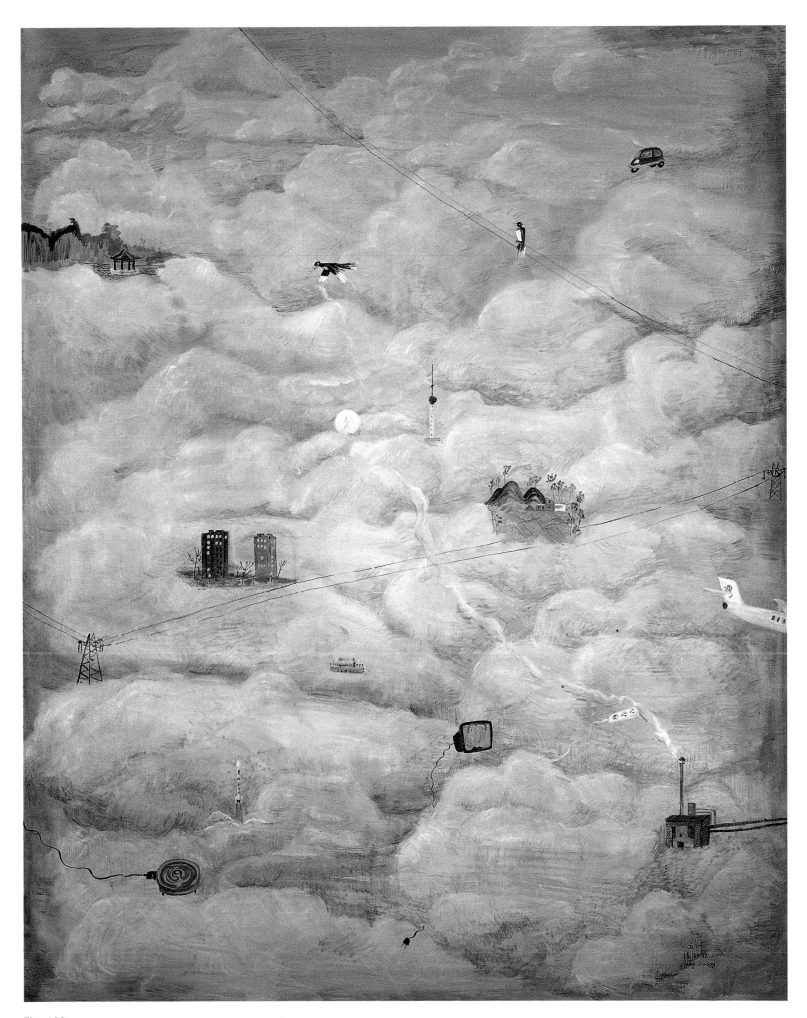

Fig. 180
Yang Jin Song
Clouds
Oil on canvas, 150 x 190 cm

Gu Ying Qing (b.1959)

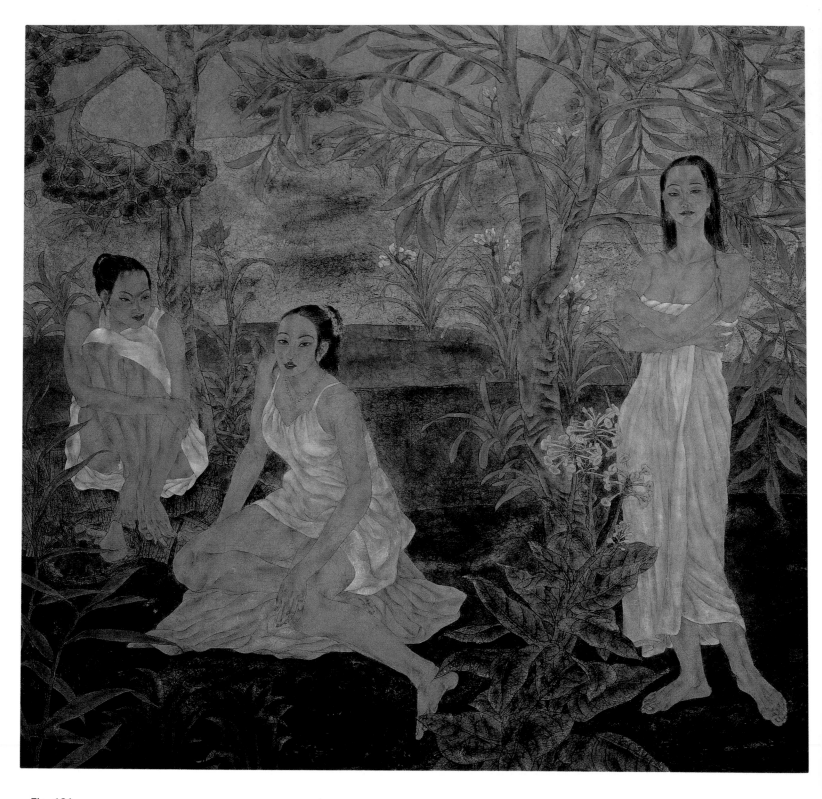

Fig. 181
Gu Ying Qing
Legend of Beauty No. 1
Ink and mixed media on rice paper, 57.5" x 55"

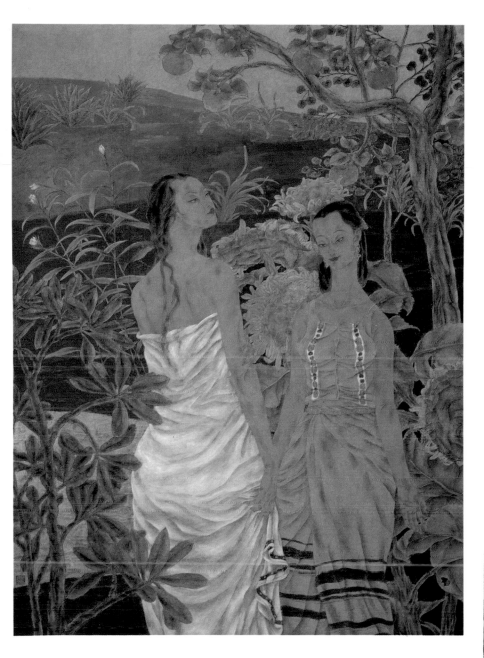

Fig. 182
Gu Ying Qing
Legend of Beauty No.2
2000
Ink and mixed media on rice paper, 48" x 64"

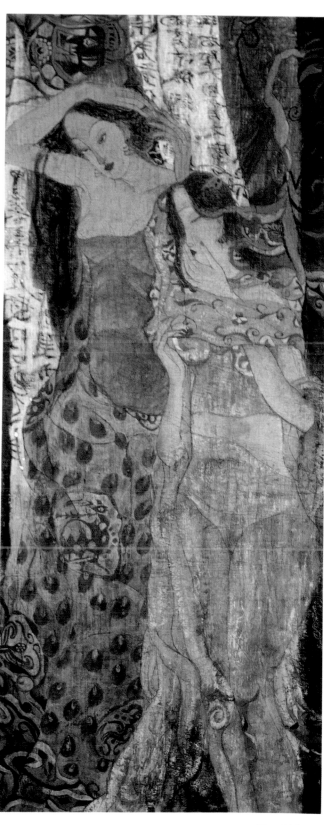

Fig. 183
Gu Ying Qing
Ancient Time
2000
Ink and mixed media on rice paper, 29" x 60"

Zhu Xin Jian

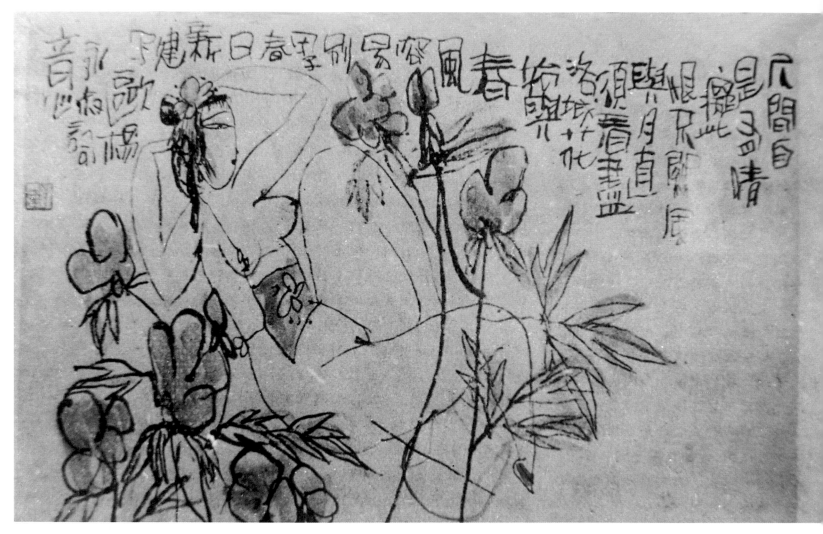

Fig. 184
Zhu Xin Jian
An Interpretation of Ou-Yan-Yon-Su's Poem
1985

Li Jin (b. 1958)

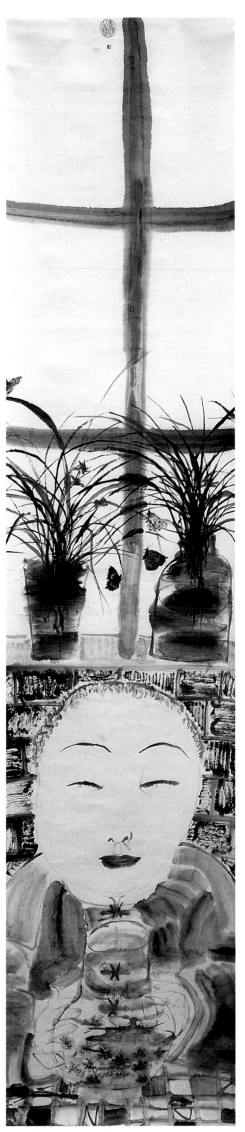

Left:
Fig. 185
Li Jin
Flower Eater
2000
Ink and color on rice paper, 101.5"
x 20.5"

Following page, left:
Fig. 186
Li Jin
Eat As You Can
2001
Ink and color on rice paper, 76.5" x
21"

Following page, right:
Fig. 187
Li Jin
The Poet
2000
Ink and color on rice paper,
68 x 68 cm"

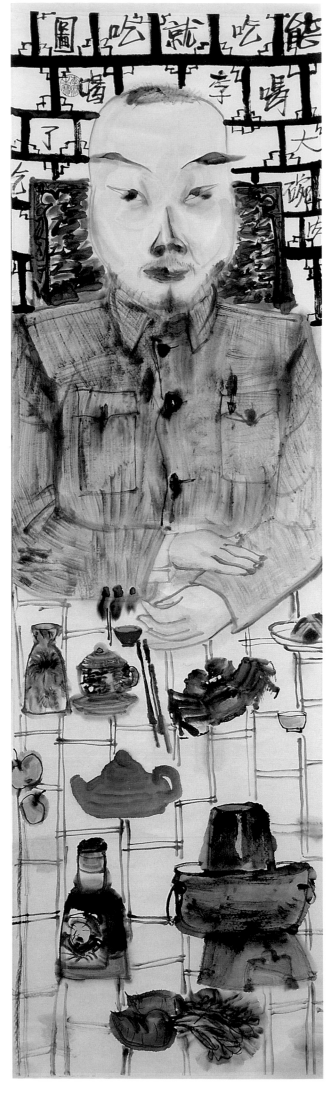

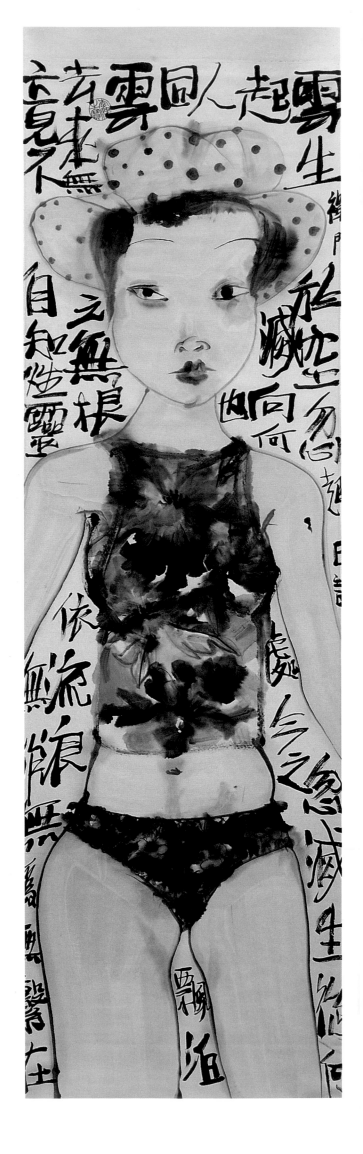

Li Xiao Xuan (b.1959)

Li Xiao Xuan with his students

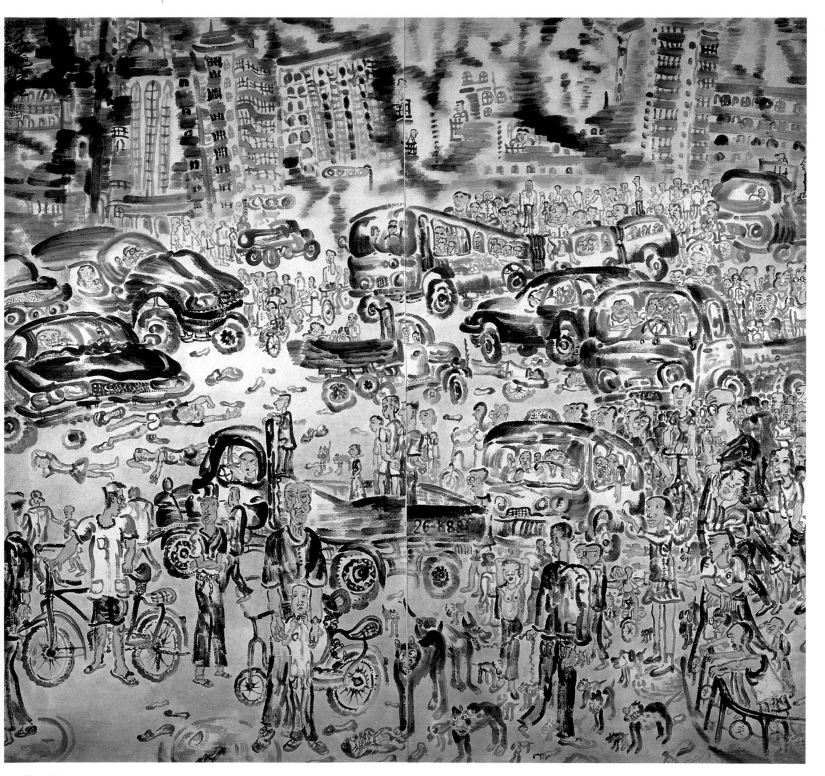

Fig. 188
Li Xiao Xuan
Palpitate
1994
Ink on rice paper

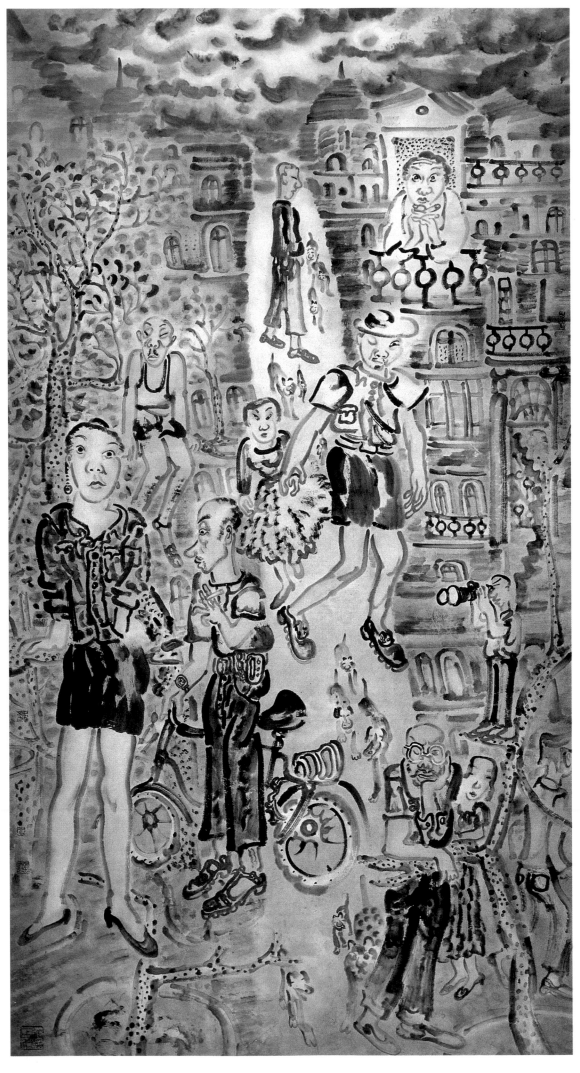

Fig. 189
Li Xiao Xuan
Dusk
1994
Ink on rice paper, 179 x 90 cm

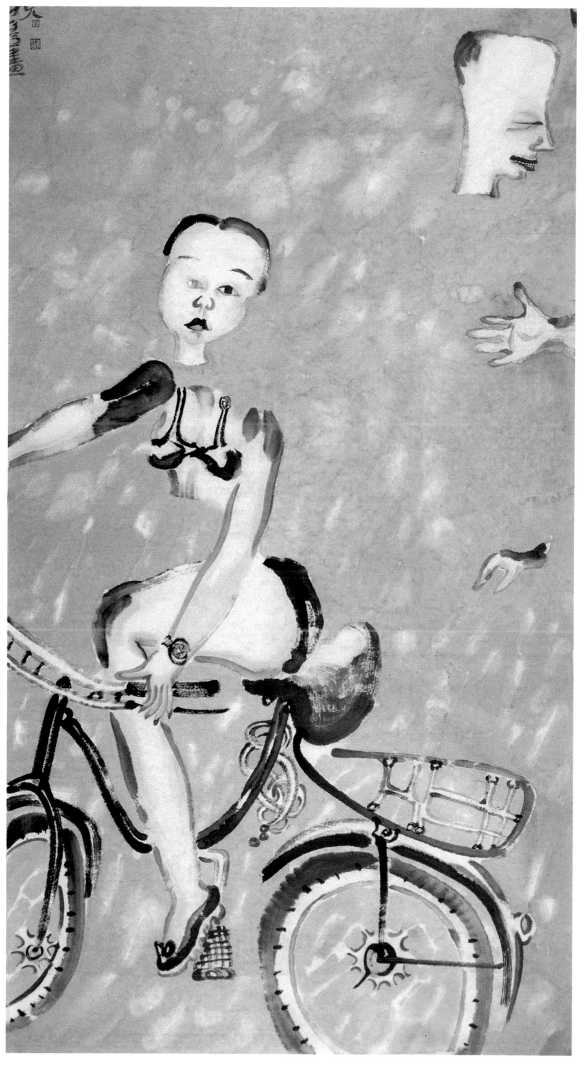

Fig. 190
Li Xiao Xuan
Endless Turns
1998
Ink on rice paper, 179 x 90 cm

Hai Ri Han (b. 1958)

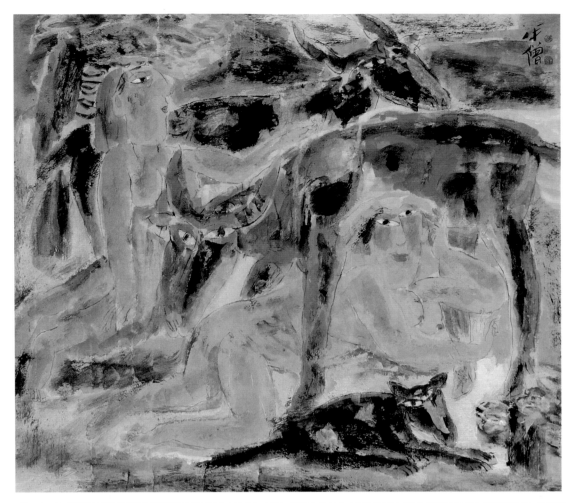

Fig. 191
Hai Ri Han
Silk Road No. 1
2001
Ink on rice paper, 21.5" x 19"

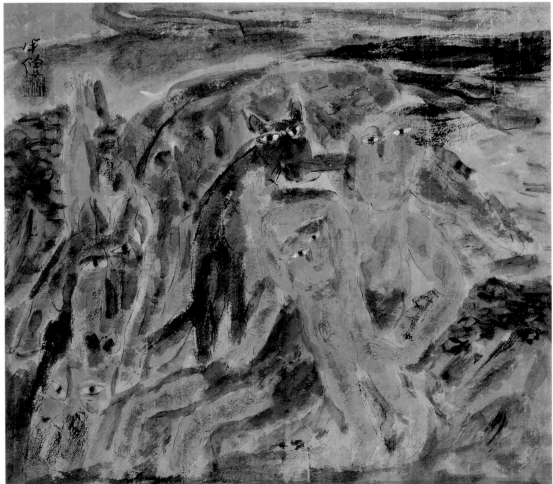

Fig. 192
Hai Ri Han
Silk Road No. 3
2001
Ink on rice paper, 21.5" x 19"

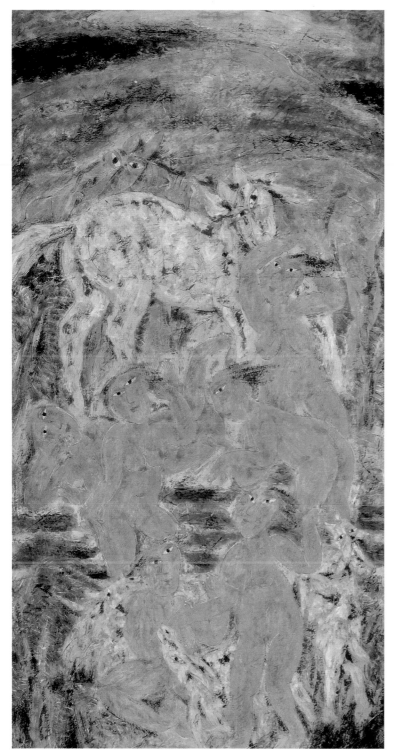

Fig. 193
Hai Ri Han
The Stony Brook No. 1
1997
Ink on rice paper, 43" x 21"

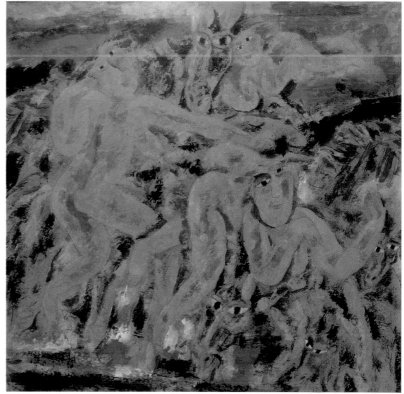

Fig. 194
Hai Ri Han
Summer No. 2
1998
Ink on rice paper, 26.5" x 26.5"

Feng Bin (b.1962)

Fig. 195
Feng Bin
2002-18
2002
Chinese pigments, acrylic, rice paper on
cotton, 230 x 200 cm

Fig. 196
Feng Bin
Hurrying
1999
Chinese pigments, acrylic,
rice paper on cotton, 230 x
200 cm

Fig. 197
Feng Bin
Blue Sky, Red Wall
1998
Chinese pigments, acrylic, rice
paper on cotton, 230 x 200 cm

Zhou Yong (b. 1962)

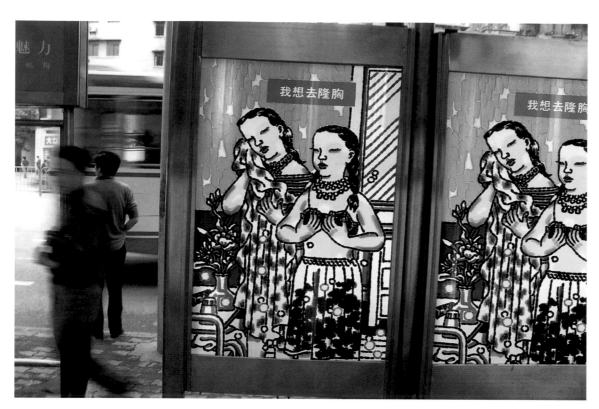

Fig. 198
Zhou Yong's work "I want a breast implant," at bus stop,
Guang Zhou

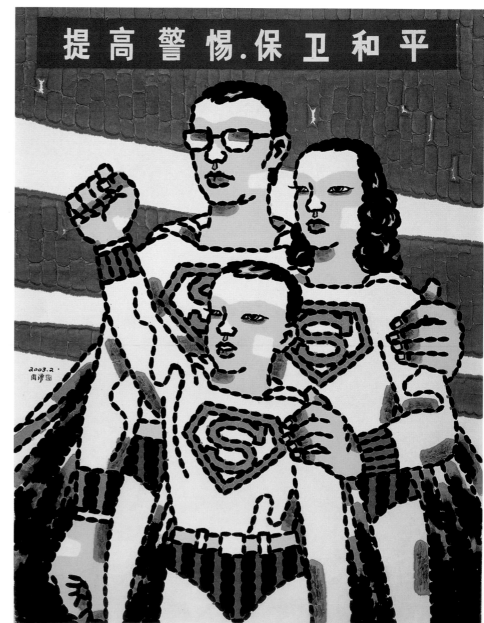

Fig. 199
Zhou Yong
Heighten our Vigilance, Protect the Peace!
2003
Ink on rice paper, 186 x 145 cm

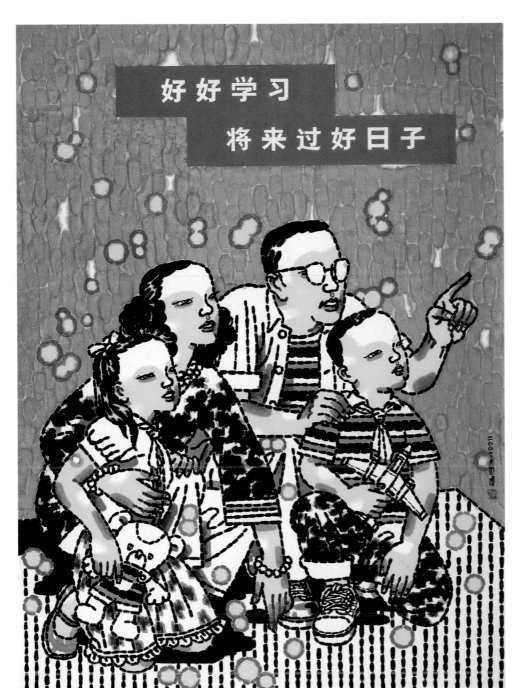

Fig. 200
Zhou Yong
Study Hard for a Bright Future
2002
Ink on rice paper, 195 x 145 cm

Fig. 201
Zhou Yong
More Trees Fresher Air
2002
Ink on rice paper, 196 x 145 cm

Zhang Yu (b.1959)

Fig. 202
Zhang Yu
Divine Light No. 31
2000
Ink on rice paper, 36" x 39"

Fig. 203
Zhang Yu
Divine Light No. 36
2000
Ink on rice paper, 36" x 39"

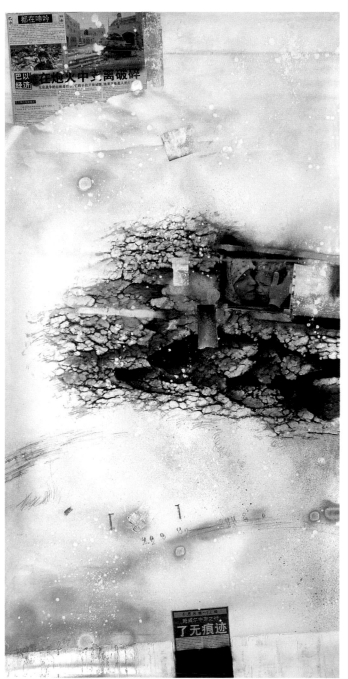

Fig. 204
Zhang Yu
News 2002
2002
Ink, newspaper, acrylic, pencil,
paint etc. on rice paper, 136 x
68 cm

Liu Zi Jian (b.1956)

Fig. 205
Liu Zi Jian
The Misted and Misplaced Space No. 1
2000
Ink on rice paper, 136 x 136 cm

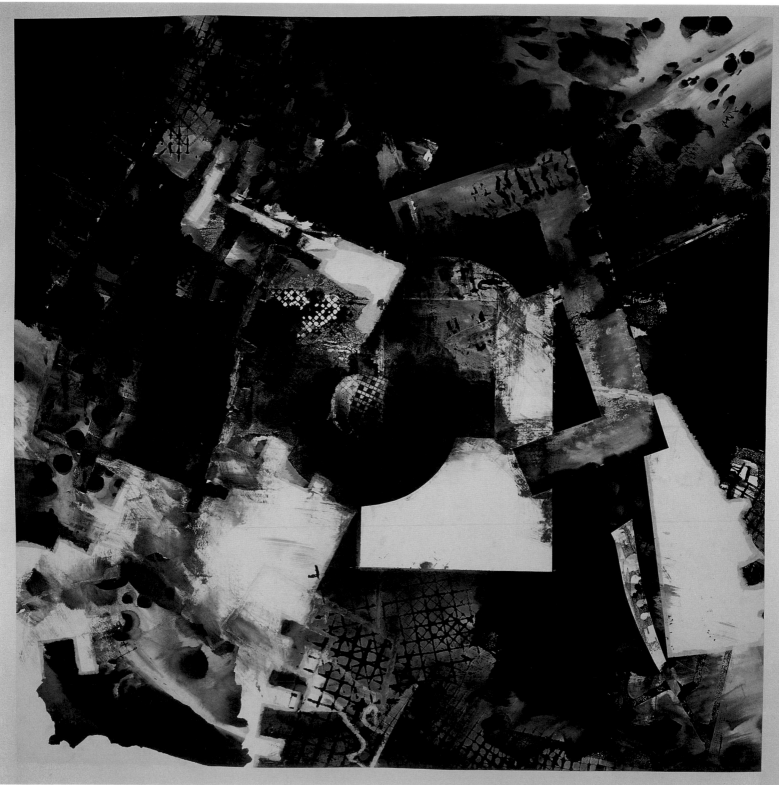

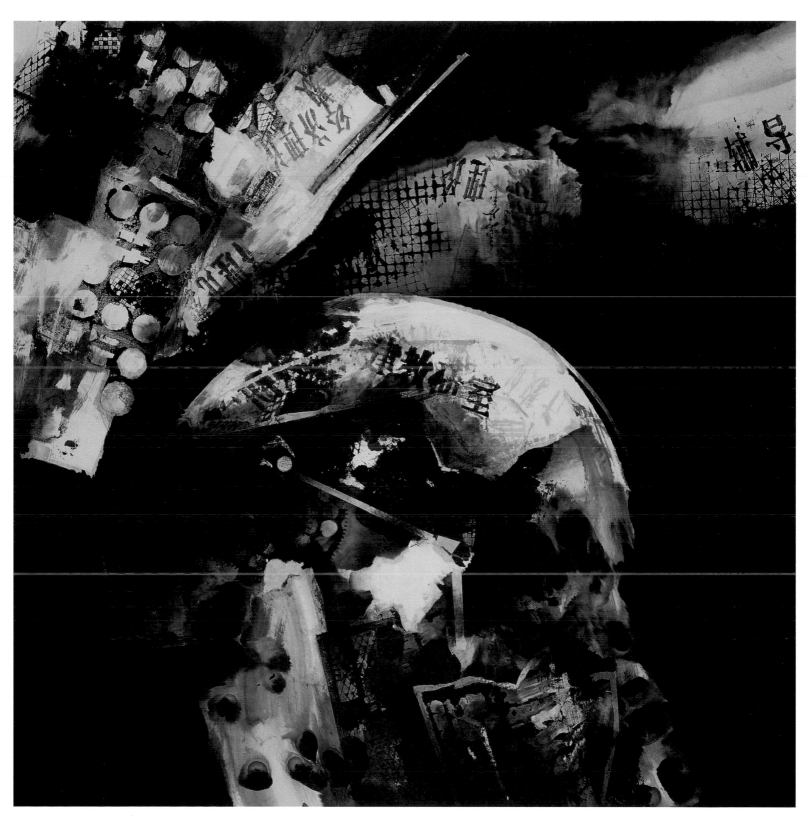

Fig. 206
Liu Zi Jian
The Misted and Misplaced Space No. 8
2000
Ink on rice paper, 136 x 136 cm

Fang Tu (b.1963)

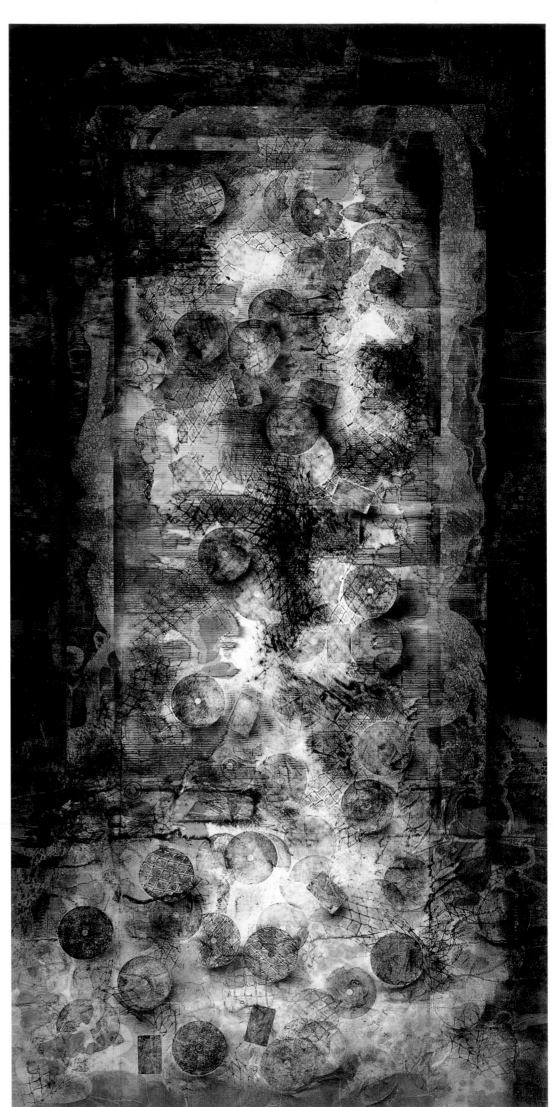

Fig. 207
Fang Tu
Net . Series (3)
2002
Ink and acrylic on rice paper, 120 x
240 cm

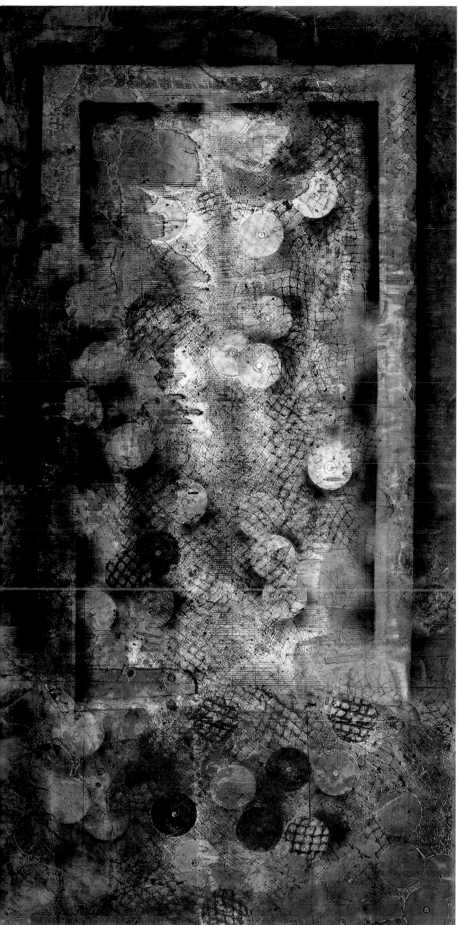

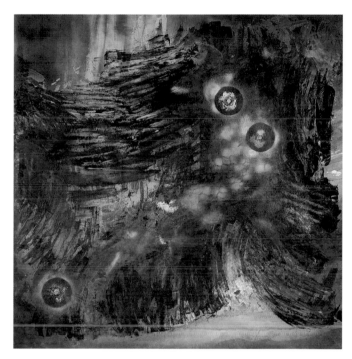

Fig. 209
Fang Tu
Great Achievements of Civilization: CD Series
1999
Ink and silver powder, with acrylic on rice paper 145 x
145 cm

Fig. 208
Fang Tu
Net . Series (1)
2002
Ink and acrylic on rice paper, 120 x 240 cm

Wei Qing Ji (b.1971)

Opposite page, top:
Fig. 211
Wei Qing Ji
The properties of Everyday Life No. 2
Mixed media on silk and newspaper, 80
x 55 cm

Opposite page, bottom:
Fig. 212
Wei Qing Ji
The Properties of Everyday Life No. 6
Mixed media on silk and newspaper, 80
x 55 cm

Fig. 210
Wei Qing Ji
The Properties of Everyday Life No. 4
Mixed media on silk and newspaper, 80 x 55 cm

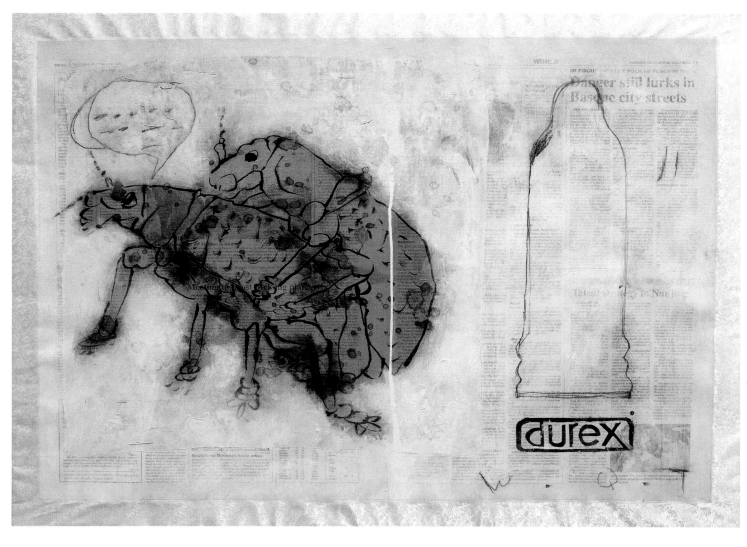

Liang Quan (b. 1948)

Fig. 214
Liang Quan
Tea
2000
Tea on rice paper

Chen Xin Mao (b.1954)

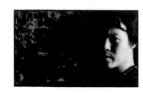

Fig. 215
Chen Xin Mao
History Books Series. Wrong Edition
2001-2002
Ink , rice paper, and mixed media, 60 x 90 cm, 18 pieces

Fig. 216
Chen Xin Mao
The Landscape of a City
2004
Ink, rice paper, acrylic, multi media, mixed media, 45 x 62 cm,
55 pieces

Qin Feng (b.1961)

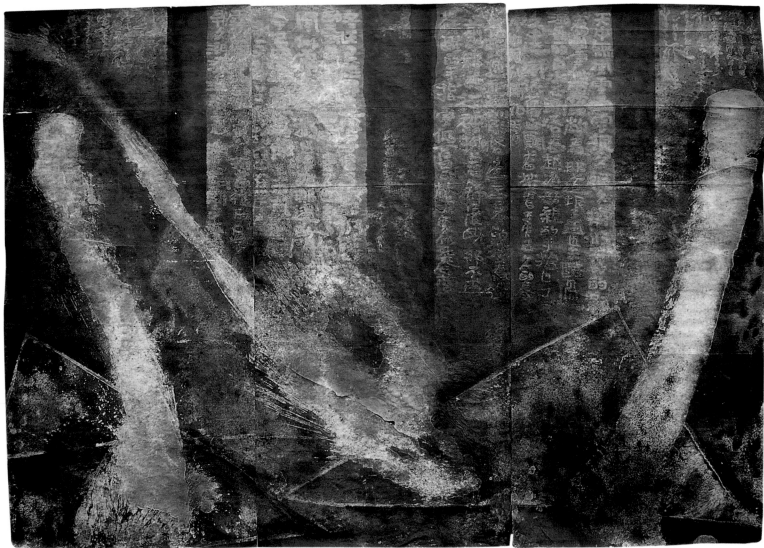

Fig. 217
Qin Feng
Between Tao and Road # 3
1999
Ink on rice paper, 300 x 400 cm

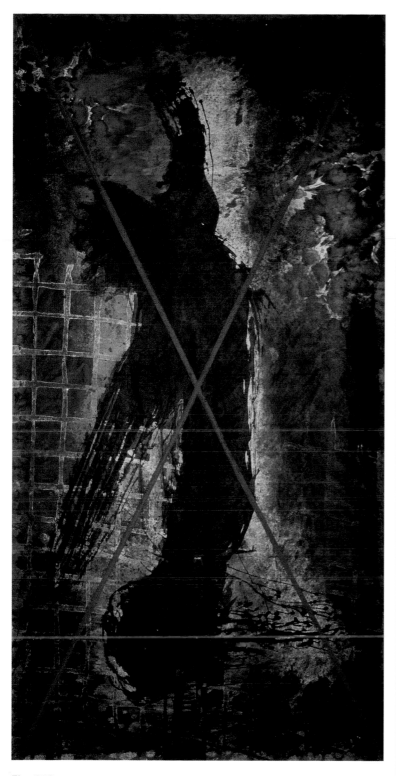

Fig. 218
Qin Feng
Game of Life
1999
Ink on rice paper, 100 x 80 cm

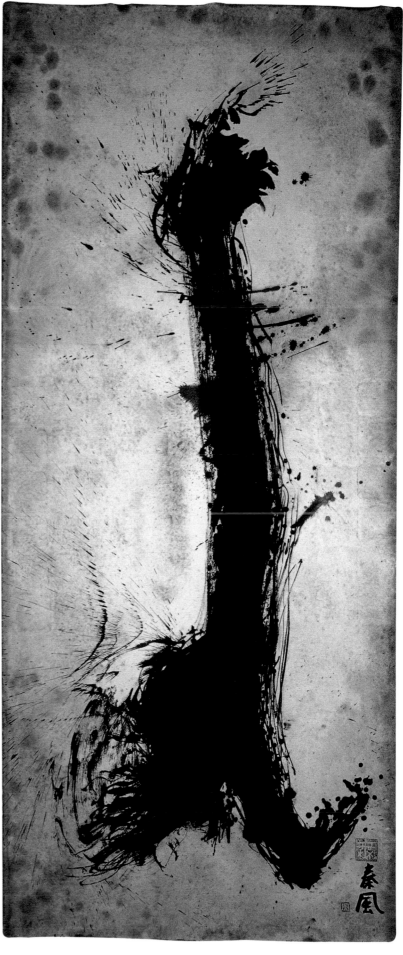

Fig. 219
Qin Feng
Aside #6
1998
Ink on rice paper, 250 x 100 cm

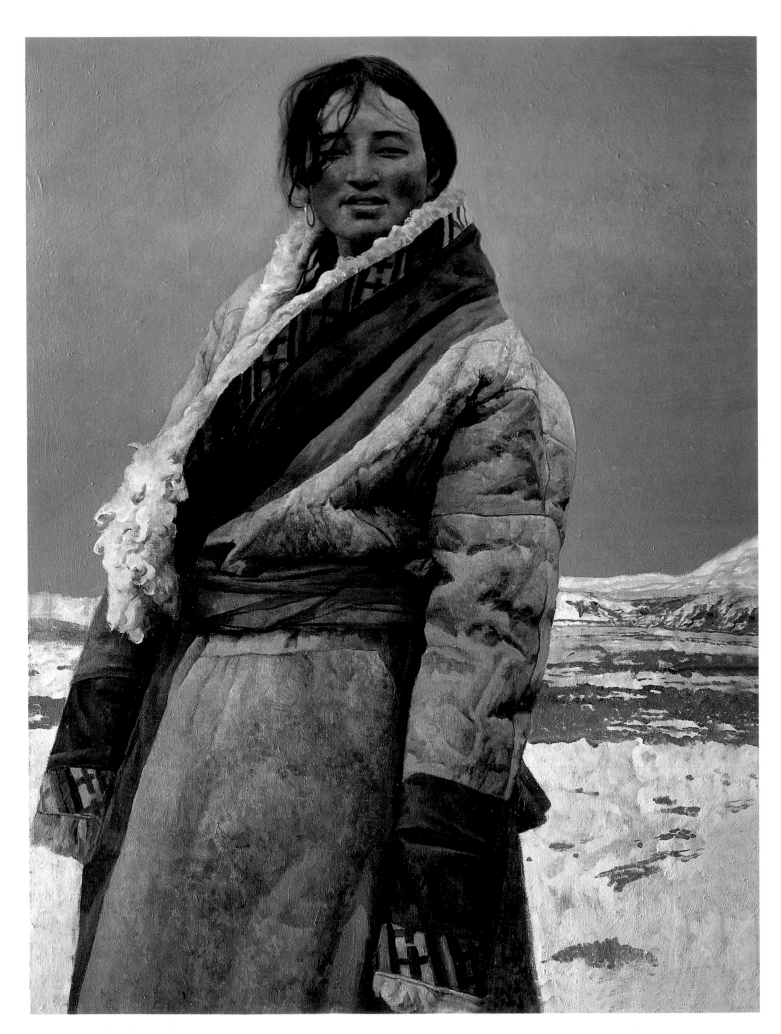

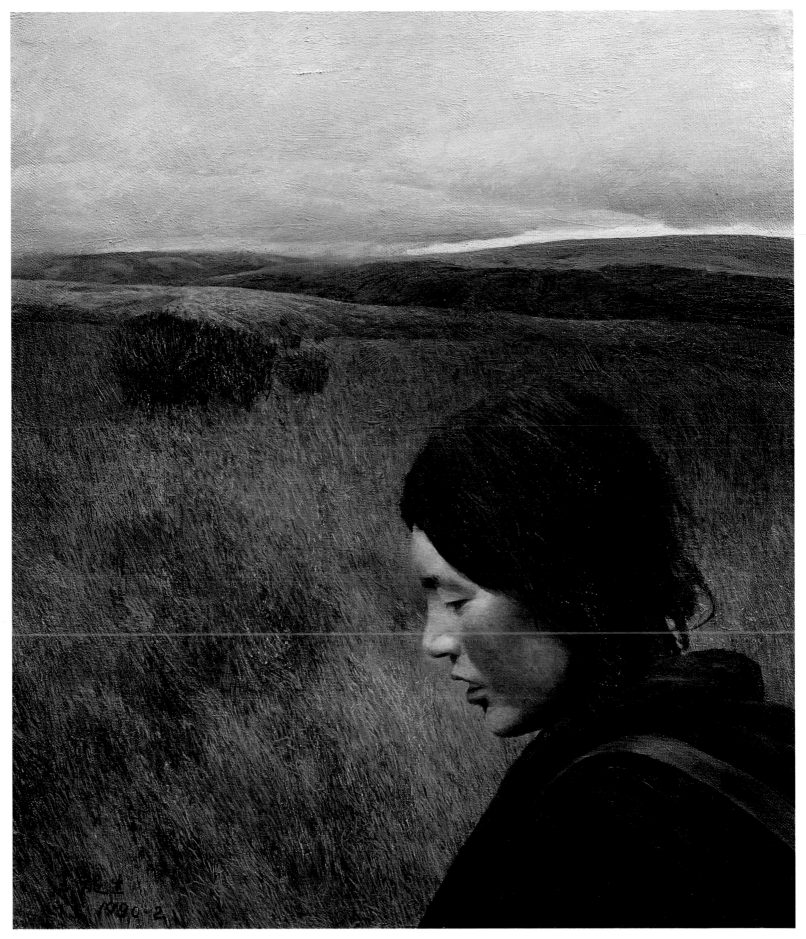

Opposite page:
Fig. 220
Wang Long Sheng
Spring Is Coming without Sound
2004
Oil on canvas, 100 x 80 cm

Fig. 221
Wang Long Sheng
Whispering
1990
Oil on canvas, 58 x 67 cm

Zhao Kai Lin (b.1962)

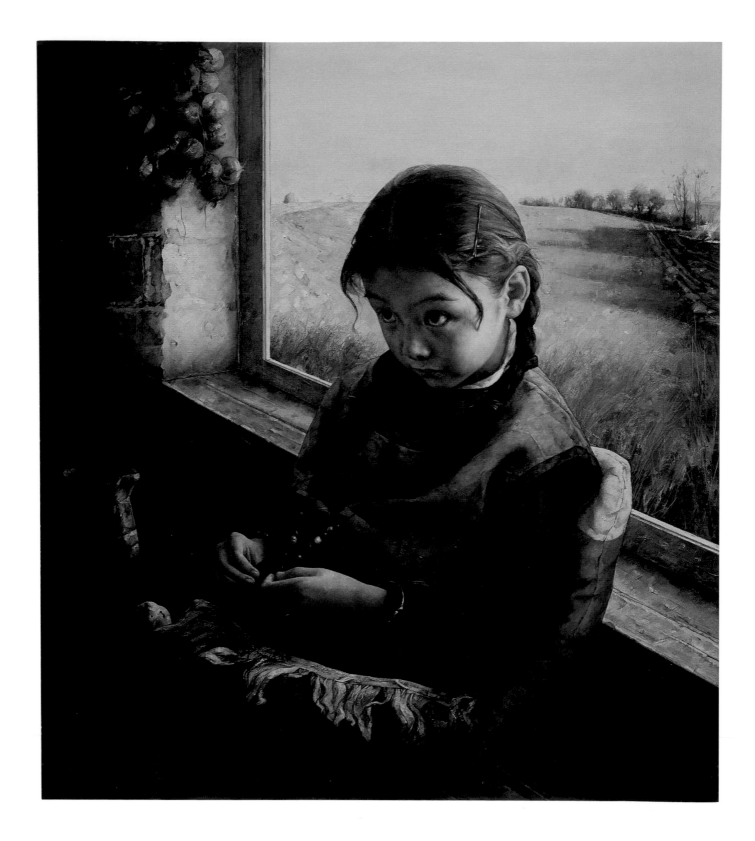

Fig. 222
Zhao Kai Lin
Qi Qi By the Window
Oil on linen, 35" x 39"

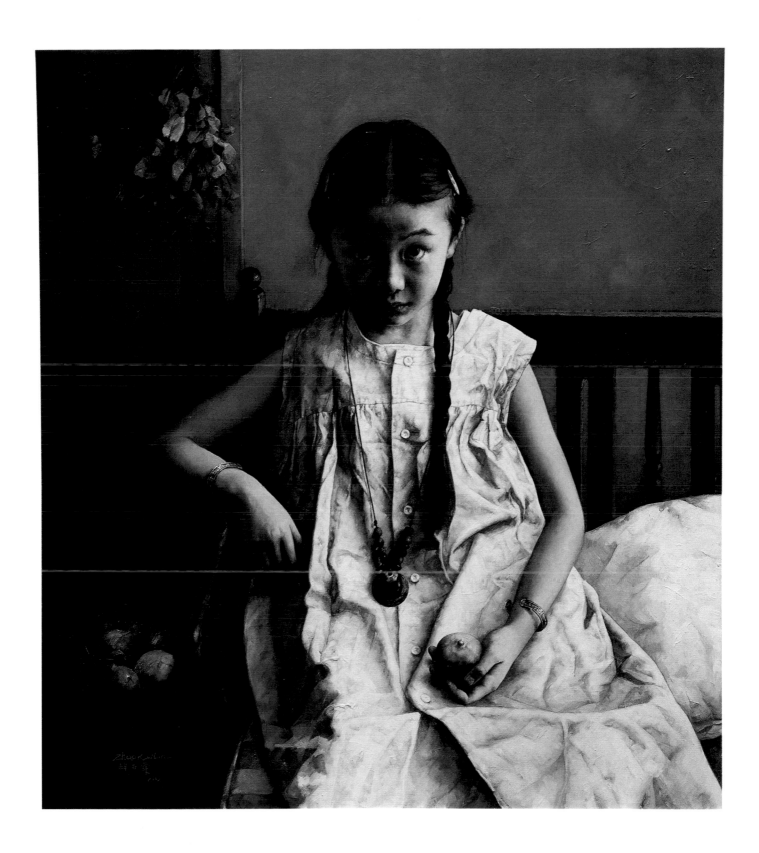

Fig. 223
Zhao Kai Lin
Qi Qi on a Chair
Oil on linen, 39.5" x 35.5"

Luo Zhong Li (b.1948)

Opposite page:
Fig. 225
Luo Zhong Li
Winter Months
1998
Oil on canvas, 170 x 120 cm

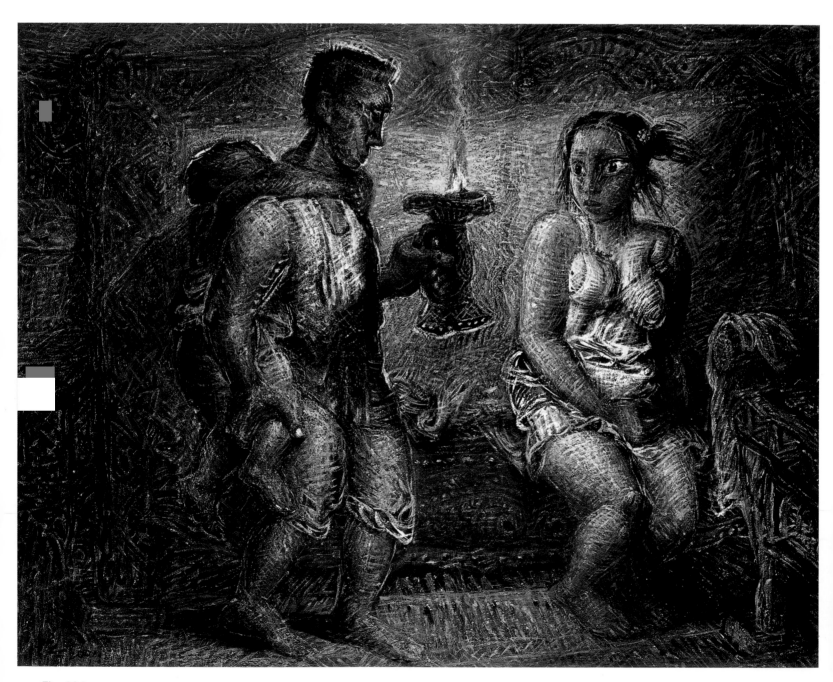

Fig. 224
Luo Zhong Li
Ba Shan's Legend
2001
Oil on canvas, 140 x 100 cm

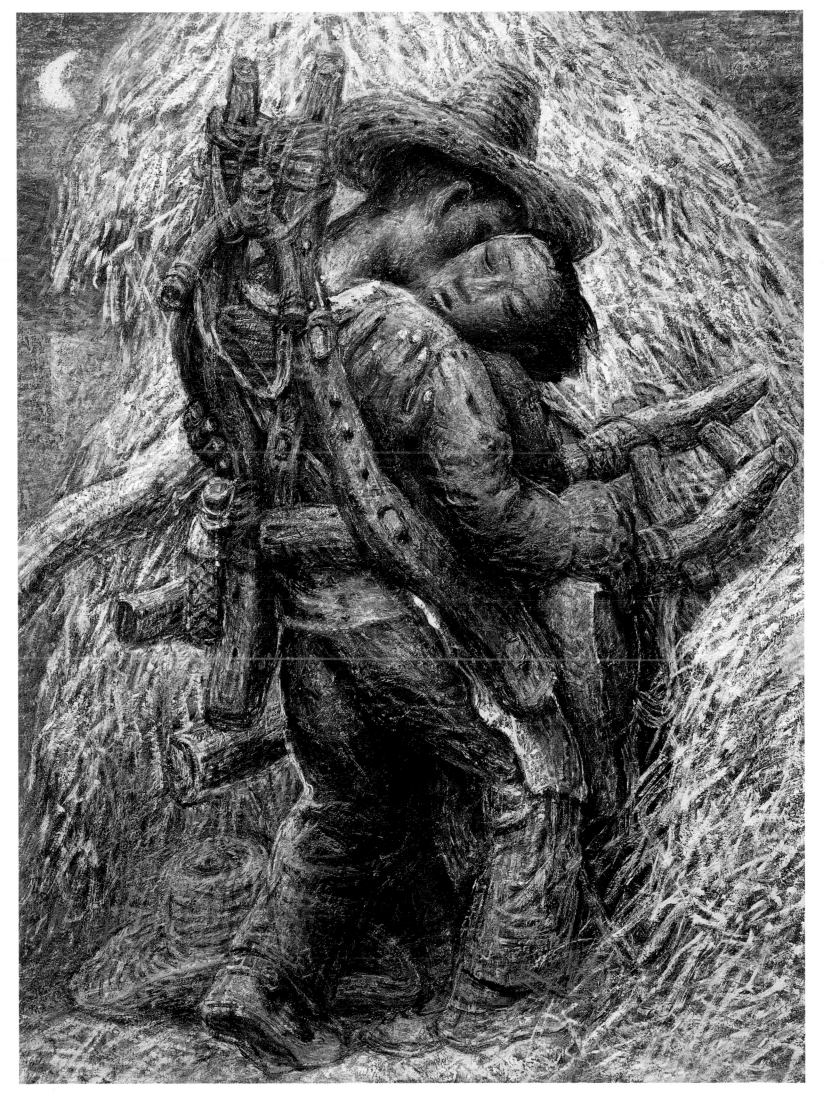

Shi Chong (b. 1963)

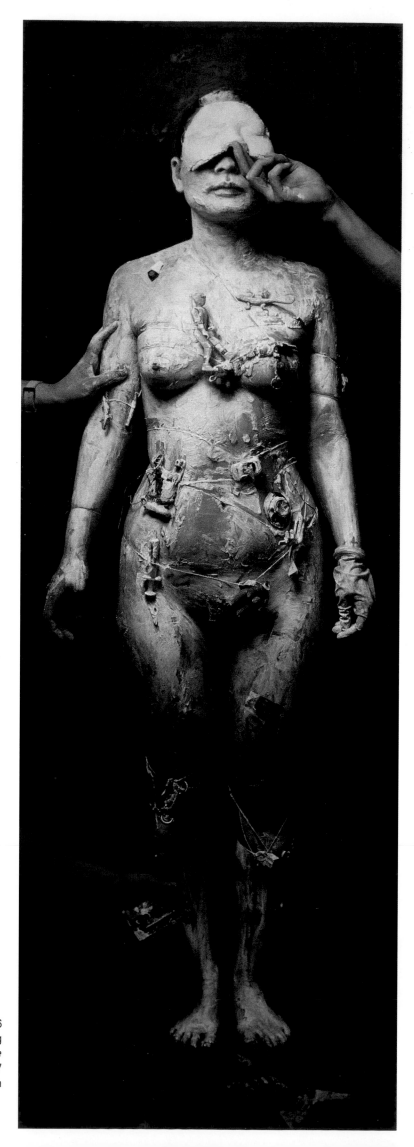

Fig. 226
Shi Chong
Stage
1997
Oil on canvas, 240 x 85 cm

Fig. 227
Shi Chong
The Portrait of x Day x Month x Year
1999-2000
Oil on canvas, 190 x 90 cm

Fig. 228
Shi Chong
Story (3)
2001-2002
Oil on canvas, 150 x 50 cm

Xin Dong Wang (b. 1963)

Xin Dong Wang with his model

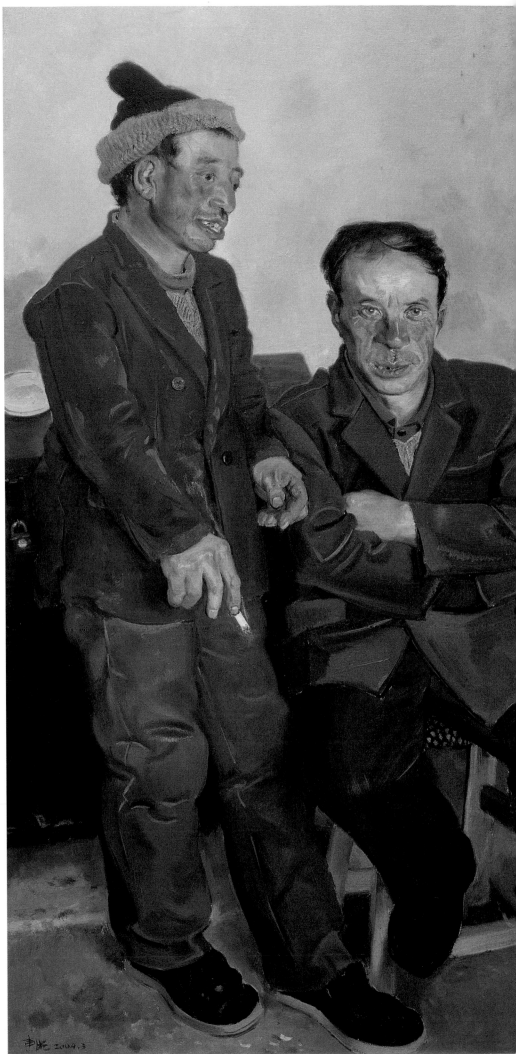

Fig. 229
Xin Dong Wang
At Ease
2004
Oil on canvas, 160 x 80 cm

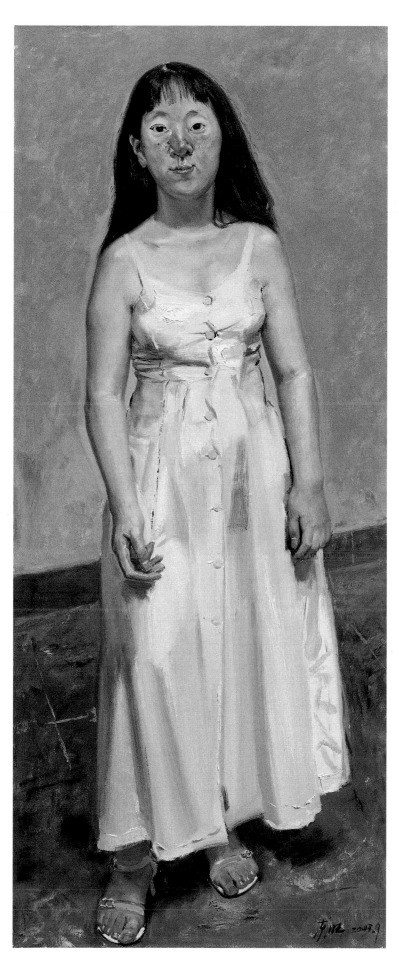

Fig. 230
Xin Dong Wang
Beauty
2004
Oil on canvas, 160 x 65 cm

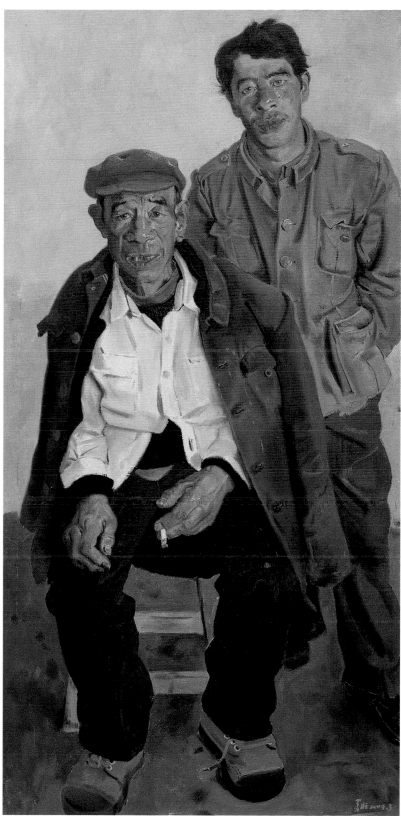

Fig. 231
Xin Dong Wang
Father and Son
2004
Oil on canvas, 160 x 80 cm

He Duo Ling (b. 1948)

Fig. 232
He Duo Ling
Xiao Ke
2001
Oil on canvas, 160 x 130 cm

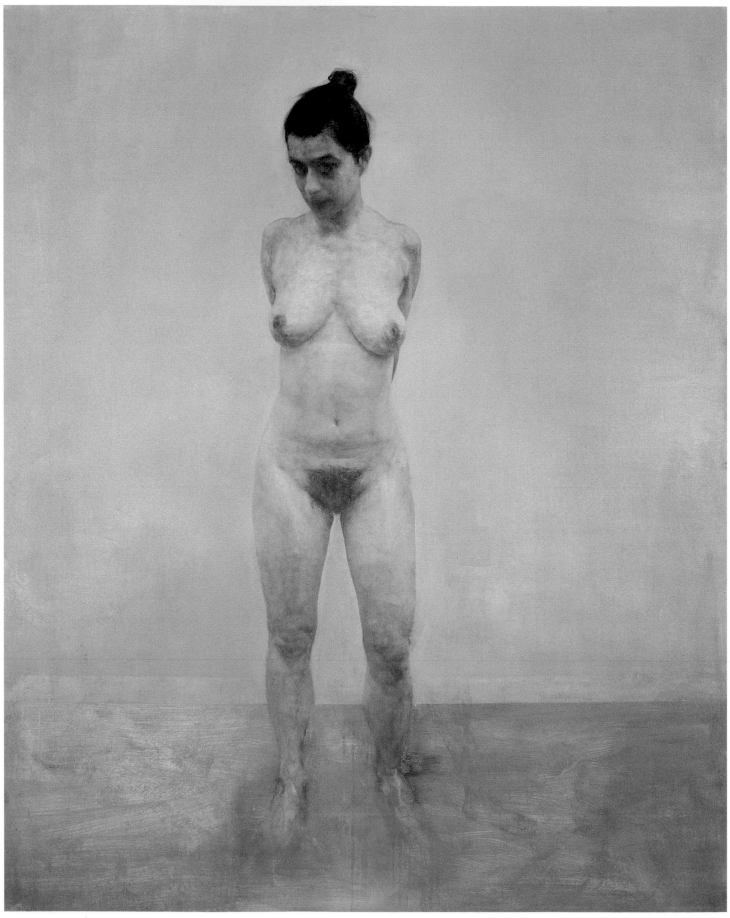

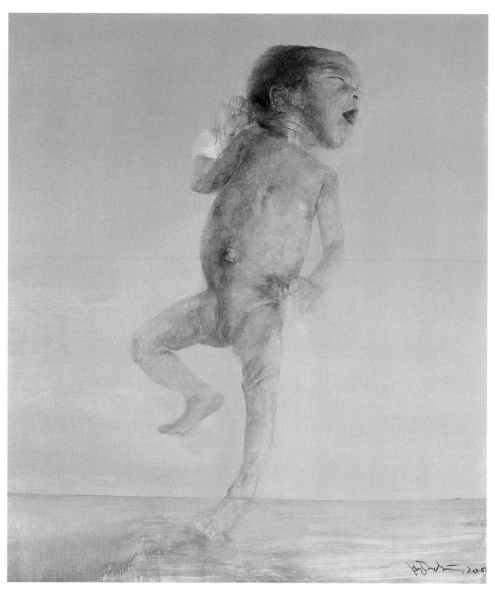

Fig. 233
He Duo Ling
The Big Infant No. 5
2001
Oil on canvas, 150 x 130 cm

Fig. 234
He Duo Ling
Summer
1992
Oil on canvas, 220 x 140 cm

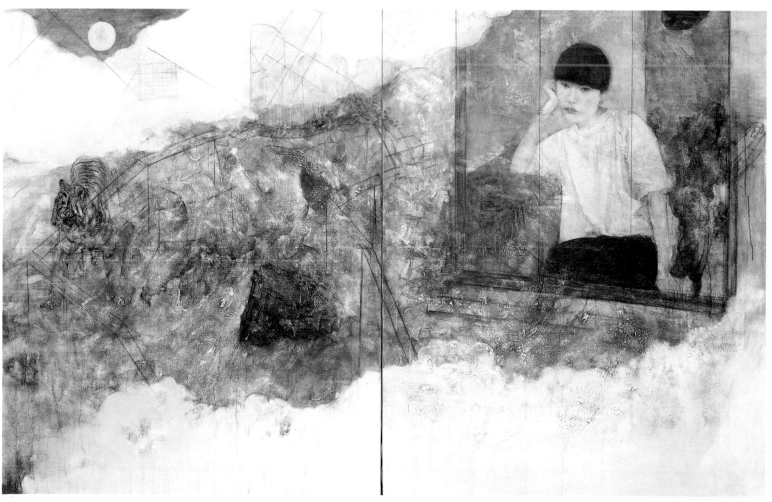

Fig. 235
Liu Hong Yuan
Being No Mood for Makeup
2002
Oil on silk mixed with linen, 74.5" x 47.5"

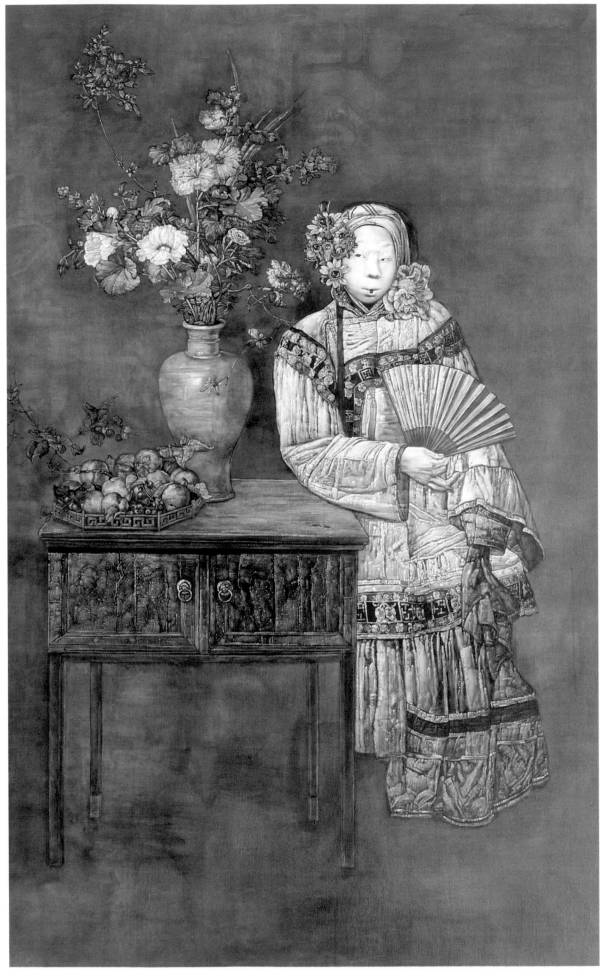

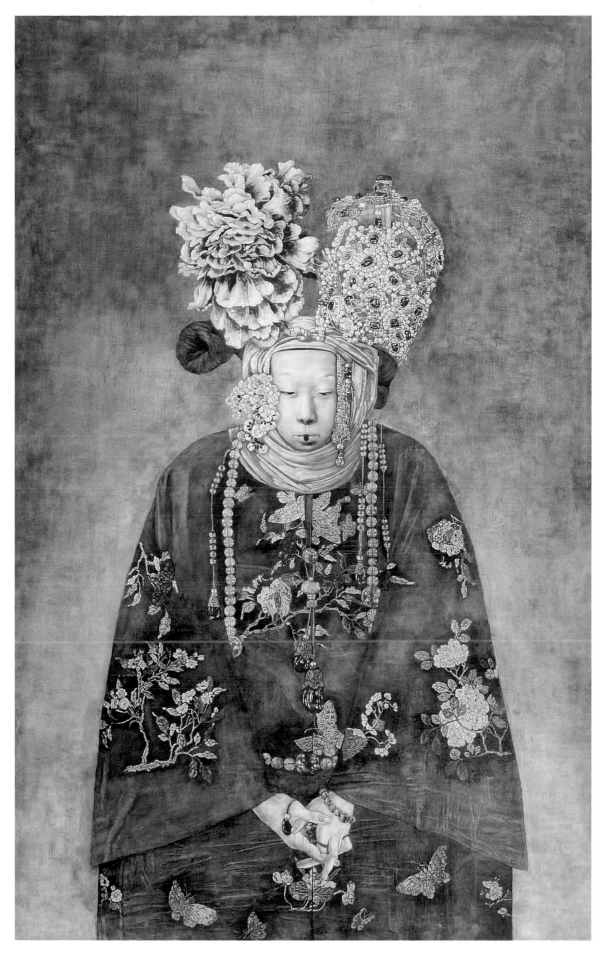

Fig. 236
Liu Hong Yuan
Dignified
2002
Oil on silk mixed with linen, 74.5" x 47.5"

Su Xin Ping (b. 1960)

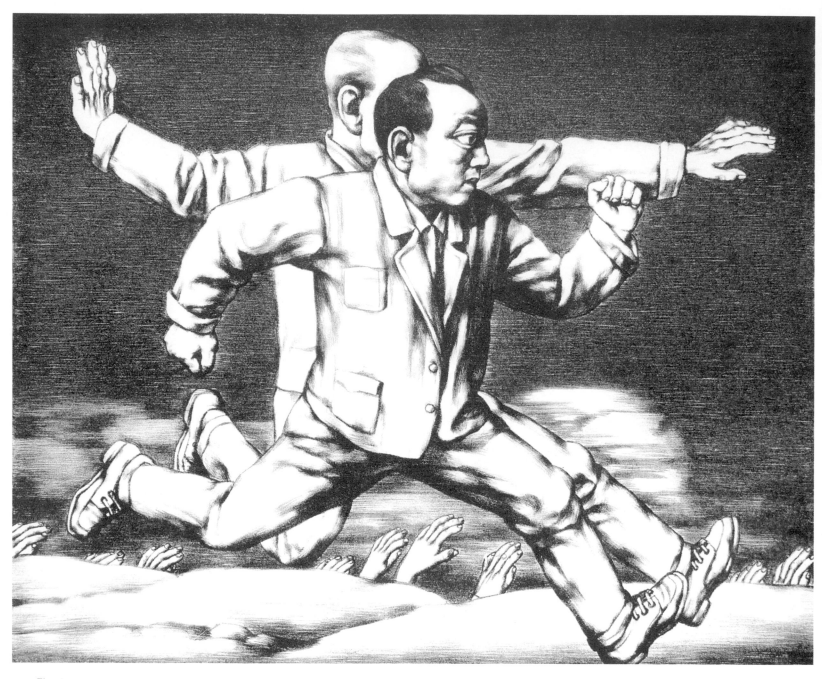

Fig. 237
Su Xin Ping
Sea of Desire IV
1996
Lithography, 14" x 17"

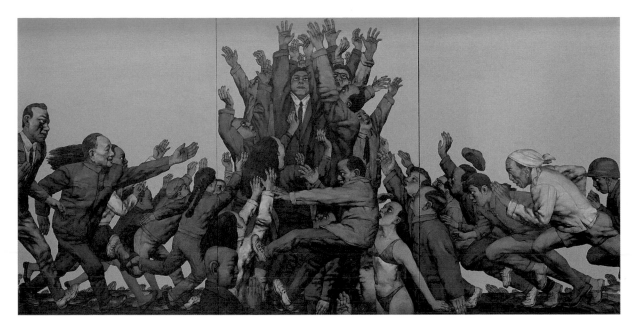

Fig. 238
Su Xin Ping
Century Tower
1997, collection of San Francisco Modern Art Museum
Oil on canvas, 194 x 390 cm

Fig. 239
Su Xin Ping
Sea of Desire No. 10
1994
Oil on canvas, 97 x 130 cm

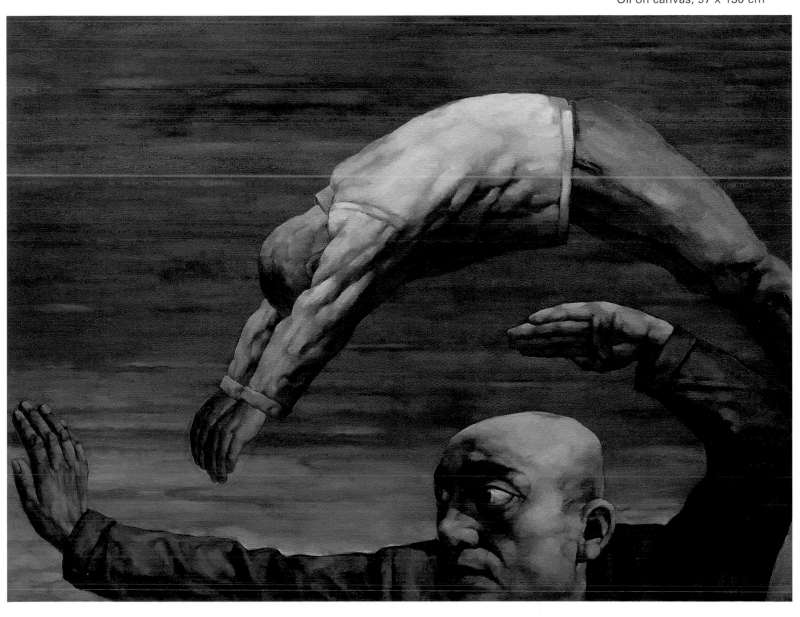

Leng Jun (b.1963)

Opposite page, top:
Fig. 241
Leng Jun
Star (2)
2000
Oil on linen, 130 x 130 cm

Opposite page, bottom:
Fig. 242
Leng Jun
The Landscape of Century (3)
1995
Oil on linen, 200 x 105 cm

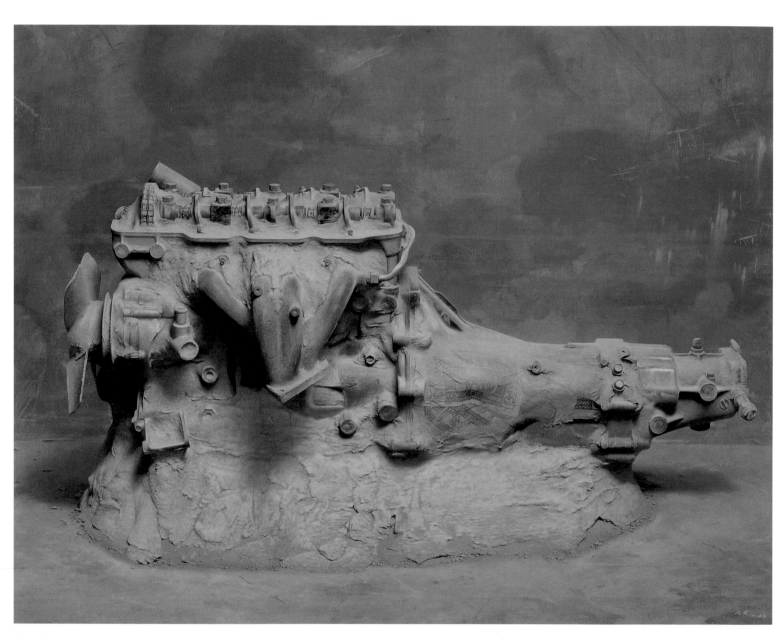

Fig. 240
Leng Jun
Historic Relic — New Product Design
1993
Oil on linen, 126 x 97 cm

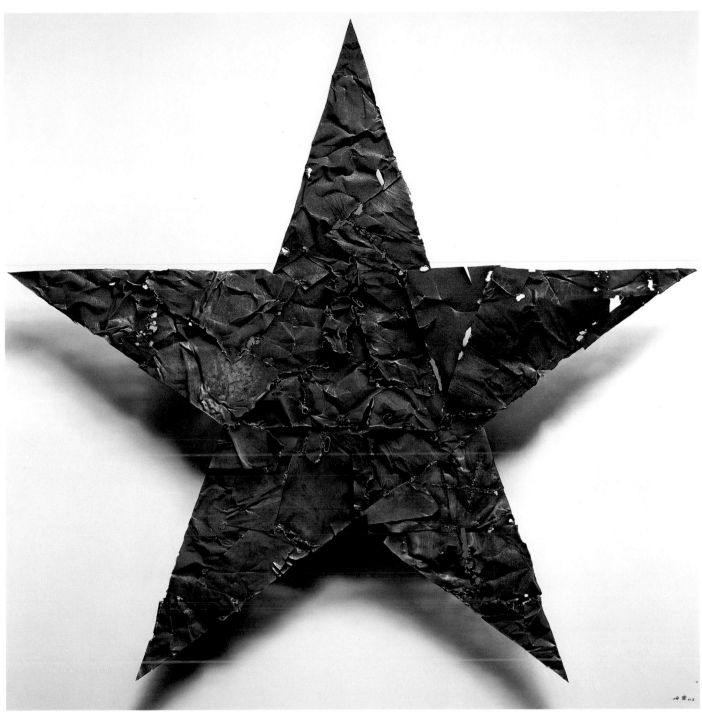

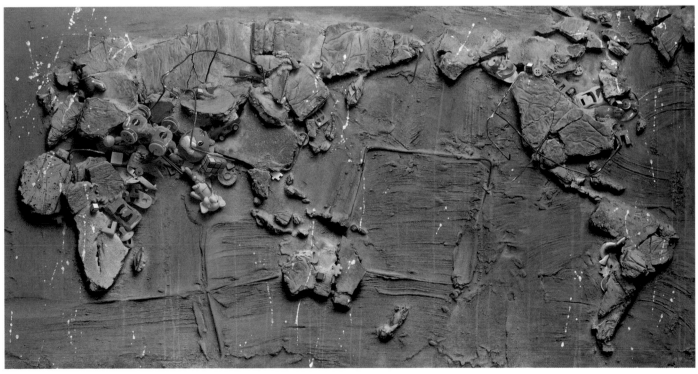

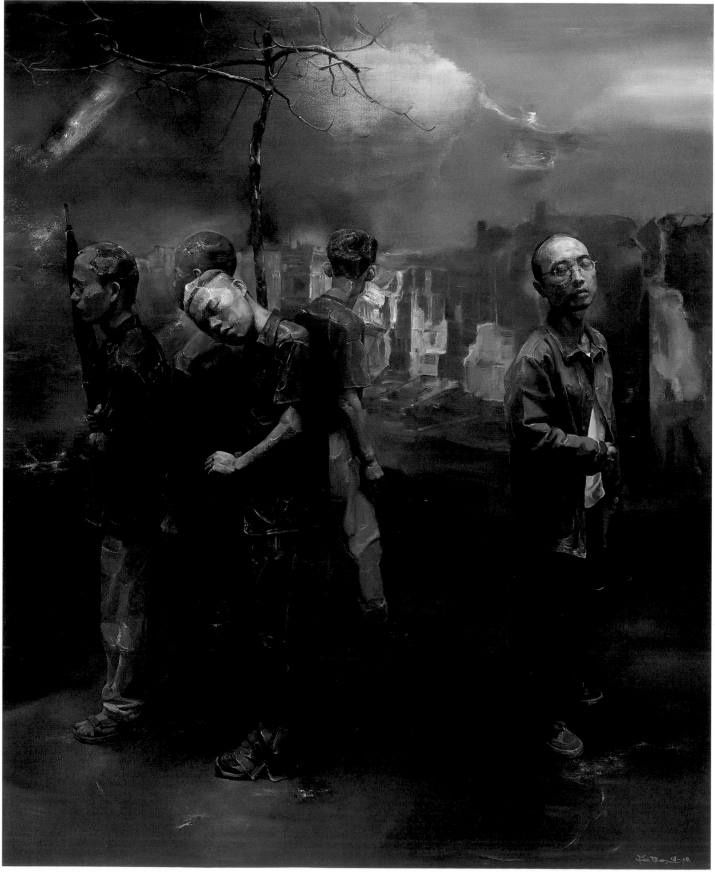

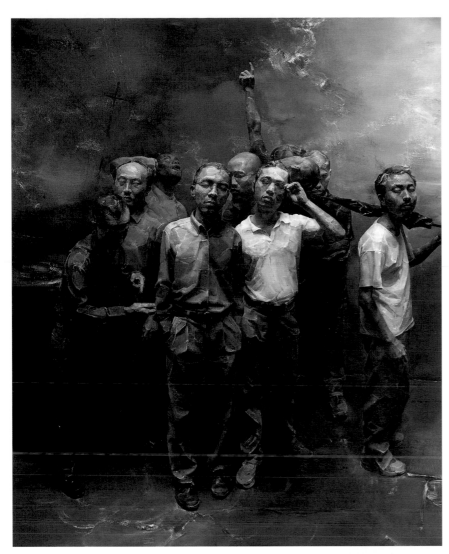

Fig. 244
Fan Bo
The Endless Dusk (1 of 3)
2004
Oil on linen, 220 x 540 cm

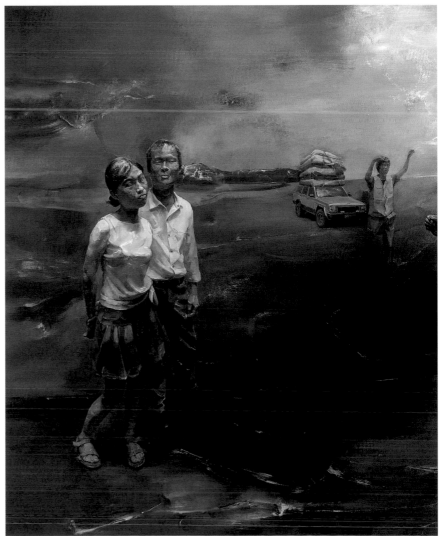

Fig. 245
Fan Bo
The Endless Dusk (1 of 3)
2004
Oil on linen, 220 x 540 cm

Ma Lin (b. 1963)

Fig. 246
Ma Lin
Sudden Shower No. 3
2003
Oil on canvas 138 x 125 cm

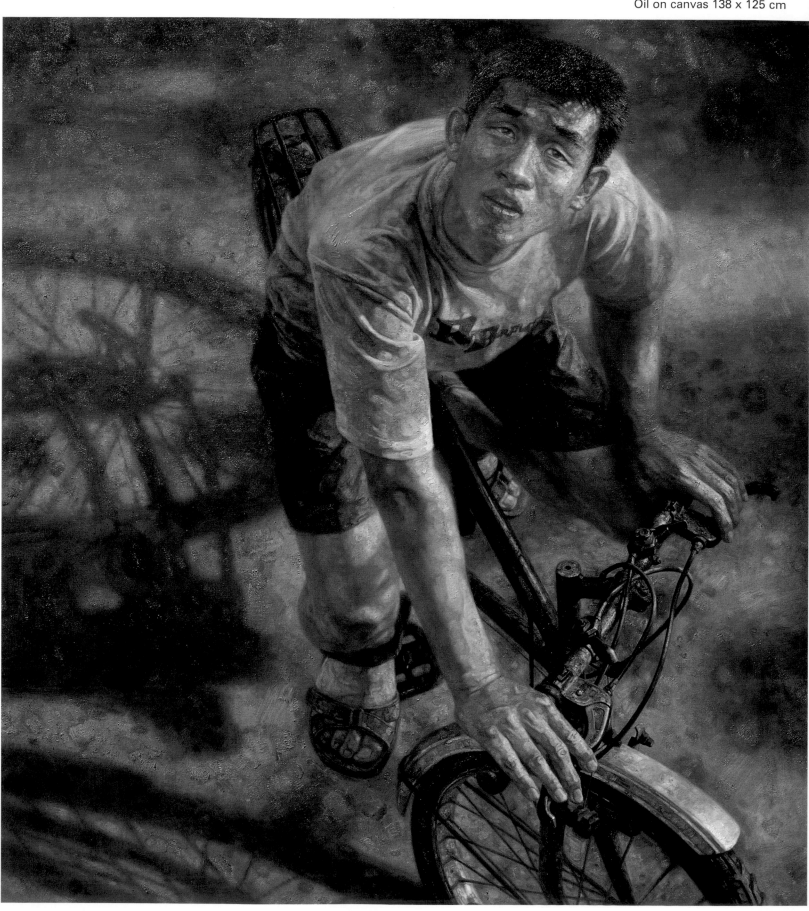

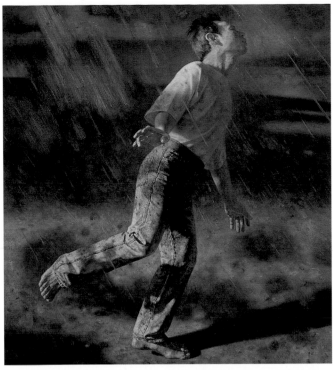

Fig. 247
Ma Lin
Sudden Shower No. 1
2002
Oil on canvas, 138 x 125 cm

Fig. 248
Ma Lin
The Floating Cloud
1999
Oil on canvas, 100" x 90"

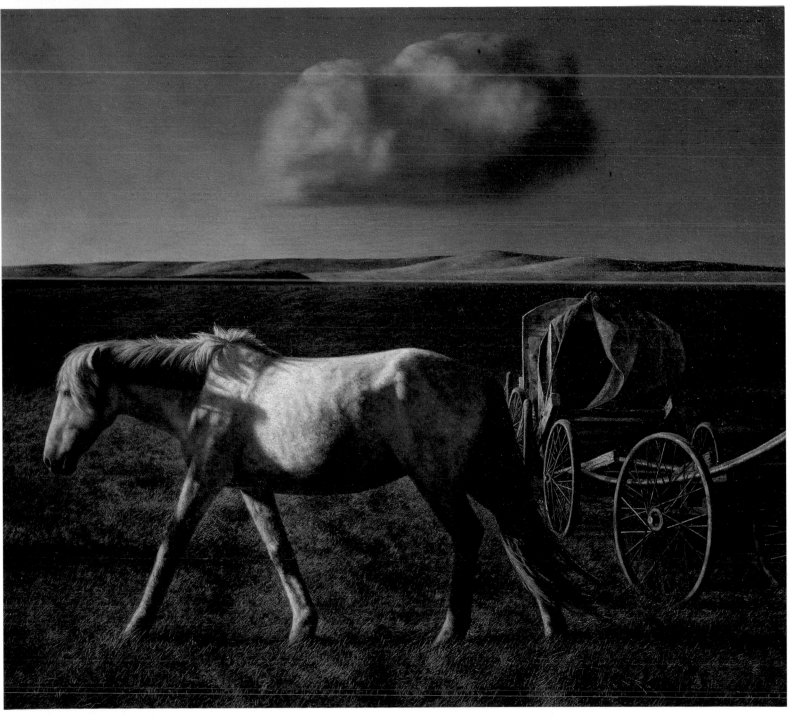

Shang Yang (b.1942)

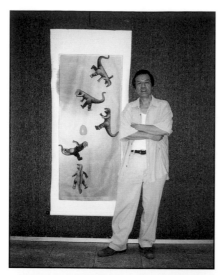

Shang Yang in front of his work
Dragon and Clouds, 2000

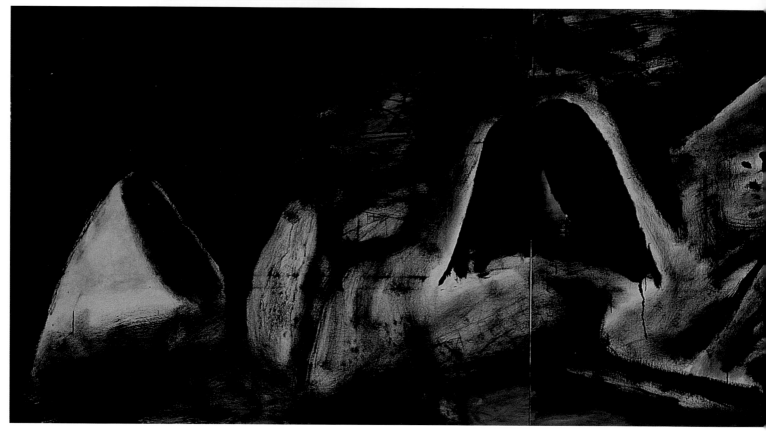

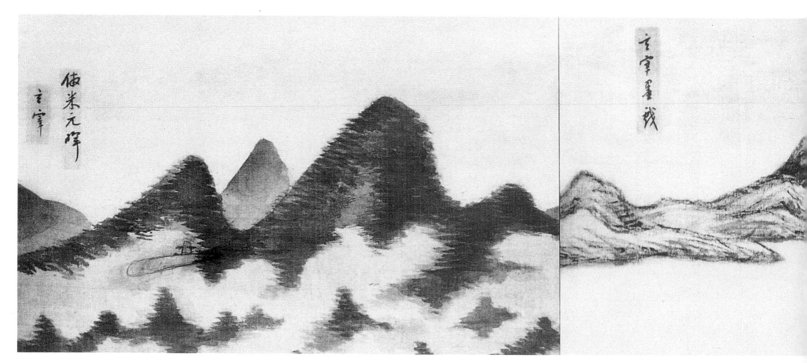

Center:
Fig. 249
Shang Yang
Grand Landscape—9-6-99
1999
Oil and acrylic on canvas, 140 x
486 cm

Bottom:
Fig. 250
Shang Yang
Dong-Qi-Chang Plan—2
2003
Oil, acrylic, air brush on canvas,
149 x 699 cm

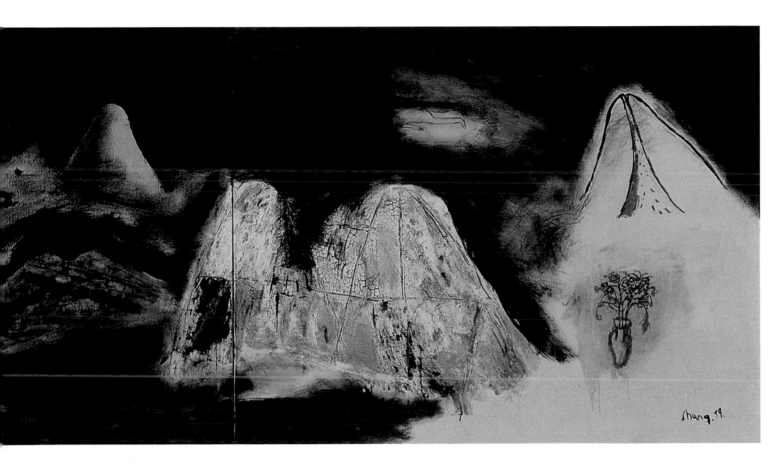

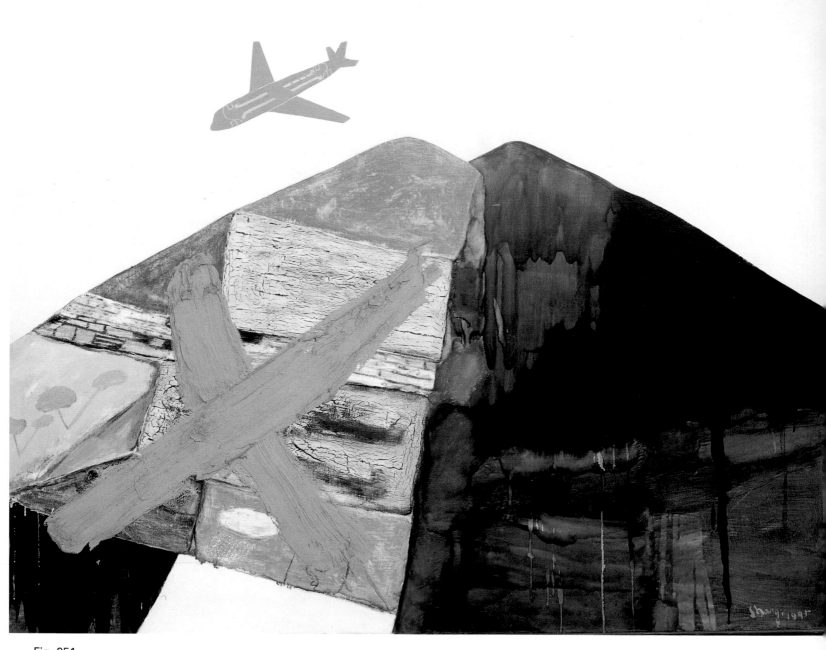

Fig. 251
Shang Yang
'95 Grand Landscape—1
1995
Oil and acrylic on canvas, 173 x 200 cm

Ming Jing (b.1960)

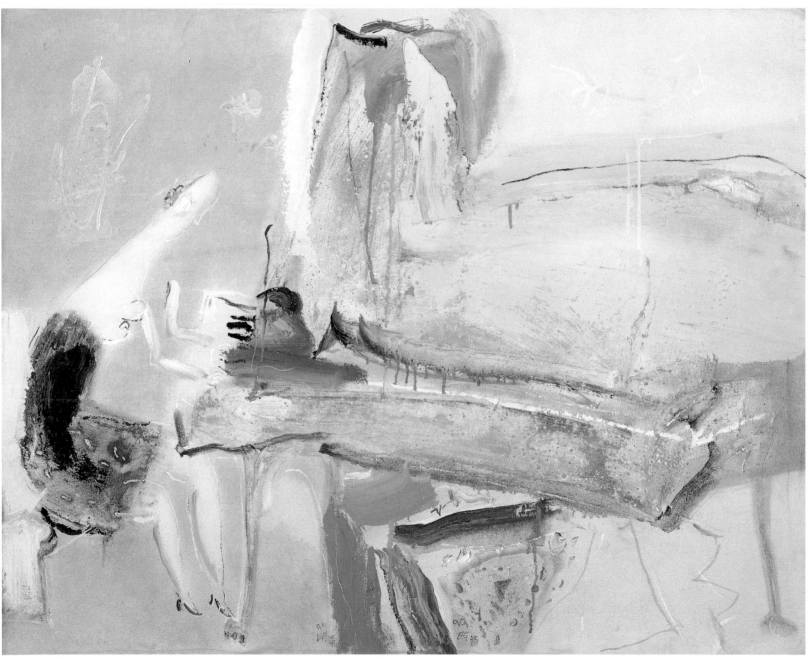

Fig. 252
Ming Jing
Piano
1999
Oil on canvas, 100 x 80 cm

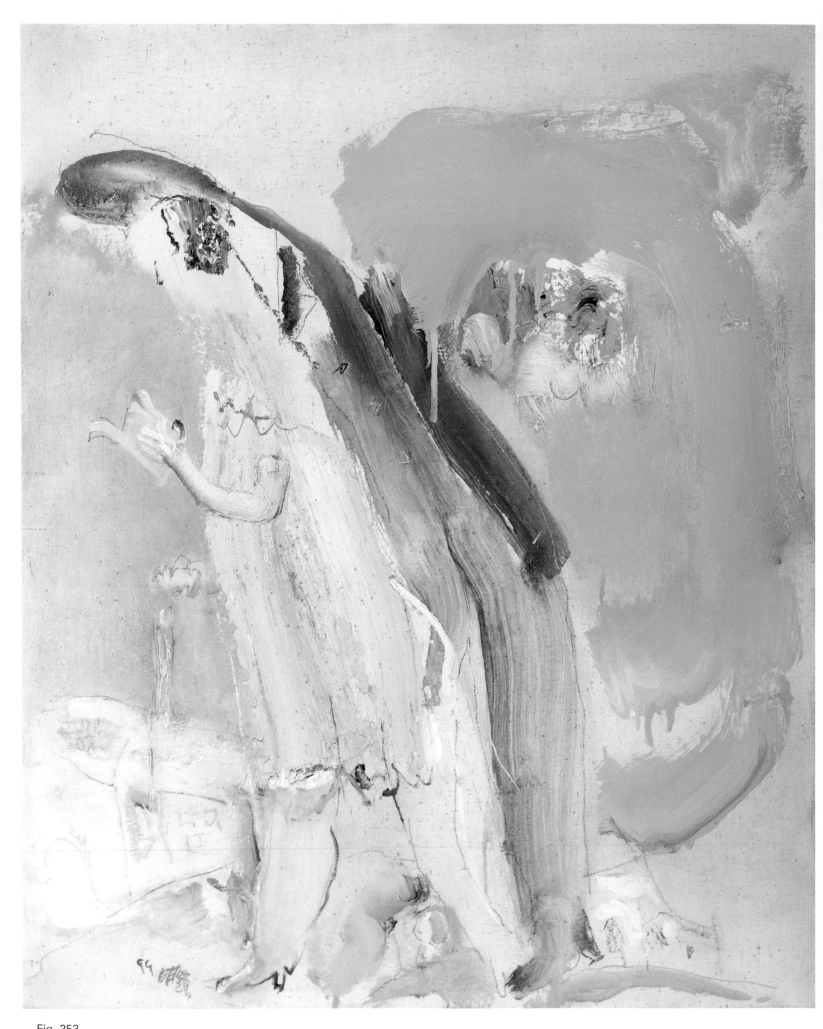

Fig. 253
Ming Jing
An Interesting Book
1999
Oil on linen, 65 x 80 cm

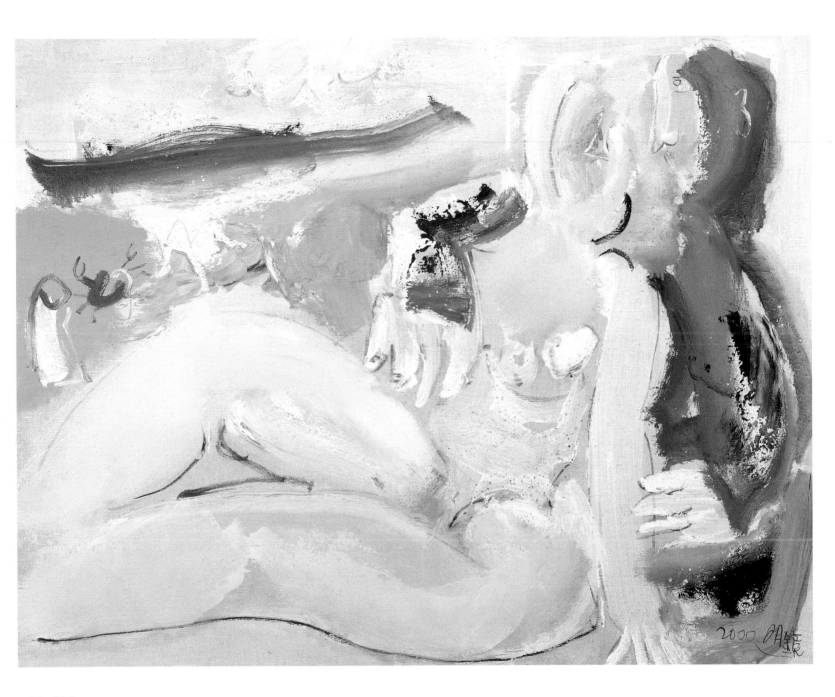

Fig. 254
Ming Jing
At Sea Side
2000
Oil on canvas, 100 x 80 cm

Zhang Jing Sheng (b. 1940)

Zhang Jing Sheng paints in his studio at night, because he is too busy with teaching during the day

Opposite page, top:
Fig. 256
Zhang Jing Sheng
The Variation of The Red Flower on Kitchen Table No. 8
2000
Oil on canvas, 80 x 100 cm

Opposite page, bottom:
Fig. 257
Zhang Jing Sheng
Afternoon Kitchen
2003
Oil on canvas, 80 x 100 cm

Fig. 255
Zhang Jing Sheng
The Variation of A Garden Scene at Fall IV
2000
Oil on canvas, 70 x 80 cm

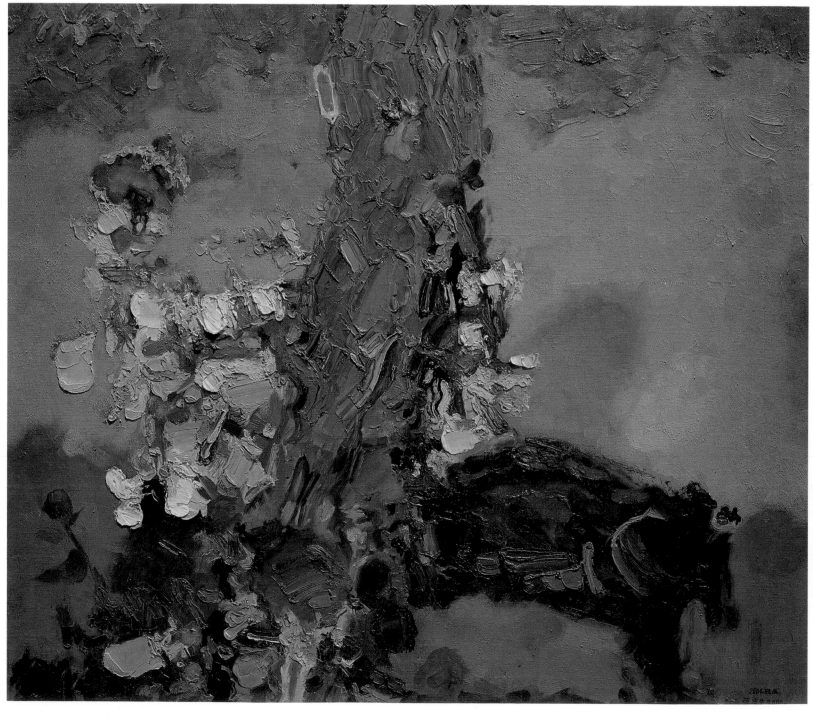

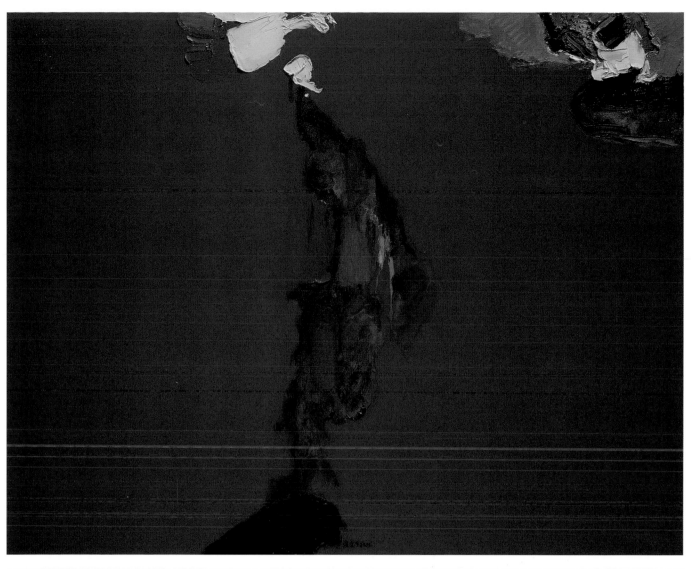

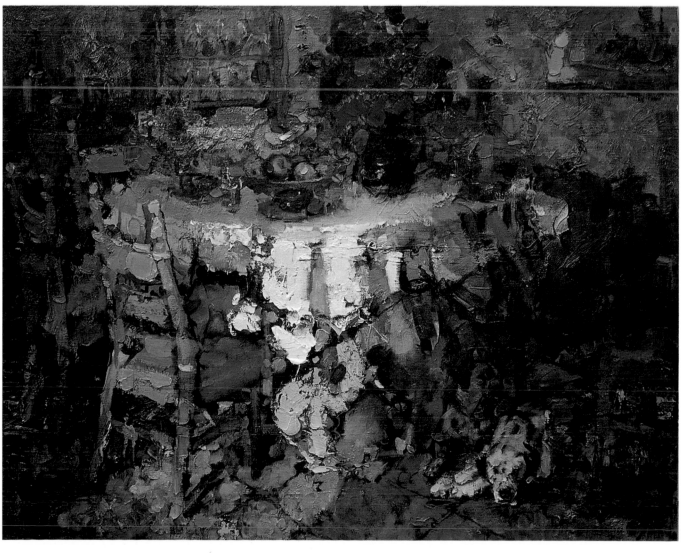

215

Zhu Jin (b. 1959)

Fig. 258
Zhu Jin
The Watcher No.1
1999
Earth and mixed media on
canvas, 80 x 100 cm

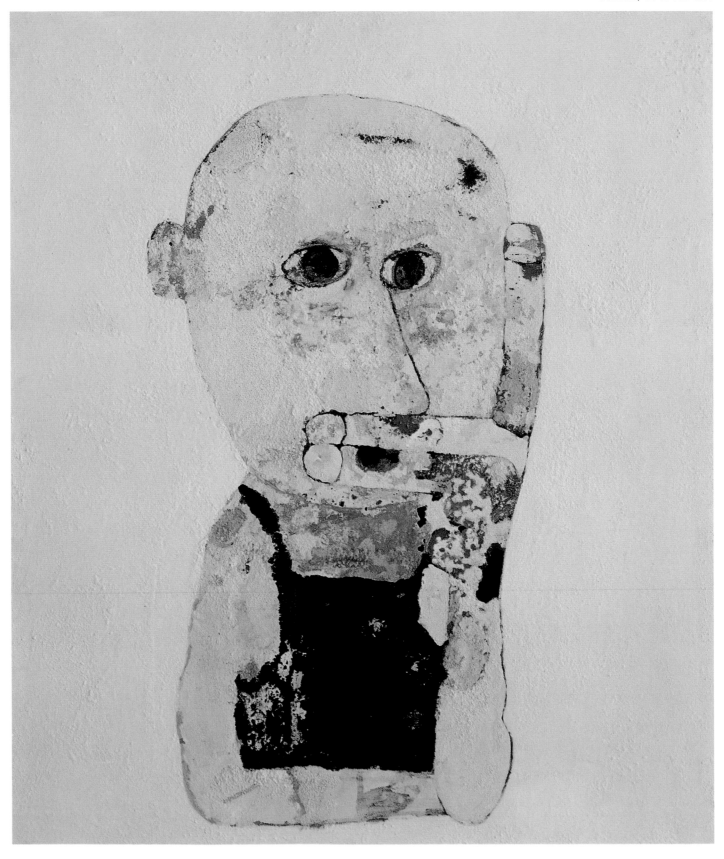

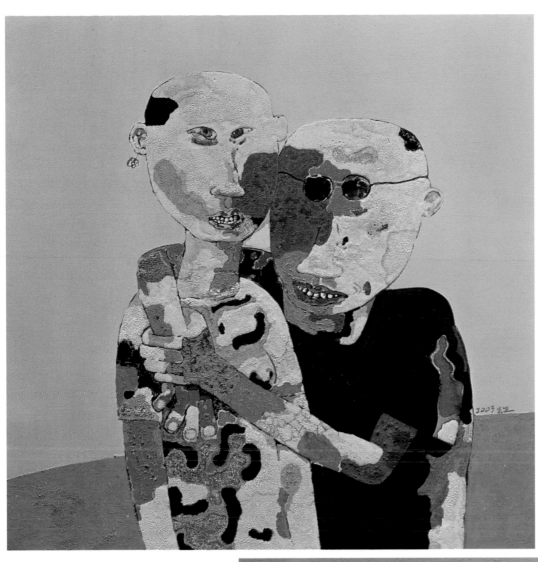

Fig. 259
Zhu Jin
Time No.8
1999
Earth and mixed
media, 100 x 100 cm

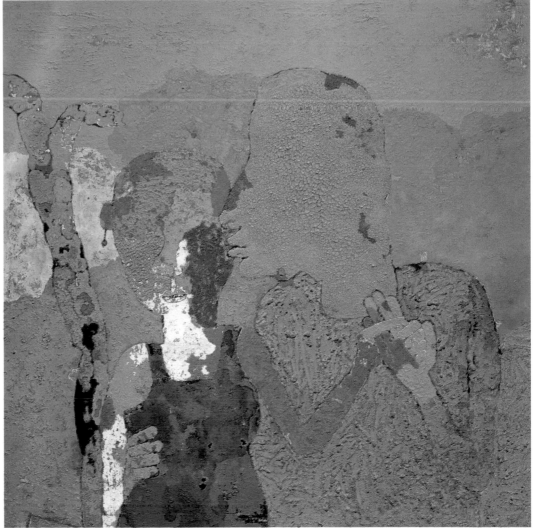

Fig. 260
Zhu Jin
Time No. 1
1999
Earth and mixed
media, 200 x 200 cm

Qi Hai Ping (b. 1957)

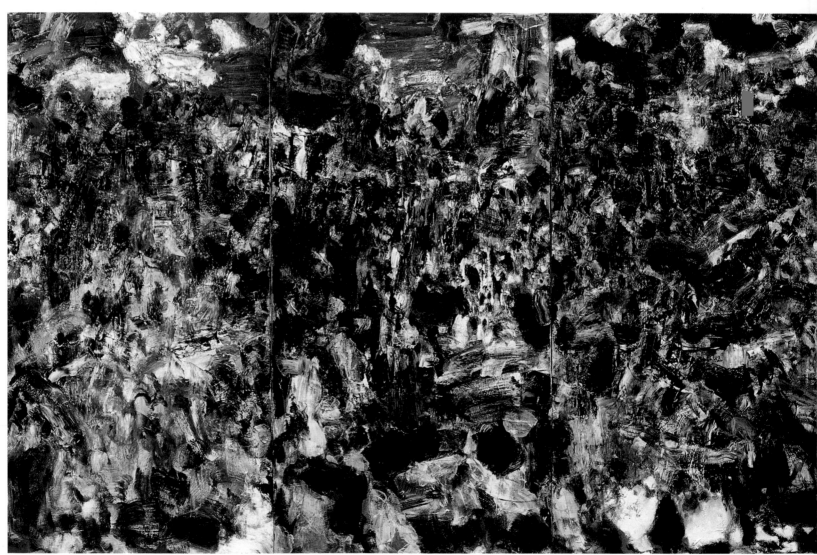

Fig. 261
Qi Hai Ping
Black No. 33
2001
Oil on canvas, 300 x 200 cm

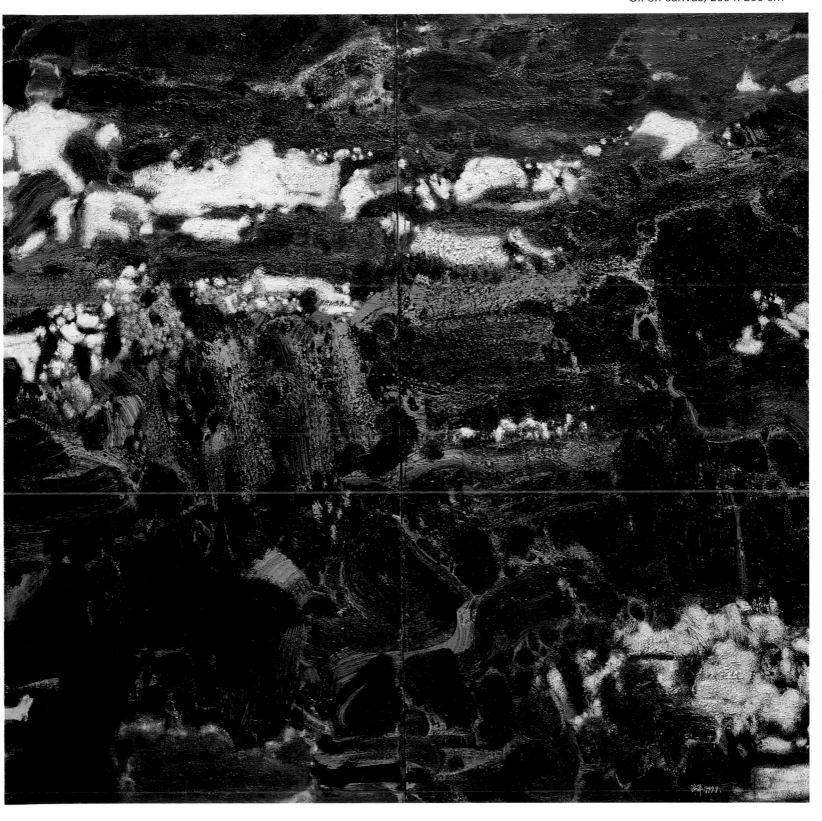

Fig. 262
Qi Hai Ping
Black No. 25
1999
Oil on canvas, 200 x 200 cm

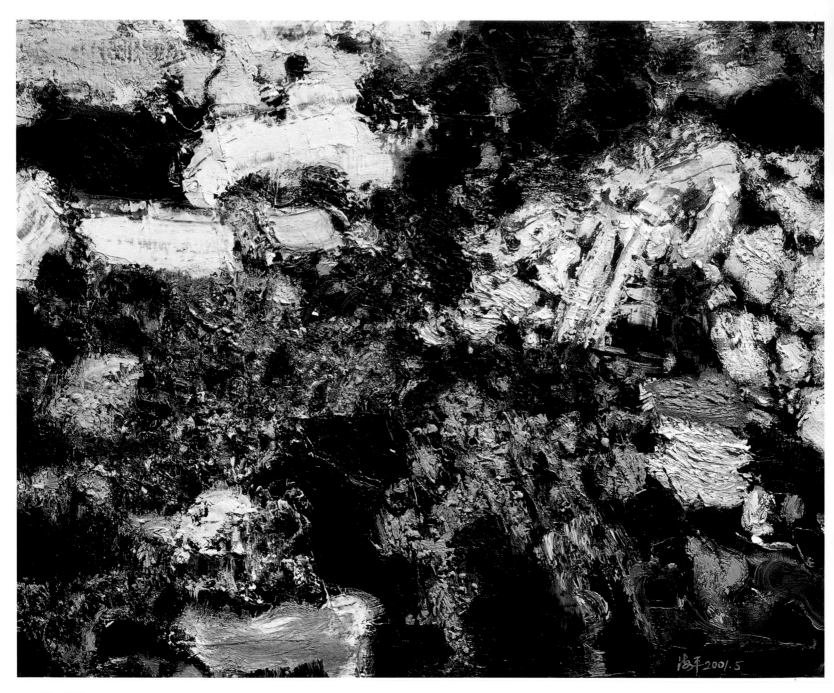

Fig. 263
Qi Hai Ping
Black No. 32
2000
Oil on canvas, 61 x 50 cm

Sha Jin (b. 1955)

Fig. 264
Sha Jin
The Red Horse
1999
Oil on canvas, 130 x 160 cm

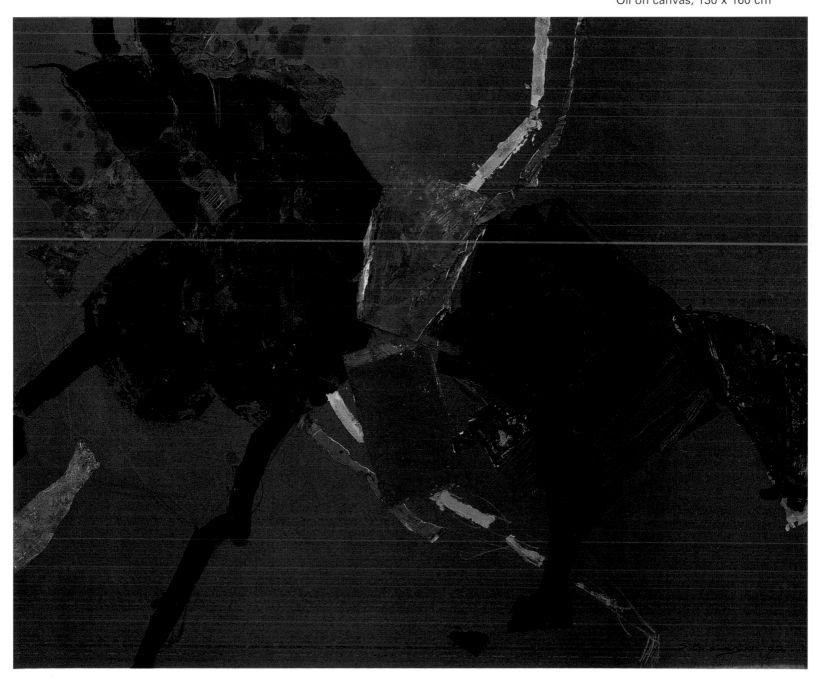

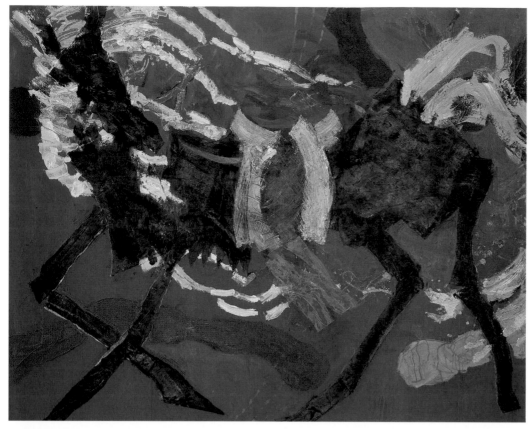

Fig. 265
Sha Jin
The Blue Horse
1999
Oil on canvas, 130 x 160 cm

Fig. 266
Sha Jin
Spring Outing No. 3
2002
Oil on canvas, 100 x 80 cm

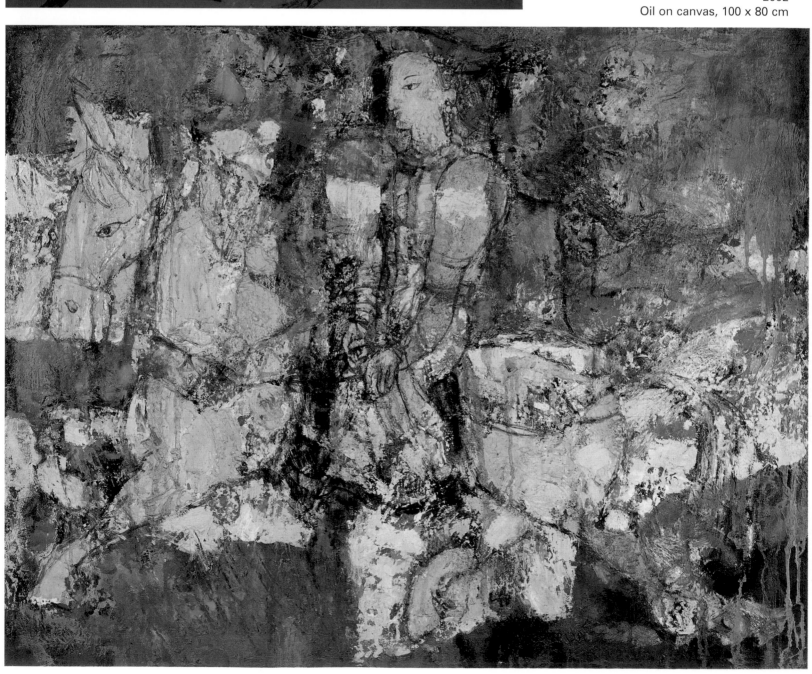

Ding Yi (b 1962)

Fig. 267
Ding Yi
Appearance of Crosses 98-B3/B6
1998
Charcoal, chalk, corrugated paper, 260 x 80 cm x 4 /p.c.

Fig. 268
Ding Yi
Appearance of Crosses 91-3
1991
Acrylic on canvas, 140 x 180 cm

Tan Gen Xiong (b. 1952)

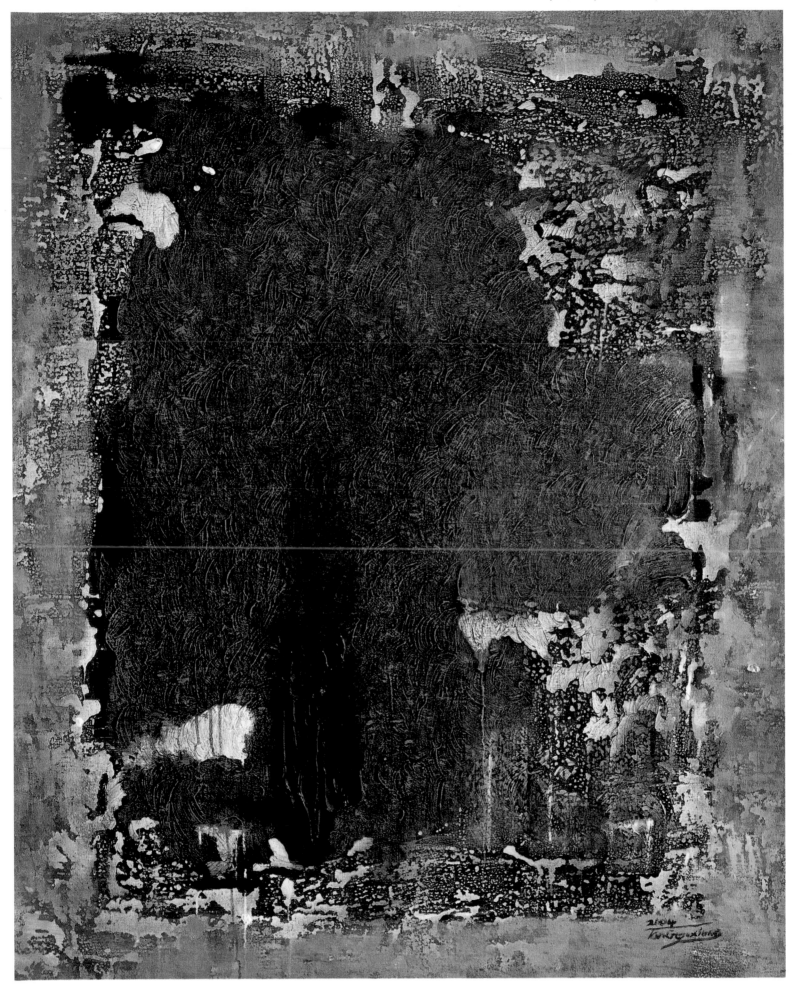

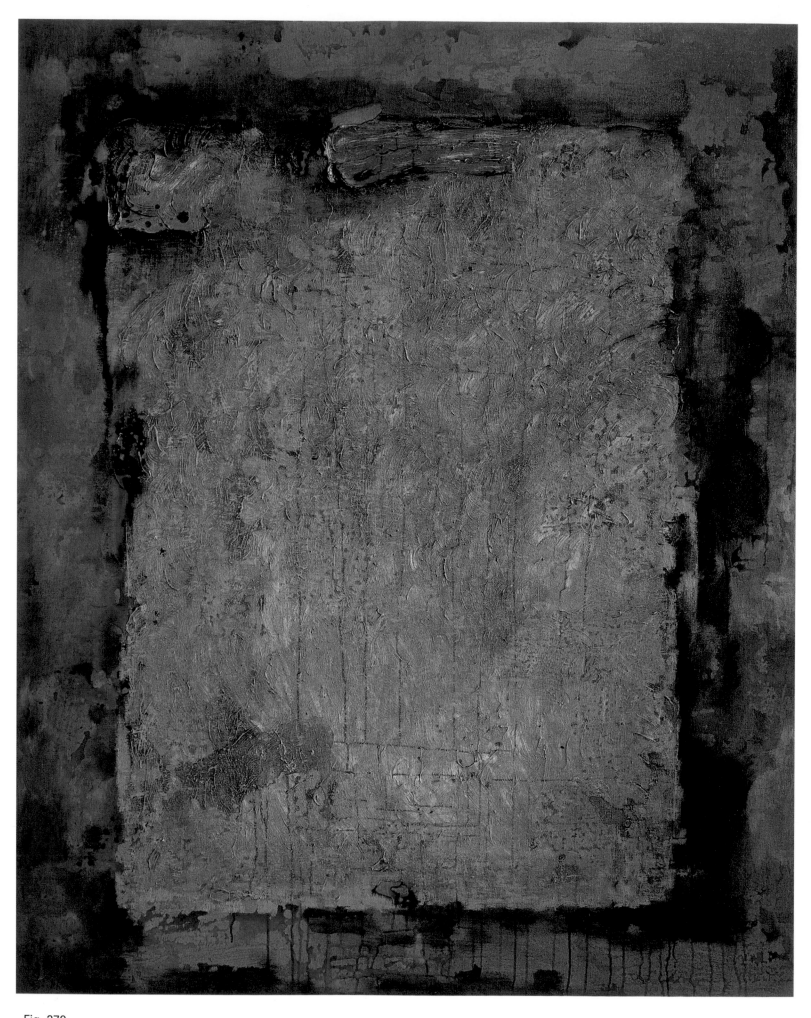

Fig. 270
Tan Gen Xiong
Dynasty #121
Acrylic, oil, paint and lead white, 150 x 120 cm

Yang Jin Song (b. 1955)

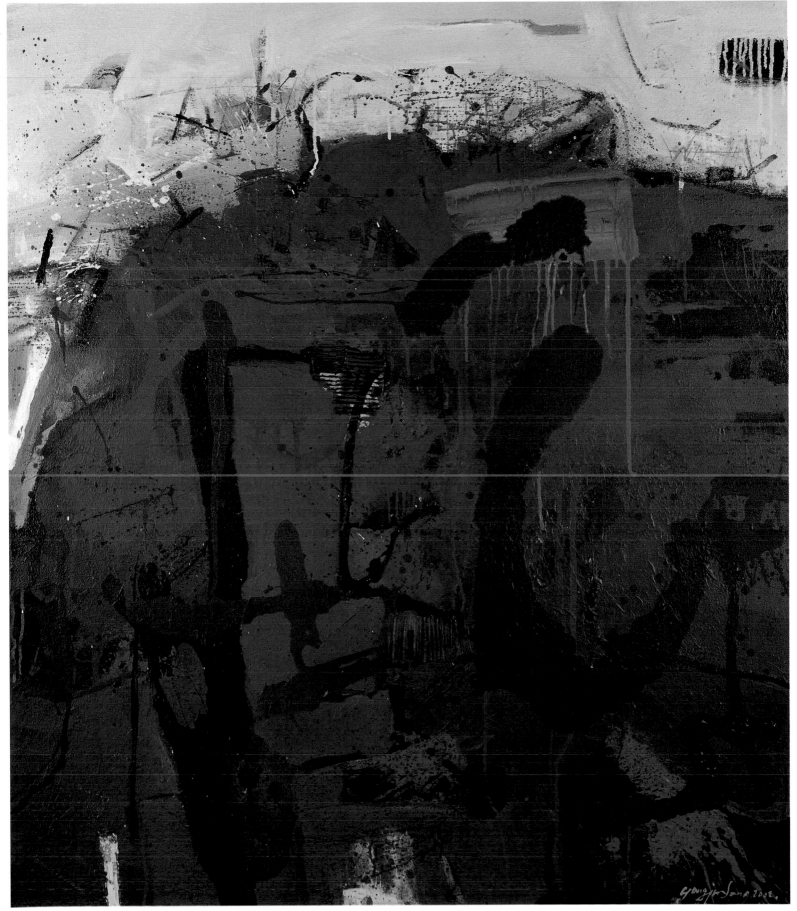

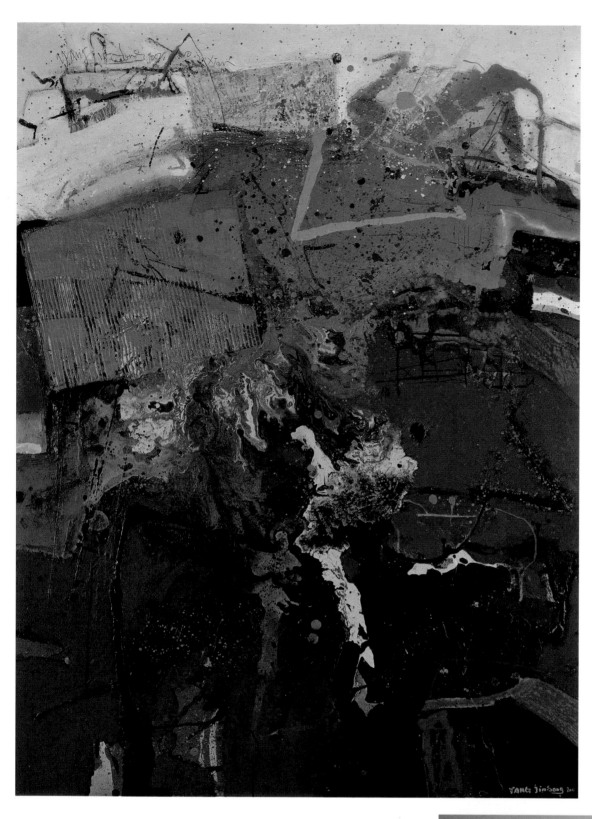

Fig. 273
Yang Jin Song
The Red City
2003
Acrylic and mixed media, 180 x
140 cm

Fig. 274
Yang Jin Song
Untitled
2002
Acrylic and mixed media, 160 x 130 cm

Final Words

Even as this book is going to press, Chinese art is moving in new directions and new artists are emerging. The creative energies coming from the country are astonishing. Clearly China's new artists will play an even more important role in the contemporary international art scene.

Epilogue

I have to believe this is fate. In February 1989 when the famous exhibition China/Avant-Garde was held in Beijing, I was as excited as the artists who were involved. I remember that day I held a very small notebook in my hand and interviewed many of the rebels both inside and outside the museum. It was there that idea of writing a book about this generation's art and artists was planted in my mind. After the exhibition, at my request, the artists, almost every one, sent slides of their work, hand-written personal stories, and statements about their art to me, some of them more than 50 pages thick. I had very little time to study them when the Tiananmen Movement took place, and everything was put aside. After the turbulence ended, I sealed the files in a brown paper bag, along with my passion for the project.

Before I left for United States in 1990, I threw out anything I couldn't carry, except for this brown paper bag. I felt I would discard the most sincere hearts of the artists and their faith in me if I did that. With only $30 in my pocket and no idea of what was ahead, I had to choose between carrying it with me or leaving it behind. I chose the latter, but asked my family to keep the bag for me, and to promise, that no matter what happened, they would never throw it away.

Thirteen years later, Douglas Congdon-Martin came in our gallery on Cape Cod, and while there mentioned to my husband, Bao Le De, an idea of writing a book on Chinese modern art. When Bao came home and told me that news, the fire rekindled up in my heart.

A few months later, I was back in China to gather materials for this book. The first task was to find the brown bag. My family had moved in the past thirteen years, and I knew that I had little chance of ever seeing it again. When my father-in-law went through a pile of my old books and handed me a dark paper bag, badly crumpled, torn at the edge and covered with dust, I couldn't believe my eyes! Crying with joy, I thanked him for saving it for so many years! I had long felt guilty that I had never written the first book, as though I owed something to those artists who had trusted me and lent me their hearts so very long ago. Now I finally had a chance to keep my promise and re-pay them.

For ten years, China has undergone unparalleled changes. To tell all that is really happening now meant that I had to leave out some of the artists from my thirteen-year-old list. I ask them to accept my apology. I would like to thank Zhang Xiao Gang, Mao Xuhui, Yie Yong Qing, Su Qun, Wang Guang Yi, Gen Jian Yi, Zhang Pei Li, Huang Yong Ping, and Xu Bing for giving me the opportunity to use their old images and information. As you have already read, most of them have become the main players in the art scene not just of China, but internationally as well.

Tong Dian, 12-10-2004
Tao Water Art Gallery,
1989 Route 6A
W. Barnstable MA 02668 USA
www.taowatergallery.com.
info@taowatergallery.com

Bibliography

Allegory of Life Zhong Biao's Oil Paintings, The. Unpublished catalog, 1997

Andrews, Julia F., and Kuiyi Shen. *A Century in Crisis.* Guggenheim Museum Publications, 1998

Bessire, Mark H. C., editor. *Wenda Gu: Art From Middle Kingdom to Biological Millennium.* The MIT Press, 2003

Cai Jin. *Of the Canvas.* Unpublished catalog, 1999

Cai Jin. People's Fine Arts Publishing House, 1995

Cartoon Generation: The Second Show. Unpublished catalog, 1998

Chen Xiaoxing and Dao Zi. *Sideline Point of View 4 Intellectual and Meaning of Art.* Unpublished catalog, 2000

China: 20 years of Ink Experiment 1980-2001. Heilongjiang Fine Arts Publishing House, 2001

Chinese Contemporary Painters: Zhang Jing Sheng. Tianjing Fine Arts Publishing House, 2003

Chinese Experimental Ink and Wash 1993-2003. Heilongjiang Fine Arts Publishing House, 2004

Chong Qing. *Chili American Tour.* Unpublished catalog, 2003

Contemporary Chinese Portrait. Catalog, France Gallery, 2000

Din Yi. *Din Yi.* Catalog of Shangh Art Gallery, 1997

Deng Hong and Liu Xiaochun. *2001 Cheng Du Biannual.* Unpublished catalog, 2001

Din, Zhengen. *Chinese Contemporary Art 1990-2000.* Liao Ning Fine Art Publishing House, 2000

Din, Zhengen. *Chinese Contemporary Art 2001.* Liao Ning Fine Art Fine Art Publishing, 2001

Fan Di An and Song Xiao Xia. *Liu Xiao Dong 1990-2000.* Unpublished catalog, 2000.

Fang Li Jun. Unpublished catalog, 1996

Fang Li Jun, Gu De Xing, Zhang Xiao Gang. Unpublished catalog, France, 1996-1997

Fang Tu: Chinese New Ink Painters in Twenty-First Century *No. 1.* Ning Nan Fine Art Publishing House, 2000

Feel the Memory. Unpublished catalog, 2004

Feng Bin. *Eternal Present 1997-2000.* Unpublished catalog, 2000

Feng Zheng Jie. *The Story of Skin.* Unpublished catalog, 1996.

Feng Zheng Jie. *Packaging.* Beijing Glerie et Xin-Dong Cheng Cheng, 2002

Feng Zheng Jie. *Coolness.* Unpublished catalog, 2001.

Feng Zheng Jie. *Regards vers l Ouest.* Beijing Glerie et Xin-Dong Cheng, 2003

Gao Minglu and Tong Dian etc. *China's Contemporary Art History 1985-1986.* Shanghai People's Publishing House, 1991.

Gu Zheng Qing. *China's Charm Conception Photography.* Unpublished catalog, 2000

Guo Gai. *China's Image 2002.* Unpublished catalog, 2002

Guo Jin. Unpublished catalog, 1999

Guo Jin and Guo Wei 2002. Unpublished catalog, 2002.

Guo Wei. Unpublished catalog, 2000

Guo Xiao Cuan. *The Revelation of China's Contemporary Art in Twenty Century.* Culture and Art Publishing House, 1998

Hai Ri Han. *Drifting in the World.* Hubei Fine Arts Publishing House, 1999

Hai Ri Han. Unpublishcd catalog, 1998

Hang Jian. *The New Representational Art: Between the Reality and Inner World.* Ji Ling Fine Art Publishing House, 1999

He Duo Ling. Jie Jiang People's Publishing House, 2003

He Sen 1999. Unpublished catalog, 1999.

He Sen 2002. Unpublished catalog, 2000.

He Sen 2003. Unpublished catalog, 2003

He Sen: Women's Portraits. Unpublished catalog 2000.

Huang Yan and Hai Po, Jiao Yingqi. *2000 China Internet Image Art.* Unpublished catalog, 2000.

Huang Zhuan, Le Zheng Wei. *Contemporary Art and Social Science.* Hunan Fine Art Publishing House, 1999.

Huang Zhuan. *Society.* Shang He Fine Art Museum, unpublished catalog, 2000.

Impression de Chine. Unpublished catalog, 2003

Jia Fang Zhou. *Centuries and Woman's Art.* Hong Kong International Chinese Fine Art Publishing House, 1998.

Lang Shao Jun. *From Realist to Absurd: Li Xiao Xuan and His Modern Ink Painting.* Hunan Fine Arts Publishing House, 1997

Li Xiao Xuan. *The Fantasy Reality.* Provisional Municipal Council of Macau edition, produced by Cultural and Recreational Service, March 2001

Li Xiao Xuan. *The Fleeting Yesterday*. Hubei Fine Arts Publishing House, 1999

Liao Wen and Li Xianting. *The Rainbow over the Century: Gaudy Art*. Hunan Fine Art Publishing House, 1999.

Liao Wen. *Women and Flowers*. Unpublished catalog 1997.

Liao Wen. *Women-ism in China's Contemporary Art*. Unpublished catalog 1995.

Liao Wen. *Woman Art: the Behavior of Women-ism*. Jiling Fine Art Publishing House.

Ling Bai and Cai Jin. *Can't Separate from the Lover*. Zhe Jiang People's Fine Art Publishing House, 2003

Liu Da Hong. Catalog, 1992

Liu Yie. Unpublished catalog, 1997.

Liu Yir Red Yellow Blue. Unpublished catalog, 2003.

Li Xianting. *What's important is not Art*. Jiansu Fine Art Publishing House, 2000

Liu Zheng 1998-2002. Unpublished catalog, 2002

Lu Fa Hui Rose: 2002. Unpublished catalog, 2002

Luobrother. Unpublished catalog, 2002

Lu Peng. *Chinese Contemporary Art History 1990-1999*. Hunan Fine Art Publishing House, 2000

Ming Jing: The Outstanding Painters of 21st Century. Jiansu Fine Arts Publishing House, 2001

New Works Guo Wei and Guo Jin. Unpublished catalog, 2000

Oil Paintings by Ming Jing. Unpublished catalog, 2003

Pang Yin. *The Art Dimension: New Direction of Art Language*. Hunan Fine Art Publishing House, 1999

Sha Jin's Paintings. Inner Mongolia University Publishing House, 2002

Shang Yang Selected Works. Tianjing Fine Arts Publishing House, 1996

Shen Xiao Tong: The Temptation of Images. Unpublished catalog, 2003

Song Yong Hong: The Bath of Consolation. Unpublished catalog, 2001

Song Yong Hong: The Burning Reality. Unpublished catalog, 1995

Su Xin Ping's Art. Hong Kong Xin Yuan Publishing House, 2003

Su Xin Ping's Lithography. Culture and Art Publishing House, 2000

Thorp, Robert L., and Richard Ellis Vinnograd *Chinese Art & Culture*. Prentice Hall, Inc., and Harry N. Abrams, Inc., Publishers, 2001

20th Century China's Oil Paintings 1900- 2000, The. Guang Xi Fine Art Publishing House, 2000

2003 Contemporary Chinese Art. Shanghai People's Publishing House, 2003

Umbilical Cord of History: Paintings by Zhang Xiao Gang. Unpublished catalog, 2001

Witness Growing Up: Yu Hong. Modern Art Publishing House, 2002

Wu Hong. *The First Guang Zhou Triennial, Reinterpretation: A Decade of Experimental Chinese Art (1990-2000)* Macau Publishing House 2002

Xiao Wu Liao. *The Passionate Fashion: Chinese's People's Art and Life of 1970s*. Shandong Pictorial Publishing House, 2002

Xin Hai Zhou. *Place Which Eyes Cannot Touch*. Unpublished catalog, 2002

Yang Jin Song. *Collection of Drawing & Etching*. Unpublished catalog, 1992

Yang Jing Song. *The Layered Texture*. Hebei Fine Arts Publishing House, 2002

Yi Ji Nan. *Post-Motherism/Stepmotherism: a Close Look at Contemporary Chinese Culture and Art*. Three Union Publishing House, 2002

Yi Ji Nan. *Knocking the Door by Myself*. Three Union Publishing House, 1999.

Yin Shuan Xi. *Idols in Painting World*. Zhu Hai Publishing House, 1999

Yue Ming Jun. Unpublished catalog, 2004

Zhang Jing Sheng: Selected Works. Tianjing Fine Arts Publishing House

Zhao Kai Lin Realism Oil Painting. Unpublished catalog, 2001

Zhao Neng Zhi -Expression 2004. Unpublished catalog, 2004

Zhou Yue Jin. *A History of Chinese Fine Arts: 1949-2000*. Hunan Fine Arts Publishing House, 2002

Zhu Bin. *Shi Chong*. Nubei Fine Arts Publishing House, 2002

Index To Artists

NEW